The Art of Painting Animals

**PALM BEACH COUNTY
LIBRARY SYSTEM
3650 Summit Boulevard
West Palm Beach, FL 33406-4198**

Quarto is the authority on a wide range of topics.
Quarto educates, entertains, and enriches the lives of our readers—
enthusiasts and lovers of hands-on living.
www.quartoknows.com

Authors: Maury Aaseng, Lorraine Gray, Jason Morgan, Kate Tugwell, Deb Watson, Toni Watts

6 Orchard Road, Suite 100
Lake Forest, CA 92630
quartoknows.com
Visit our blogs @quartoknows.com

Printed in China

10 9 8 7 6 5 4 3 2

The Art of
Painting Animals

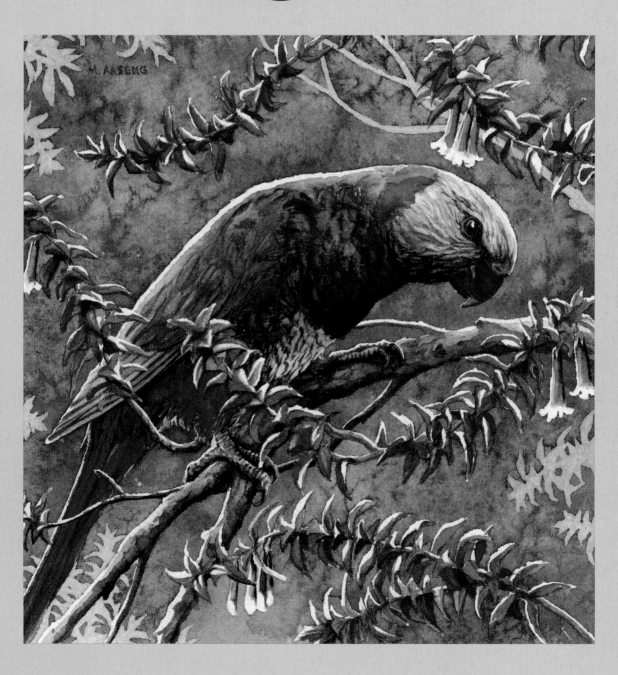

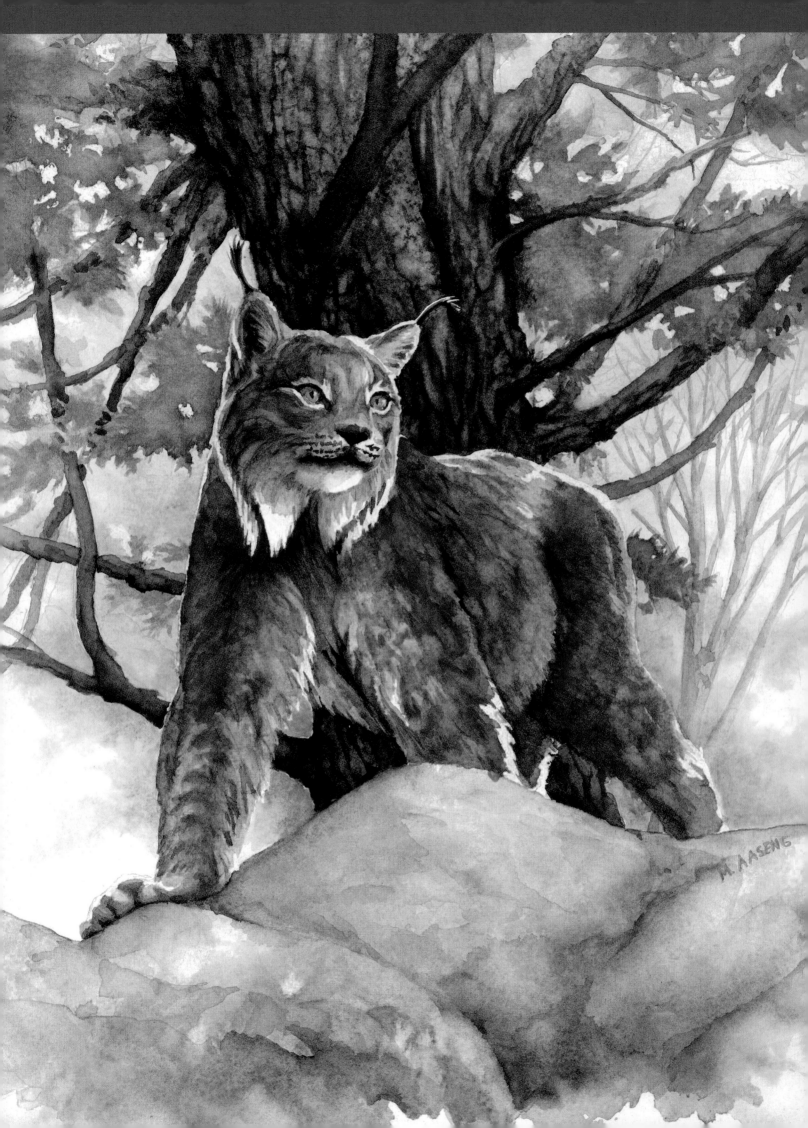

Contents

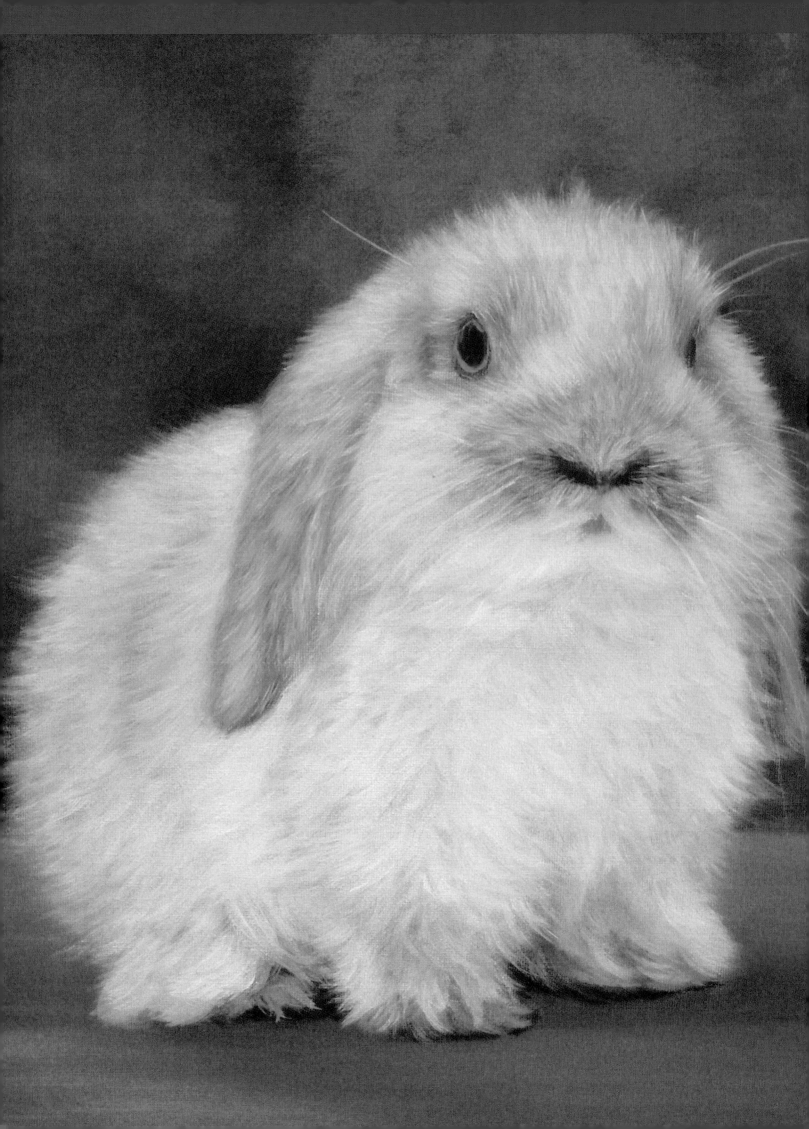

CHAPTER 1

Introduction

Oil, acrylic, watercolor—the beauty of wildlife can be captured using all of these mediums. This book will guide you in how to use each medium and help you bring some of the world's most majestic creatures to life on paper or canvas, from wild and marvelous to domesticated and endearing. Each chapter guides you through step-by-step lessons designed to help you master the art of painting in each medium, featuring the expert insight and instruction of six talented artists. From using the appropriate tools and painting techniques to color theory and rendering realistic animal features and textures, artists of all skill levels will benefit from the lessons and techniques featured in this book. Enjoy the painting process, and unleash your creativity!

Tools & Materials

Paints

Paint varies in expense by grade and brand, but even reasonably priced paints offer sufficient quality. Very inexpensive paints might lack consistency and affect your results, but buying the most costly color may limit you. Find a happy medium.

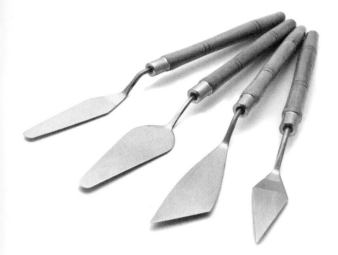

Palette & Painting Knives

Palette knives are mainly used for mixing colors on your palette and come in various sizes and shapes. Some knives can also be used for applying paint to your canvas, creating texture in your work, or even removing paint. Palette knives are slightly rounded at the tip. Painting knives are pointed and a bit thicker, with a slightly more flexible tip.

Palettes

Palettes for acrylic range from white, plastic handheld palettes to sheets of plexiglass. The traditional mixing surface for oils is a handheld wooden palette, but many artists opt for a plexiglass or tempered glass palette. A range of welled mixing palettes are available for watercolorists, from simple white plastic varieties to porcelain dishes.

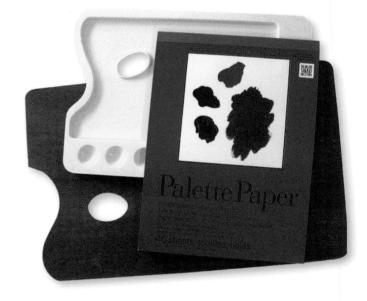

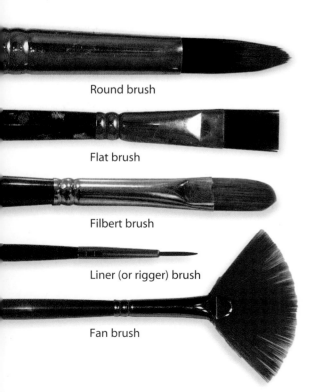

Round brush

Flat brush

Filbert brush

Liner (or rigger) brush

Fan brush

Brushes

Synthetic brushes are the best choice for acrylic painting because their strong filaments can withstand the caustic nature of acrylic. Sable and soft-hair synthetic brushes are ideal for watercolor. A selection of hog bristle brushes is a staple for all oil painters. Build your starter set with small, medium, and large flat brushes; a few medium round brushes; a liner (or rigger) brush; a medium filbert brush; and a medium fan brush. Brushes are commonly sized with numbers, although the exact sizes vary between manufacturers. Generally #1 to #5 are small brushes, #6 to #10 are medium brushes, and #11 and up are large brushes. Flat brushes are often sized by the width of the ferrule (or brush base), such as 1/4-inch, 1/2-inch, and 1-inch flat brushes.

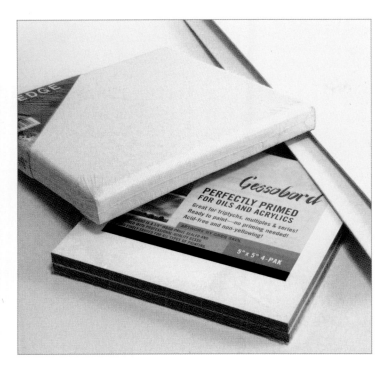

Painting Surfaces

Although you can paint with oils and acrylics on almost any material, from watercolor paper to wooden board, canvas is the most popular choice. Watercolor paper is the perfect surface for the fluid washes of watercolors. Many artists like using this durable paper for other wet and dry media.

Mediums, Solvents & Additives

Drying oils and oil mediums allow artists to change the consistency and reflective qualities of oil paint. Although you can technically paint straight from the tube, most artists add medium to extend the paint and to build an oil painting in the traditional "fat over lean" layering process. Because oil-based paints do not mix with water, artists traditionally use solvents, such as odorless mineral spirits, for paint thinning and cleanup. If you choose to purchase a solvent, be sure it is intended for fine-art purposes. Note any instructions and cautions provided by the manufacturer.

To thin and clean up acrylic and watercolor, water is the simplest medium. However, you can also find mediums and additives made specifically for these types of paint. A range of gels, pastes, and additives allow artists alter to the behavior and properties of acrylic paint, such as extending the drying time or creating a coarse texture. Watercolor mediums are less common, but some artists rely on adding ox gall, gum arabic, granulation medium, or iridescent medium to create specific effects.

Additional Supplies

Some additional supplies you'll want to have on hand include:
- Paper, pencils, and a sharpener for drawing, sketching, and tracing
- Jars of water, paper towels, and a spray bottle of water
- Fixative to protect your initial sketches before you apply paint

Color Theory Basics

Acquaint yourself with the ideas and terms of color theory, which involve everything from color relationships to perceived color temperature and color psychology. In the following pages, we will touch on the basics as they relate to painting.

Color Wheel

The color wheel, pictured to the right, is the most useful tool for understanding color relationships. Where the colors lie relative to one another can help you group harmonious colors and pair contrasting colors to communicate mood or emphasize your message. The wheel can also help you mix colors efficiently. Below are the most important terms related to the wheel.

Primary colors are red, blue, and yellow. With these you can mix almost any other color; however, none of the primaries can be mixed from other colors. *Secondary* colors include green, orange, and violet. These colors can be mixed using two of the primaries. (Blue and yellow make green, red and yellow make orange, and blue and red make violet.) A *tertiary* color is a primary mixed with a near secondary, such as red with violet to create red-violet.

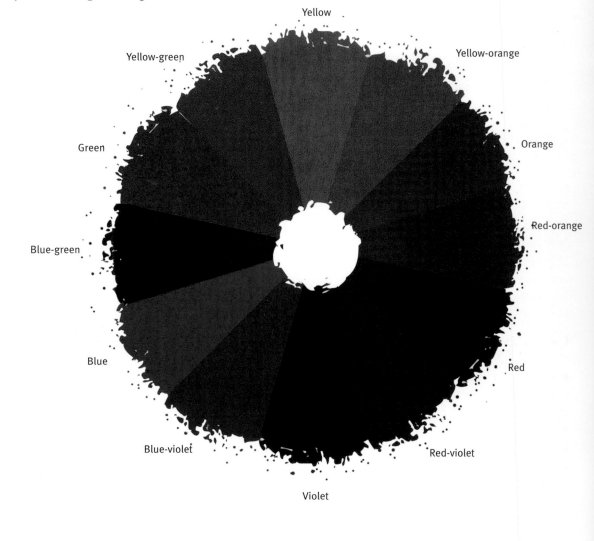

Complementary Colors

Complementary colors are those situated opposite each other on the wheel, such as purple and yellow. Complements provide maximum color contrast.

Analogous Colors

Analogous colors are groups of colors adjacent to one another on the color wheel, such as blue-green, green, and yellow-green. When used together, they create a sense of harmony.

Neutral Colors

Neutral colors are browns and grays, both of which contain all three primary colors in varying proportions. Neutral colors are often dulled with white or black. Artists also use the word "neutralize" to describe the act of dulling a color by adding its complement.

A B C D

A hue is a color in its purest form (A), a color plus white is a tint (B), a color plus gray is a tone (C), and a color plus black is a shade (D).

A single color family, such as blue, encompasses a range of hues—from yellow-leaning to red-leaning.

Color & Value

Within each hue, you can achieve a range of values—from dark shades to light tints. However, each hue has a value relative to others on the color wheel. For example, yellow is the lightest color and violet is the darkest. To see this clearly, photograph or scan a color wheel and use computer-editing software to view it in grayscale. It is also very helpful to create a grayscale chart of all the paints in your palette so you know how their values relate to one another.

A grayscale representation of a color wheel can help you see the inherent value of each hue.

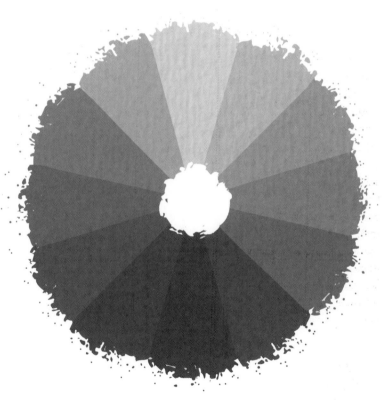

Artist's Tip

Art & craft stores sell spinning, handheld color wheels for painters that serve as color mixing guides. The wheels also show a range of gray values for reference.

Painting Techniques

Most painters apply paint to their supports with brushes. The variety of effects you can achieve—depending on your brush selections and your techniques—is virtually limitless.

Watercolor Techniques

Flat Wash A flat wash is a thin layer of paint applied evenly to your paper. First wet the paper, and then load your brush with a mix of watercolor and water. Stroke horizontally across the paper and move from top to bottom, overlapping the strokes as you progress.

Gradated Wash A gradated (or graduated) wash moves slowly from dark to light. Apply a strong wash of color and stroke in horizontal bands as you move away, adding water to successive strokes.

Backruns Backruns, or "blooms," create interest within washes by leaving behind flower-shaped edges where a wet wash meets a damp wash. First stroke a wash onto your paper. Let the wash settle for a minute or so, and then stroke another wash within (or add a drop of pure water).

Tilting To pull colors into each other, apply two washes side by side and tilt the paper while wet so one flows into the next. This creates interesting drips and irregular edges.

Wet-into-Wet Stroke water over your paper and allow it to soak in. Wet the surface again and wait for the paper to take on a matte sheen; then load your brush with rich color and stroke over your surface. The moisture will grab the pigments and pull them across the paper to create feathery soft blends.

Using Salt For a mottled texture, sprinkle salt over a wet or damp wash. The salt will absorb the wash to reveal the white of the paper in interesting starlike shapes. The finer the salt crystals, the finer the resulting texture. For a similar but less dramatic effect, squirt a spray bottle of water over a damp wash.

Spattering First cover any area that you don't want to spatter with a sheet of paper. Load your brush with thinned paint and tap it over a finger to fling droplets of paint onto the paper. You can also load your brush and then run a fingertip over the bristles to create a spray.

Applying with a Sponge In addition to creating flat washes, sponges can help you create irregular, mottled areas of color.

Acrylic & Oil Techniques

Flat Wash To create a thin wash of flat color, thin the paint and stroke it evenly across your surface. For large areas, stroke in overlapping horizontal bands, retracing strokes when necessary to smooth out the color. Use thinned acrylic for toning your surface or using acrylic in the style of watercolor.

Glazing As with watercolor, you can apply a thin layer of acrylic or oil over another color to optically mix the colors. Soft gels are great mediums for creating luminous glazes. Shown here are ultramarine blue (left) and lemon yellow (right) glazed over a mix of permanent rose and Naples yellow.

Drybrushing Load your brush and then dab the bristles on a paper towel to remove excess paint. Drag the bristles lightly over your surface so that the highest areas of the canvas or paper catch the paint and create a coarse texture. The technique works best when used sparingly and when used with opaque pigments over transparents.

Dabbing Load your brush with thick paint and then use press-and-lift motions to apply irregular dabs of paint to your surface. For more depth, apply several layers of dabbing, working from dark to light. Dabbing is great for suggesting foliage and flowers.

Scraping Create designs within your paint by scraping it away. Using the tip of a painting knife or the end of a brush handle, "draw" into the paint to remove it from the canvas. For tapering strokes that suggest grass, stroke swiftly and lift at the end of each stroke.

Stippling This technique involves applying small, closely placed dots of paint. The closer the dots, the finer the texture and the more the area will take on the color and tone of the stippled paint. You can also use stippling to optically mix colors; for example, stippling blue and yellow in an area can create the illusion of green. You can dot on paint using the tip of a round brush, or you can create even more uniform dots by using the end of a paintbrush handle.

Wiping Away Use a soft rag or paper towel to wipe away wet paint from your canvas. You can use this technique to remove mistakes or to create a design within your work. Remember that staining pigments, such as permanent rose (above with Naples yellow), will leave behind more color than nonstaining pigments.

Scumbling This technique refers to a light, irregular layer of paint. Load a brush with a bit of slightly thinned paint, and use a scrubbing motion to push paint over your surface. When applying opaque pigments over transparents, this technique creates depth.

Animal Features & Textures

Ears, Eyes & Noses

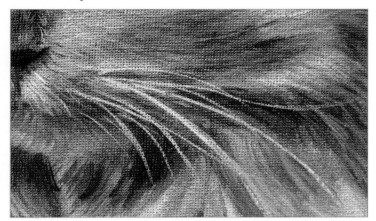

Cat Whiskers
To create whiskers, use a very fine brush and white paint diluted to a thin consistency. Starting at the base, quickly sweep the brush in the direction of the whisker, lifting the brush at the end for a tapered stroke.

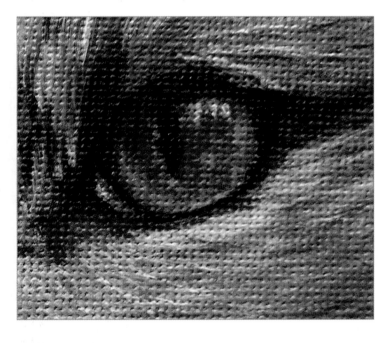

Cat Eyes
Cats' eyes are made up of lovely colors. Start by drawing the shapes of the eye and pupil with a round brush using a burnt umber and ultramarine blue mix. While this is wet, mix cadmium yellow and ultramarine blue for the green, and paint around the inner edge of the eye. For the midtone yellow, mix lemon yellow with a bit of cadmium yellow and blend slightly into the green. Eyes reflect colors from their surroundings, so highlights are never pure white. Try mixing a bit of ultramarine blue or cobalt blue into white and flick highlights near the top of the eye. If there's too much, simply lift some off with your thumb. When the eye is dry, place a dab of white at the edge of the blue highlight. To soften the outer edge of the eye, paint a thin wash of burnt sienna and burnt umber along the bottom.

Cat Noses
Using a small round brush, mix burnt umber and ultramarine to paint the dark bridge and tip of the nose. With a very small round brush, use a diluted mix of cadmium red, alizarin crimson, and white for the pink color on the lower nose. While wet, mix more white into the color and add the lighter pink areas. Do this while the paint is still wet to allow the colors to blend, avoiding any hard edges. If you use acrylics, you can use a slow-drying medium to extend the amount of time the paint stays wet and workable. Once this is dry, use a very small round brush to add the fur texture on the bridge of the nose with a mix of burnt umber and a bit of white. Apply little brushstrokes down the nose to create the fur texture. Then clean your brush and mix the highlight color with white and a little ultramarine blue. Dilute the paint so it is thin enough to glide easily off the brush without leaving thick paint on the canvas.

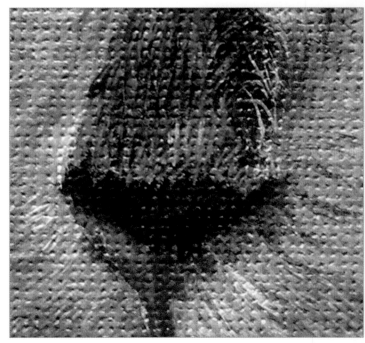

Dog Noses

Most often you'll find it useful to paint from dark to light, but sometimes it is better to do the opposite. For this nose, paint the lighter undercolor using burnt sienna. Once dry, mix burnt umber and ultramarine blue to create the dark of the nose. Paint a thin layer on top. You may press your thumb on the nose to remove some of the paint and allow the lighter undercolor to show. This is a great technique for noses in oils and acrylics. While the paint is still wet, use a small round brush to darken the nostril and add a line up the center of the nose. Once dry, use a mix of white and ultramarine blue to paint the highlights with a small brush, lifting off a bit with a clean thumb again.

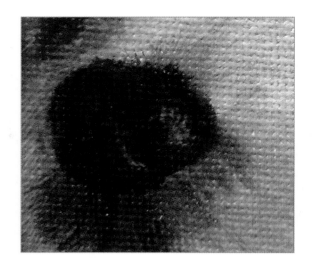

Dog Eyes

Dog eyes are usually very dark and reflect the colors from their surroundings. For this dog eye, use a mix of burnt umber and ultramarine blue to draw the shapes of the eye and pupil with a very small round brush. While the paint is still wet, use a mix of burnt sienna and burnt umber to paint the dark brown iris. To soften the eye's outer edge, mix burnt sienna with just a bit of burnt umber and shade around the eye. Once dry, use thinned cadmium yellow to apply a soft brushstroke to the left of the pupil, showing a bit of reflected light. Add highlights to the eye with white and a bit of ultramarine blue.

Long Hair for Tails & Manes

This is an example of a dog's long, fluffy tail, but you can use the same technique to paint horse manes and tails. To achieve this fluffy texture, the background needs to be wet to encourage blending. If you are working with acrylics, use a slow-drying medium to keep your paint wet and workable. Build up the background in three layers using a mix of burnt umber and burnt sienna. Let each layer dry before applying the next, making the last layer slightly thicker than the first two. While the background is still wet, begin painting the tail. For the dark cream undercolor, use a mix of yellow ochre and a bit of burnt sienna. Use a #8 filbert brush to apply sweeping brushstrokes, flicking the brush up into the wet background beginning at the center of the tail. Then lighten the cream mix by adding some white, and use the same brush and technique to flick in highlights.

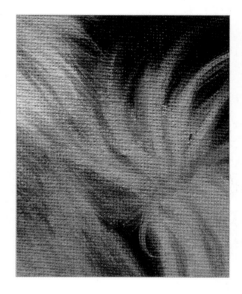

Ears

Use a similar technique for ears as you did for the tail. First use a #8 filbert brush to paint a thin layer of a burnt sienna and burnt umber for the darkest ear color. For the center of the ear, use a thin mixture of cadmium red and a bit of alizarin crimson. When dry, tone down the pink by applying a thin layer of burnt umber. Allow the paint to dry and then create a beige mix of burnt umber and white. Using a #3 round brush, stroke in the direction of fur growth. Flick some fur texture on the ear. Then clean your brush and mix raw sienna with white to create a cream color; use this to flick on more fur texture. The beige color is still wet, so the cream blends in slightly for a soft, fluffy look. Follow the same technique with white paint and let the painting dry. Add more white highlights where needed. To get a soft, fluffy look, be sure to use paint that isn't too thick.

Smooth Canine Fur

Step 1 To create long, smooth canine fur like that of a golden retriever, begin by laying in a medium value of thinned burnt sienna and sap green using a ½-inch flat brush. This golden brown mix will show through the fur as you paint subsequent layers, but it is also transparent and will allow the drawing to show through. Remove some of the color in the lightest areas by cleaning your medium pointed brush, wiping it almost dry, and picking out color wherever you desire.

Step 2 To build a good base from which to render the soft, light fur, continue to darken the shadows with equal parts of raw sienna and black using a soft ½-inch flat brush. Always work your strokes in the direction of the hair growth. For the background, add some white to create a warm gray and work from the edges of your piece toward the fur, lessening your pressure at the end of each stroke to create soft, blurred ends. Add more white to this mixture and use a long, fine-pointed brush to paint loose, soft-edged hairs that fade into the background, working wet-into-wet.

Step 3 To build the middle tones of the smooth, soft hair, start by mixing cadmium yellow medium, yellow ochre, and a bit of black. Using a fine-pointed brush, twist and turn your wrist as you move in the direction of the hair growth, creating brushmarks that range from one to two inches long. Vary the pressure you put on the brush to create lines that are both thick and thin. For the lighter areas of the fur, add a small amount of white. You may go over your brushmarks with a soft, dry brush to minimize the texture and create the illusion of softer fur.

Step 4 To create the final layer of smooth canine fur, mix three parts raw sienna with one part white and adjust a couple steps lighter than those you already used as a base. Load your pointed brush and wipe off the excess paint onto a dry cloth so your brushmarks are softer and silkier. Start with the bottom layers of fur and work upward so each brushstroke lays over the previous. Use varying amounts of pressure to create thicker and thinner lines. It is a good idea to thin the paint for better flow. Add a very small amount of black to this mixture to create a greenish tone for the shadow areas, but be careful to leave these areas simpler and softer so they recede. Add more white to your original mixture for the lighter areas.

Short Cat Hair

Step 1 When painting hair or fur, work from dark to light and leave the detail work for the lightest areas. First apply the warm shadows using a ½-inch flat brush and a thin mix of two parts raw sienna to one part black. This transparent layer will provide a dark underpainting while allowing the drawing to show through. Clean your brush and pat it dry, and then use it to lift color from the lightest areas of the fur. This will make it easier for you to build clean, bright whites over the dark background.

Step 2 To create soft edges within the fur, apply quick, soft marks that you can build on. Use the flat edge of your ½-inch flat brush to loosely paint the darker parts of the fur with ½-inch to 1-inch long strokes and a blend of two parts raw sienna and one part black.

Step 3 To create the multiple layers of fur in short-hair cats, use the thin edge of a ½-inch flat brush in a zigzag pattern and work your way down the canvas. Build up the basic middle value areas with cadmium yellow medium, a small amount of cadmium red light, and raw sienna to create an orange color. For the white fur, use white mixed with a little bit of black and yellow ochre.

Step 4 Lastly, address the fine detail and brighter lights, switching to a small pointed brush. Thin equal parts of white, cadmium orange, and raw sienna just enough to make your color flow smoothly. Use short, delicate strokes that flow in the direction of the hair growth to pull up the highlights in the orange fur. Reload your brush when your marks begin to get rough. Add new brushstrokes to fill in the gaps and suggest depth in your painting. To lighten the white areas of fur, add a small amount of your mixed orange to white, and continue to build up short marks.

Horse Coat

Step 1 Using raw sienna with a small amount of black and a ½-inch flat brush, lay down your underpainting with short strokes in the direction of the hair growth. Unlike cat or dog fur, horsehair is very short and lays flat on the muscle, creating a smooth texture. To achieve this, do not leave too many visible brushstrokes.

Step 2 To build up the darkest shadow values of this horse coat, use a ½-inch flat brush and a mixture of equal parts of burnt sienna and sap green. With a light touch, apply your brushstrokes in the direction of the hair growth. Keeping your dark values transparent helps them to recede, resulting in the illusion of more depth.

Step 3 Next build up the reddish middle values of this chestnut coat using an old, stiff #5 round brush. This is where those old, roughly handled brushes come in handy! Mix variations of cadmium orange and burnt sienna lightened with white, and dab your brush into the paint as you spread the bristles apart. This helps create lines in your strokes that resemble hair. Work in the direction of the hair growth, paying close attention to the various muscles and vascular areas under the horse's skin.

Step 4 To bring up the lightest areas, use a #1 round and various mixtures of burnt sienna, cadmium orange, and white. Work from dark to light and use short, delicate strokes in the direction of the hair growth to add detail and give volume to the muscles and veining prevalent in the lean contours of the horse's anatomy.

Horse Mane

Step 1 To create the long, somewhat coarse texture of this mane, start by painting the darkest shadows, using a ½-inch brush loaded with two parts burnt sienna and one part black. Apply the paint in long, full-length strokes that start at the ridge and move toward the ends of the hairs. Use a soft, dry blending brush to trace over the strokes to blur and soften the edges. Clean your brush and pat it dry and then use it to pick out color from the lightest areas. Use the edge of the brush and less pressure as you reach the ends of the hairs to create fine-pointed tips. Wipe your brush clean after every few strokes.

Step 2 Use the same ½-inch brush to paint the middle value of reddish brown in the mane and on the neck of the horse, using a mix of equal parts of raw sienna, black, and burnt sienna. Cut into this color with a darker color mixed from equal parts of black and burnt sienna to define the dark negative spaces between sections of hair.

Step 3 The only difference between the hair of a horse's mane and human hair is that the horsehair is coarser. Using the same long, fine-pointed brush you would use for human hair, apply a mix of raw sienna, cadmium red light, and white to create the reddish colors in the mane. Turn your painting whichever direction is most comfortable for you to paint the entire length of the individual hairs with long, soft, smooth brushstrokes. Work back and forth, arcing your hand to delicately create the curves of the flowing mane. If you have difficulty getting long, smooth strokes, thin your paint for better flow.

Step 4 Lastly, we'll address the fine detail and brighter lights, switching to a small pointed brush. Thin equal parts of white, cadmium orange, and raw sienna just enough to make your color flow smoothly. Use short, delicate strokes that flow in the direction of the hair growth to pull up the highlights in the orange fur. Reload your brush when your marks begin to get rough. Add new brushstrokes to fill in the gaps and suggest depth in your painting. To lighten the white areas of fur, add a small amount of your mixed orange to white, and continue to build up short marks.

Elephant

Step 1 To paint the rough, deep wrinkles found in elephant skin, start by painting an even layer of two parts burnt sienna cooled down with one part sap green. These are both transparent colors, so they will allow your drawing to show through while creating a warm undertone for the following cooler layers. Using an eraser cloth, remove color from what will become the lightest areas of the skin.

Step 2 The most important element to capture in elephant skin is the depth and texture of its wrinkles. For the deepest creases and shadows, mix equal parts of black and burnt sienna, with a touch of white to increase the opacity of the color. Using both the width and length of the edge of a ¼-inch flat brush, render the lines and shadows with loose, drybrush texture and soft edges. Wipe off excess paint from your brush before you stroke to help achieve texture.

Step 3 For the basic middle-value gray that makes up the bulk of elephant skin, mix white with a touch of black. Using a ¼-inch flat brush and short, square strokes, gently paint in the rest of the skin. Use a light touch and try to capture the texture of your board, allowing bits of the original reddish browns to show through, especially in the cracks. Add more white for lighter areas, but don't overwork by adding too much paint.

Step 4 Once your previous layers are dry, add more white to your gray mixture and a bit of yellow ochre to warm it up. Continue using your ¼-inch flat brush and wipe off most of the excess paint from your brush and then paint the lightest highlights of the rough elephant skin. Use the texture of your canvas or board to build texture with the drybrush technique and short, impressionistic strokes. Do not blend. Instead, leave your marks very painterly.

Leopard

Step 1 To add warmth to the leopard pattern, start with a wash of three parts raw sienna to one part black. Thin the color so you can still see your drawing through the paint.

Step 2 Warm up black with a small amount of raw sienna and use a pointed brush to create the dark spots of the leopard pattern. Working in the direction of the hair growth, use a light touch at the beginning and end of each short stroke to create the effect of fine hairs lying flat against the body. Allow some of the golden underpainting to show through for finer detail.

Step 3 With a fine-pointed brush, create highlights in the black fur using black lightened with a bit of white. For the middle values of the white fur, use white with a small amount of yellow ochre and black to create short, fine marks in the direction of the hair growth, allowing some of the underpainting to show through.

Step 4 Finally, enhance your brightest highlights. This is a job for your finest pointed brush. Add a small amount of raw sienna to white and use small, short, pointed brushstrokes to paint the brightest highlights in the fur, always working in the direction of the hair growth. For the darker areas in the shadows, add black to your mix and more raw sienna, if required. Continue with the same kind of brushmarks, adding more texture. You can also use the same color to brighten the highlights in the black spots.

Feathers

Step 1 Painting feathers is fun and easy once you master a few brush techniques. The easiest way to start is to establish the shadow colors. Mix a neutral purple of equal parts of alizarin crimson and Payne's gray. Thin it enough to reduce it to a middle value that will remain transparent, similar to a rich watercolor wash. With a ½-inch flat brush, work in the direction of the feather's pattern with long, smooth strokes. For more detailed areas, use the tip of the brush to create fine lines.

Step 2 Create a mixture of three parts white to one part yellow ochre for the lightest feather. Thin it enough to make it flow smoothly without losing the body of the paint. Tap a small fan brush into your mix, so that the bristles spread out and separate. Work from the center stem outward following the natural curve of the line pattern. Finish each stroke with a quick sweep to the right as you lift the brush off the canvas. Add burnt umber to your mix for the darker feathers and use the same types of strokes, overlapping the feathers and allowing the colors to blend wet-into-wet.

Step 3 To clean up the edges and add more specific detail, use a #1 round brush and a mixture of one part black to two parts white to paint shadows between and around the separated parts of the feather. Use the same mix to paint the stems before adding final highlights with pure white. If you want to add more highlights to the feathers themselves, simply use the same brush and work carefully in the direction of the pattern, starting from the stem and working toward the ends.

Artist's Tip

A fan brush can help you achieve delicate, parallel strokes that are perfect for creating the subtle textures of grass, feathers, and fur. However, using a fan brush effectively requires some practice. Subtlety is best achieved with dry or moist (but not wet!) brush hairs and minimal paint. You may even want to stroke the brush on scrap paper or a cloth before touching your canvas to avoid small blobs of paint.

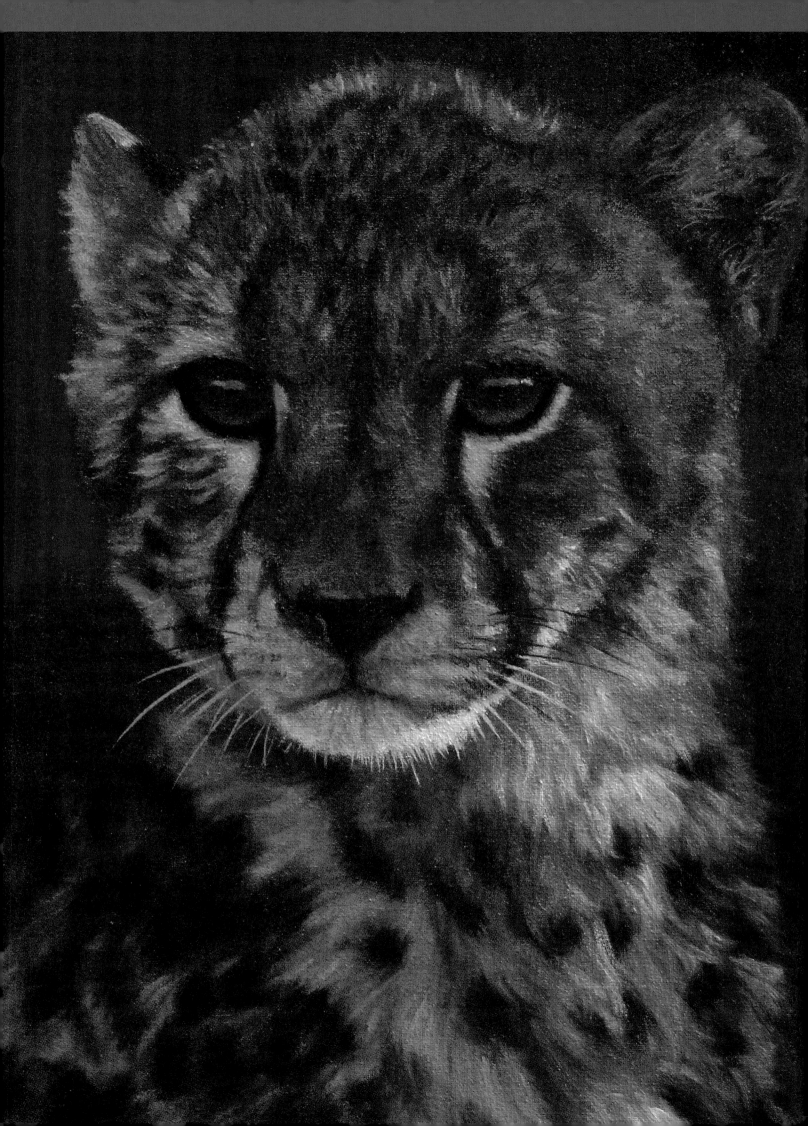

CHAPTER 2

Painting Animals in Oil

with Jason Morgan & Lorraine Gray

Capturing the beauty of wildlife and pets in a painting is a rewarding experience, and oil is a beautiful medium for creating realistic animal portraits. In this chapter, talented artists Jason Morgan and Lorraine Gray will help you discover how to paint wild and domesticated animals, beginning with a simple sketch and progressing to a finished, realistic portrait.

Cheetah *with Jason Morgan*

Everyone loves cheetah cubs, but what really enticed me to paint this particular cub was the beautiful, warm sunlit side of its face, offset against the cool shadowed side. It was this play of light, rather than the subject, that I fell in love with.

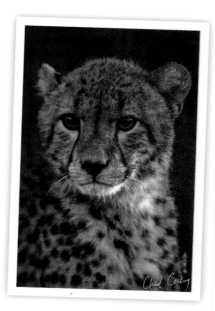

Color Palette
burnt sienna • burnt umber • cadmium orange
cadmium yellow deep • lamp black • Naples yellow
olive green • titanium white • ultramarine blue • Winsor red
Winsor yellow

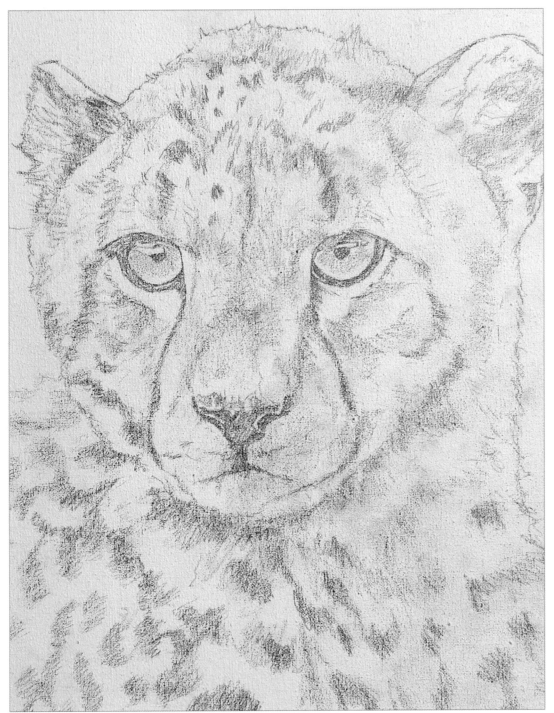

Step 1 I start by drawing the cheetah cub on the canvas using a standard graphite HB pencil. Then, to prevent it from smudging when I begin to apply the paint, I seal it with a light spray of permanent pencil fixative and allow it to dry, which only takes about 10 minutes.

Artist's Tip
Use acrylic paint to tone the canvas, as it dries much faster than oil. You can paint oil over acrylic, but you can't paint acrylic over oil.

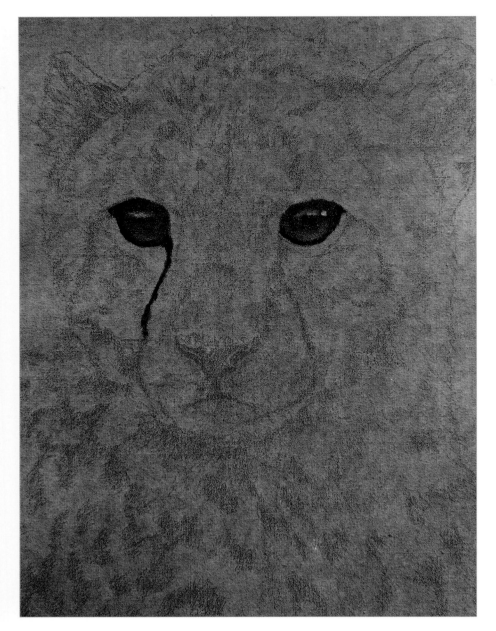

Step 2 I then tone the canvas using burnt sienna thinned with enough water that the drawing can still be easily seen through it. Toning the canvas gives me a warm midtone to work over, which will show through both my light and dark paint applications. If I leave the canvas white, any light tones painted at this stage won't show up clearly, if at all. I allow this tone to dry before I begin to block in the eyes with oil paint. The eyes are a very important part of most wildlife paintings, so I generally paint them in at an early stage.

Artist's Tip
(See step 3 below.)

I painted a small amount of light on the shadowed side of the face in order to judge the warm side against the shadowed side, even at this early stage.

▼**Step 3** I continue blocking in color, working outward from the eyes using a long, flat #2 bristle brush. I use various mixes of Winsor yellow, cadmium yellow, and cadmium orange for the fur in the warm, glowing light. For the shadowed areas I mix Naples yellow, burnt umber, and ultramarine blue. You can see that I've made many intermediate colors from the main mixes on my glass palette.

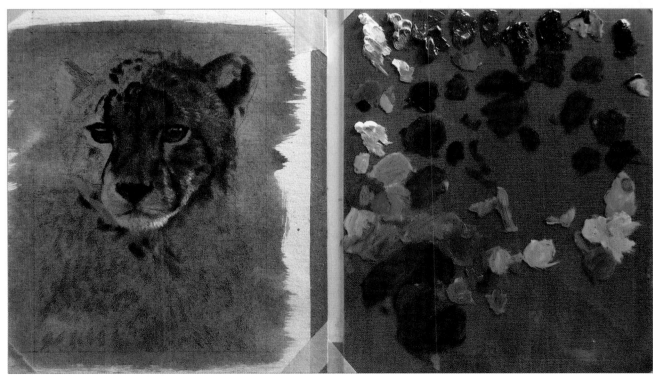

Step 4 It is also important to assess how the subject is influenced by its surroundings. With that in mind, I paint a small area of dark green behind the subject, which immediately brings the cheetah forward in the painting and also makes the warm tones appear even warmer. I then focus on brightening the highlight on the chin. I now have a full range of tones and colors on the canvas, making it easier to judge and compare any subsequent colors and values.

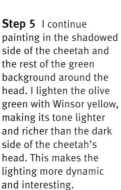

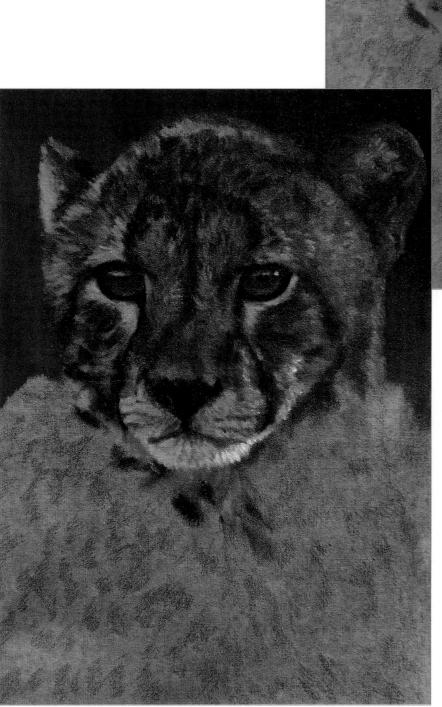

Step 5 I continue painting in the shadowed side of the cheetah and the rest of the green background around the head. I lighten the olive green with Winsor yellow, making its tone lighter and richer than the dark side of the cheetah's head. This makes the lighting more dynamic and interesting.

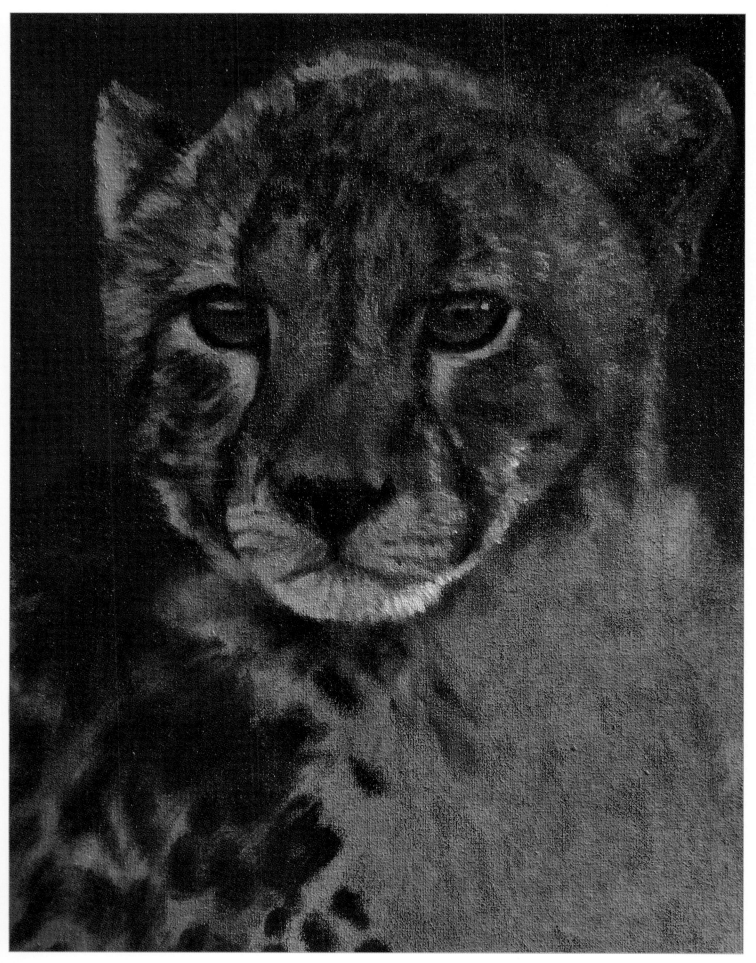

Step 6 Now it's time to start on the longer fur of the body, and for that I switch to a larger #3 flat bristle brush. The body can seem daunting at first with its dark spots and varying fur color. To simplify the process, I first focus on painting in the dark spots. Then I paint the slightly lighter areas of fur, gradually working from dark to light.

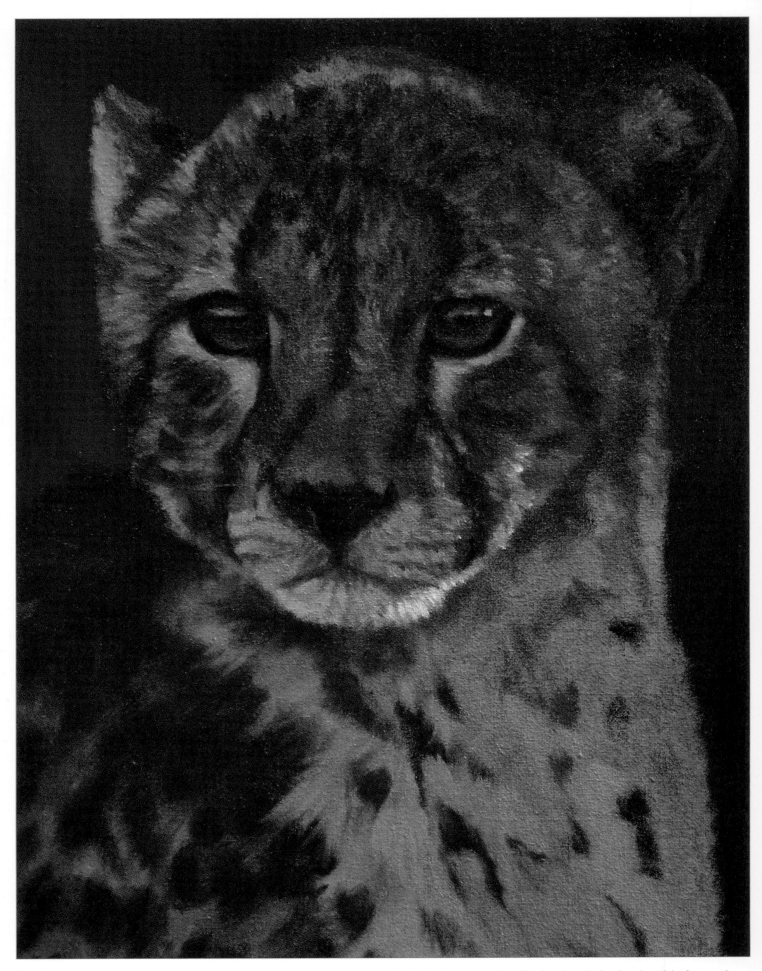

Step 7 As I work my way around the chest area, I start using longer brushstrokes for the lighter, more defined fur, brushing in the direction of the fur growth. I use mixes of Naples yellow, ultramarine blue, and burnt sienna.

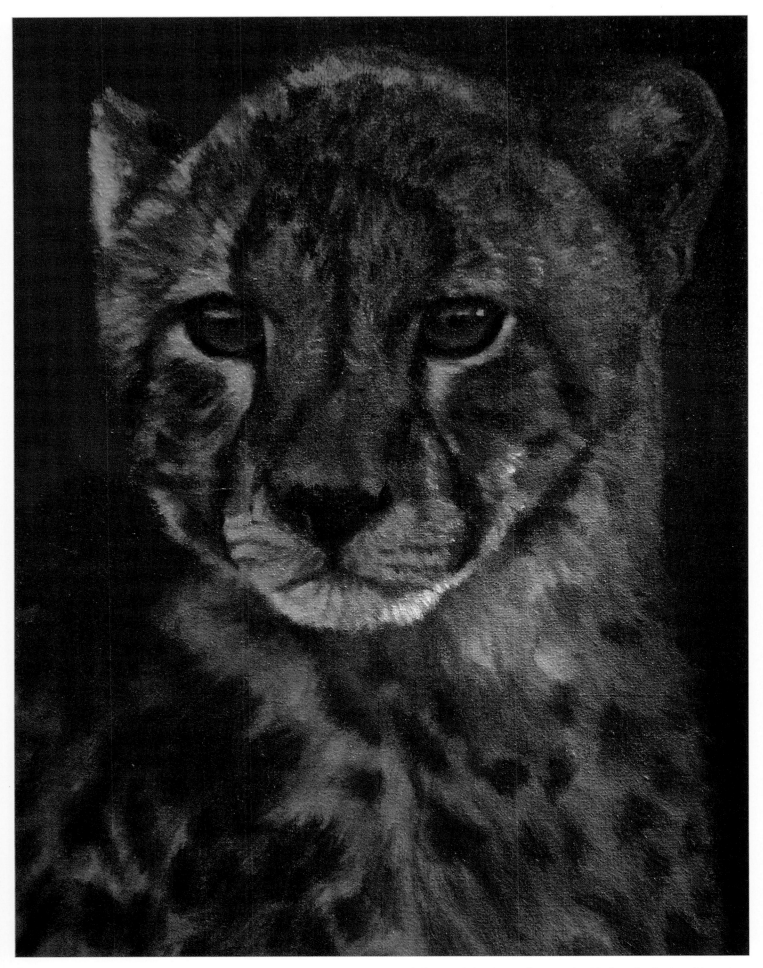

Step 8 With all of the canvas now blocked in, I sit back and assess the painting as a whole. I gently brush over the areas that I feel need softening with a soft, synthetic brush; this blurs the brush marks so they visually recede.

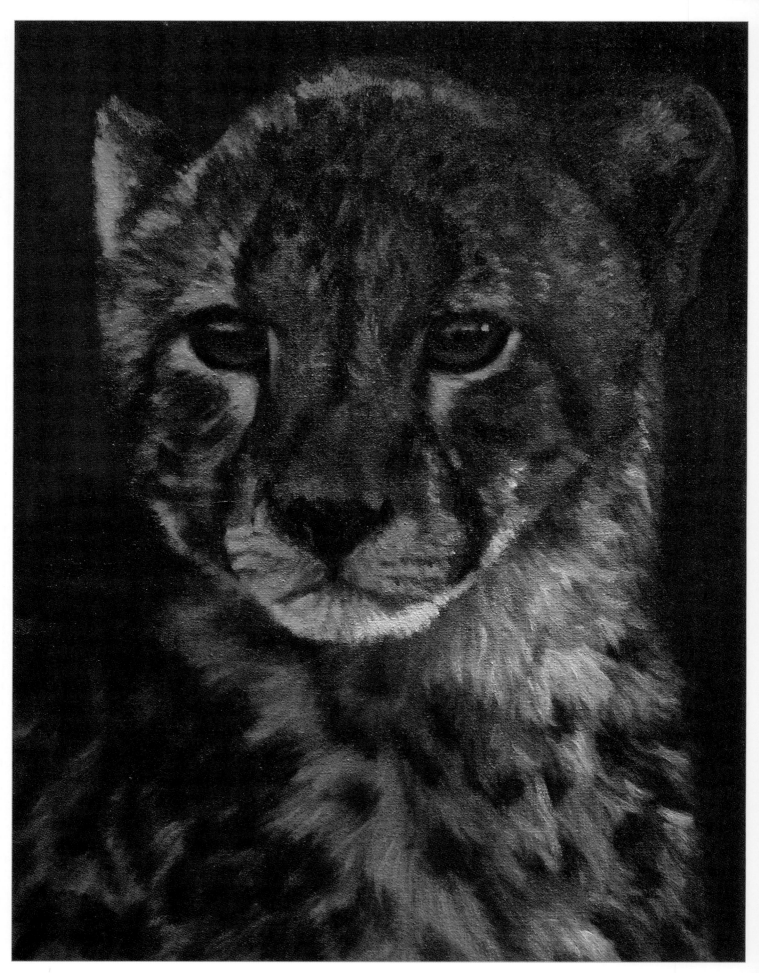

Step 9 Now that the important groundwork has been finished, I focus on refining the portrait. I switch to a smaller #1 flat bristle brush and load it with thick paint on both sides to create a chiseled edge. I then use the edge of the brush to stroke in the direction of the fur growth, making much more distinctive marks.

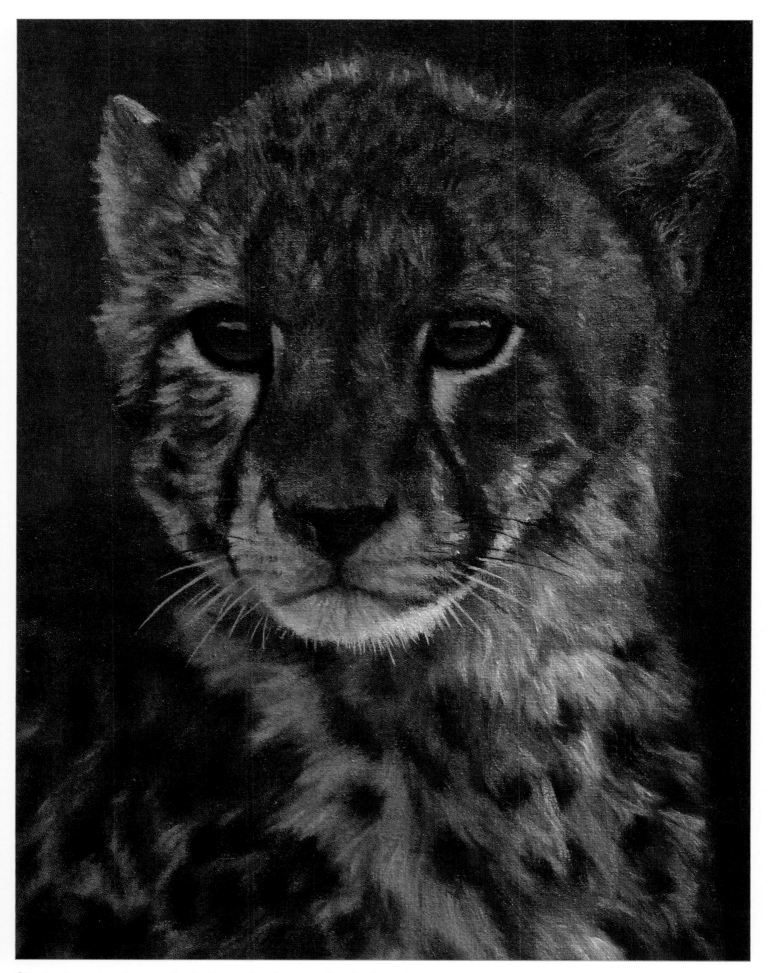

Step 10 The final step is like putting the icing on the cake. I use a rigger brush to indicate individual hairs, and I use much thicker paint—sometimes straight from the tube—in areas with the brightest highlights, which gives the painting texture and a more three-dimensional appearance. To complete the portrait, I add a few fine whiskers.

Leopard Cub *with Jason Morgan*

Even at rest a wild leopard cub is alert and inquisitive, and I hope to capture this feeling in the painting, as the cub eagerly waits for its mother to return from the hunt.

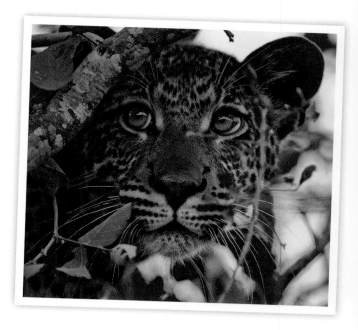

Color Palette

burnt sienna • burnt umber • cadmium yellow deep
• lamp black • Naples yellow • olive green
titanium white • ultramarine blue • yellow ochre

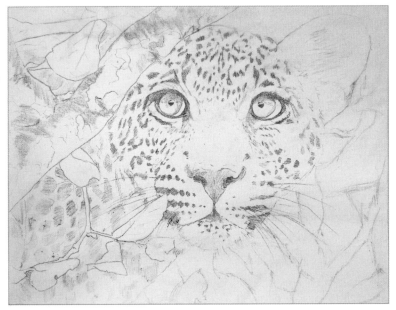

◀ **Step 1** This drawing is complicated, so I start by drawing on standard paper so any mistakes can be easily erased. I then transfer the drawing to my canvas by tracing over the drawing using a piece of transfer paper. To seal the drawing, I use a light spray of permanent pencil fixative and allow it to dry.

Step 2 Per my standard procedure, I tone the canvas using burnt sienna acrylic paint thinned with water. Once this preparatory layer is dry, I typically like to start with the eyes. They are especially important in this painting as they are clearly the center of interest. I begin by blocking them in with Naples yellow as the base color, darkening where needed with burnt sienna and burnt umber. I use lamp black for the dark areas around the eye and also for the pupil, and I add a touch of black and ultramarine blue to titanium white to paint the white of the eye and the highlight.

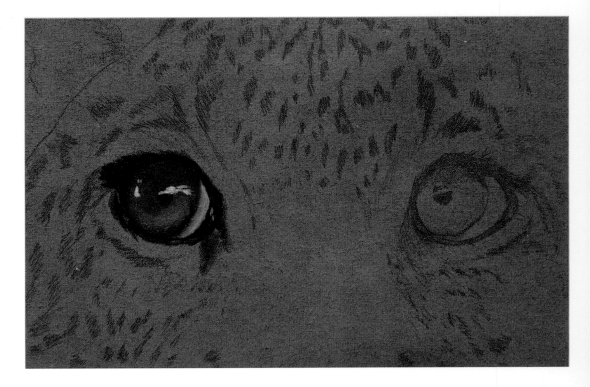

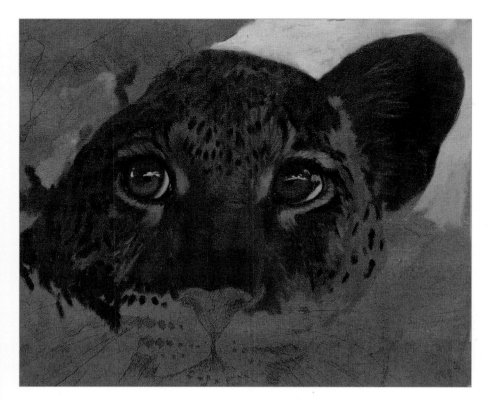

Step 3 With the left eye finished, I then move on to the other eye, painting it in the same way. Then I use a small, flat #2 brush and block in the dark spot markings. If I don't block in the markings at this early stage, I will lose the pencil drawing underneath as I paint in the fur texture. I carefully paint in the spots and then paint in the fur color around them. The fur color is a combination of Naples yellow, yellow ochre, and burnt sienna on the light side of the face; I use the same mix plus lamp black and ultramarine blue on the dark, shadowed side. I also start blocking in the sky.

Artist's Tip

I like to have my reference photos as close to the painting as possible as I paint. My glass palette is to the right of the painting; it has been toned a similar color to the canvas. This makes mixing and matching colors much easier than if I were to use a white palette.

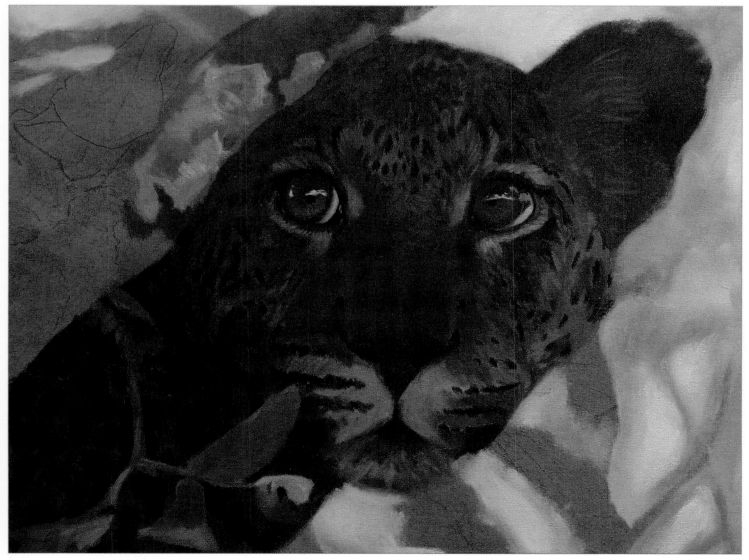

Step 4 I continue to block in the sky and then start to block in the leaves, using olive green and Naples yellow for the lighter areas and olive green, ultramarine blue, and burnt umber for the darker areas. This instantly adds depth to the painting, pushing the leopard back. Note that I don't wipe off any of the previous wet paint mixes from my palette; instead, I use them to adjust mixes as I go. Sometimes a previous mix becomes the base mix of a new area. Working with colors in this way gives unity to the whole painting.

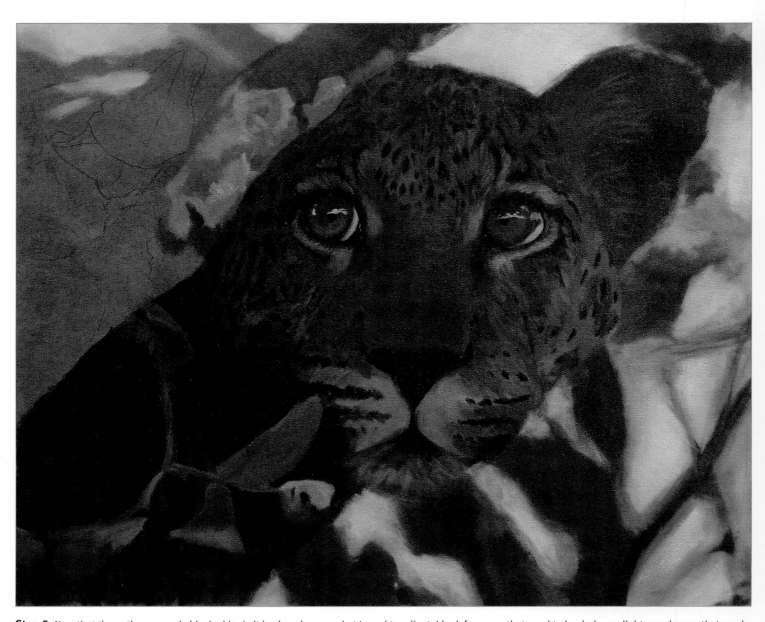

Step 5 Now that the entire canvas is blocked in, I sit back and asses what I need to adjust. I look for areas that need to be darker or lighter and areas that need to be more vibrant to make them stand out. I decide that the background is too vibrant to give a sense of depth, so I cool down the background mixes in relation to the foreground using ultramarine blue and white, softening the edges. I then allow the paint to dry overnight.

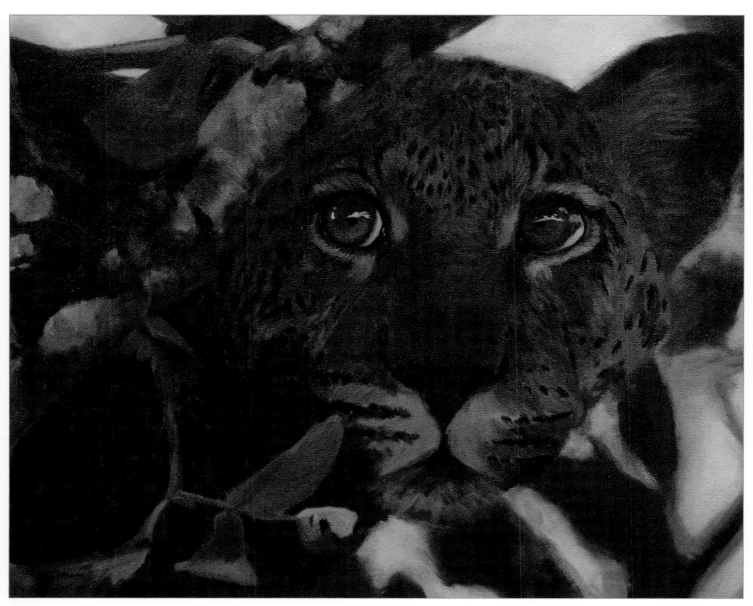

Step 6 I continue to block in more of the distant branches and leaves. While the background is still wet, I use a large, soft brush to blend the background areas together, blurring them slightly to give the appearance of more depth. I will intensify this effect by painting the sharpest details around the face and eyes.

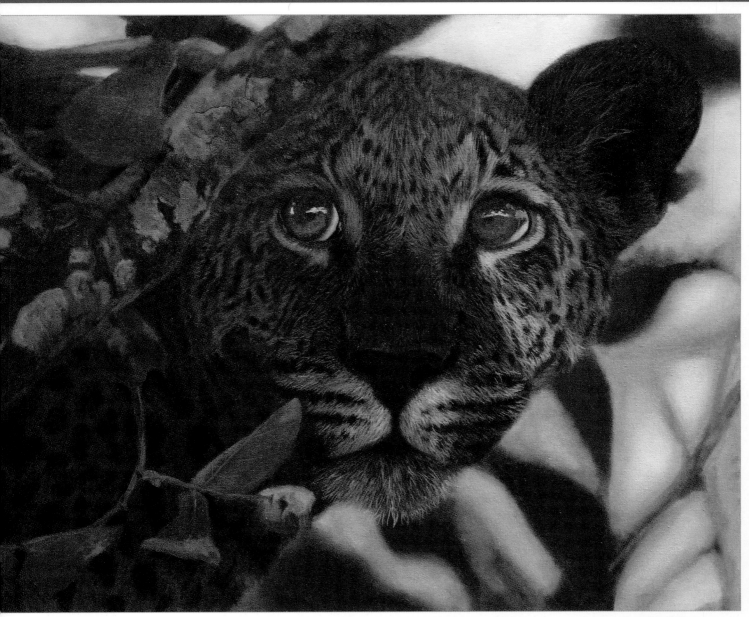

▲ **Step 7** The background works much better now that I've cooled the colors, so I begin adding a second layer to the cub. I am careful to push my tones even darker, especially in the shadows of the body. I then begin to add some fur texture and details to the face using a rigger brush, starting with the areas farthest away and working forward with overlapping strokes. I also add dark tones and details to the branch before leaving the paint to dry overnight.

Step 8 With the painting completely dry, I apply glazes to some areas using alkyd oil medium and various mixes of burnt sienna, burnt umber, cadmium yellow, and ultramarine blue. I ensure each glaze is very transparent so that the details underneath are not lost. The glaze really just acts as a stain on the underpainting. You can see that the painting is much larger than life size. When working on large paintings like this, reserve your small brushes only for the finest of the final details. Here I am painting the whiskers with paint thinned with an odorless paint thinner.

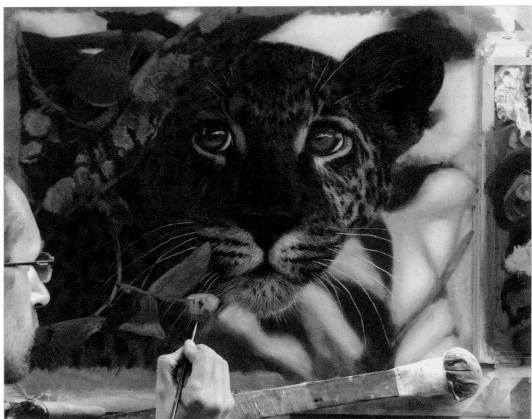

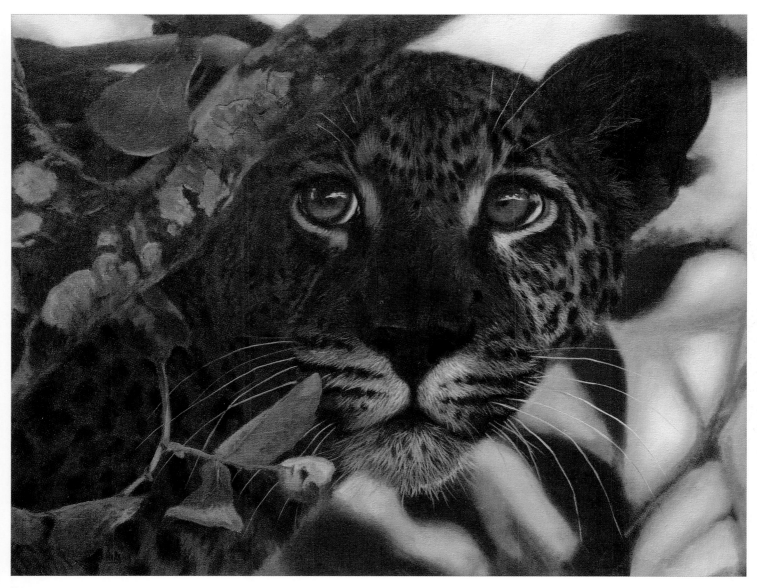

Step 9 I finish the final stage by adding a few glazes and brightening the lightest areas in the eyes and background.

Elephant *with Jason Morgan*

With its many wrinkles and recesses, an elephant seems like a daunting subject to paint in detail. However, its skin calls for opaque paint, so you'll only need a few layers to cover the canvas.

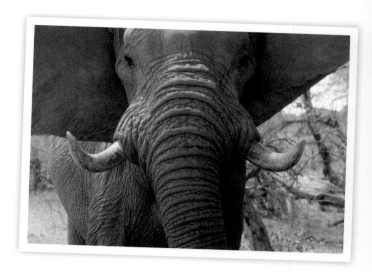

◄ Color Palette
burnt sienna • burnt umber • cadmium orange
cadmium yellow deep • lamp black • Naples
yellow • titanium white • ultramarine blue
Winsor yellow • yellow ochre

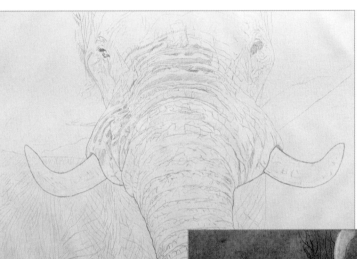

Step 1 This drawing is very complicated, so I first draw it on a large sheet of standard paper. When I am happy with the drawing, I trace it on tracing paper and use graphite transfer paper to copy the drawing onto the canvas. This prevents any drawing mistakes and eraser marks on the canvas. To keep it from smudging, I seal the layer with a light spray of permanent pencil fixative and allow it to dry.

Step 2 I tone the canvas with burnt sienna acrylic paint thinned with water, which gives it a nice warm color. Before it dries, I wipe out some of the lightest highlights with a paper towel. I then allow the painting to dry. Using a hair dryer will speed up the drying process.

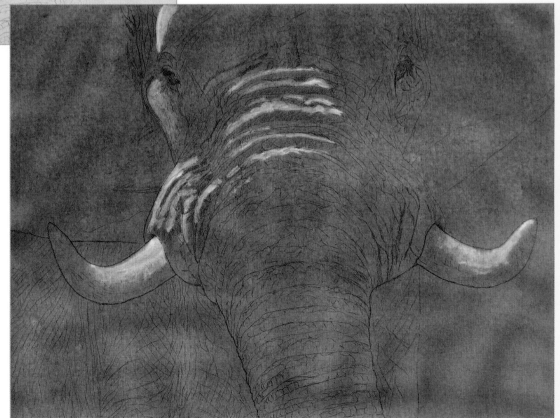

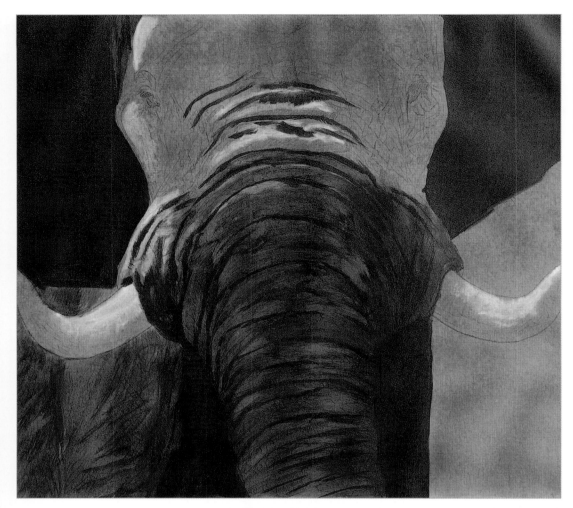

Step 3 As the main color in this painting is dark, it makes sense to darken areas of the underpainting with another layer of acrylic paint. Here I use acrylic paint mixes of burnt umber and burnt sienna thinned with water to paint a more detailed underpainting layer.

Step 4 With the acrylic underpainting now finished and completely dry, I begin to lay in the very first layer of oil paint with ultramarine blue, white, and a little black. Notice how the warm acrylic underpainting acts as the elephant's midtone skin color, and the opaque gray-blue oils give the painting a solid three-dimensional look. I also place a few marks here and there to represent the darkest darks, such as the shadowed ears, and also the lightest lights, such as the tusks. This represents the full range of tones, which I can now use to judge subsequent colors and values.

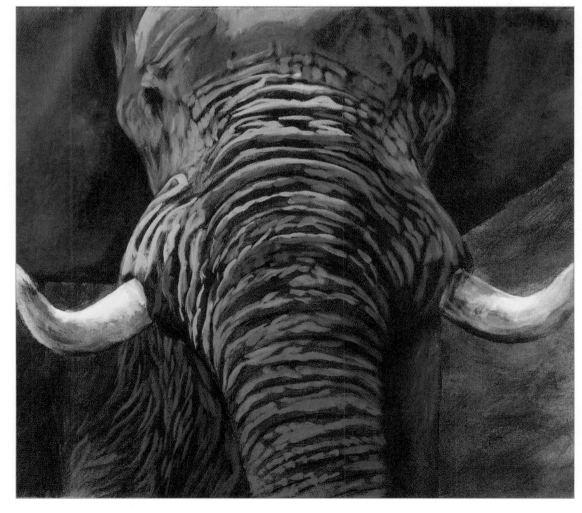

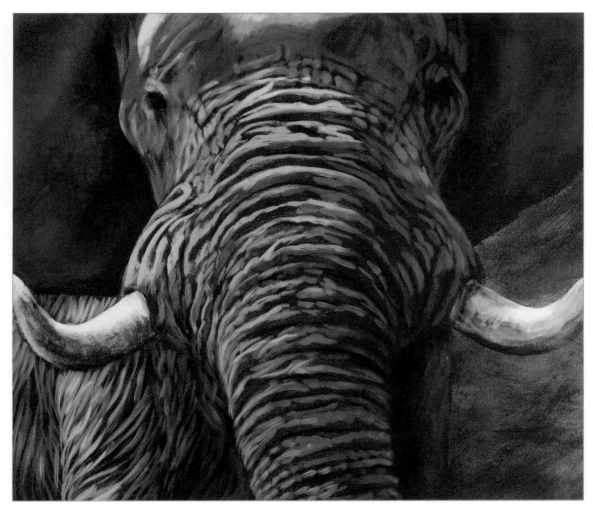

Step 5 I paint the highlighted areas of skin using a lighter mix of ultramarine blue, white, and a bit of black. I follow the lines of the wrinkles and creases, as they give the elephant its shape and form. I constantly look back to my reference photo to ensure that I am painting them in the correct places, as it is very easy to get lost.

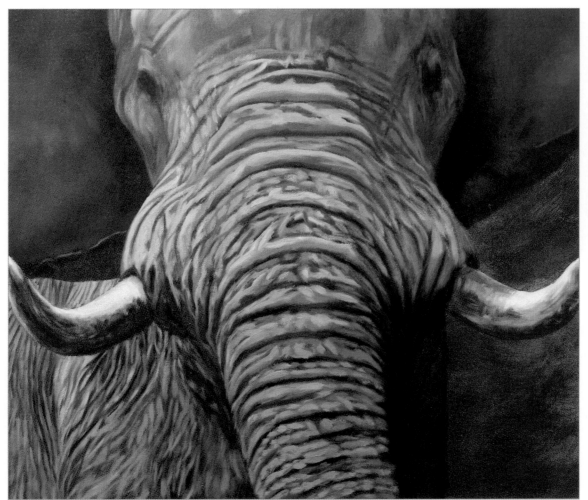

Step 6 Once the highlights are blocked in, I begin to paint in the midtones and shadows for each wrinkle to give them their rounded forms. I use mixes of the same basic colors—ultramarine blue, white, and black, with some of the cadmiums added for the reflected light under the ear fold. I find it easier to use three brushes for this stage—one for the midtone, one for the darks, and one to touch up the highlights where needed. This saves lots of time, as I don't have to wash the brush each time I switch to a different paint color.

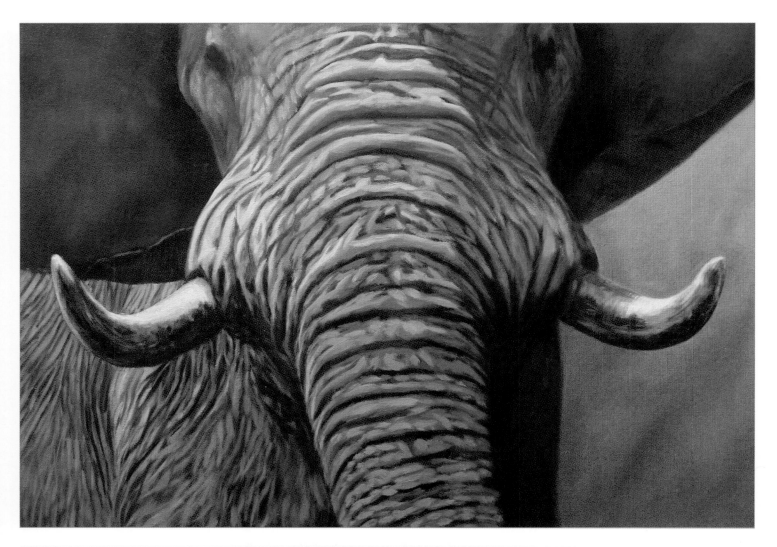

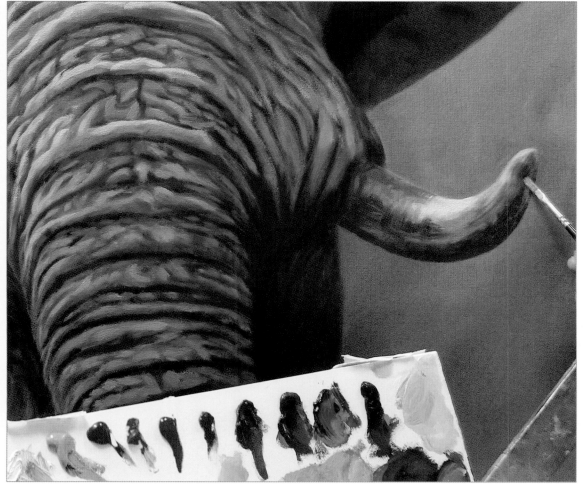

▲ Step 7 I then block in the subdued, dusty background with Naples yellow and yellow ochre, darkened here and there with a little burnt umber and some of the elephant body color. I create a soft edge along the elephant's front leg, as it would otherwise interfere with the center of interest. I increase the highlights in some places on the elephant's trunk with almost pure white. I then allow the painting to fully dry again.

Step 8 With the first full layer of oil paint now complete, I start the whole process again. But this time I am even more careful with my color choices and tones. I look at my reference photo less, as I begin to create the painting I envisaged rather than a copy of a reference photo. I once again use my three-brush technique to paint the form of each wrinkle and crease. Here I paint in the reflected light on the underside of the tusk. The painting is then left to dry.

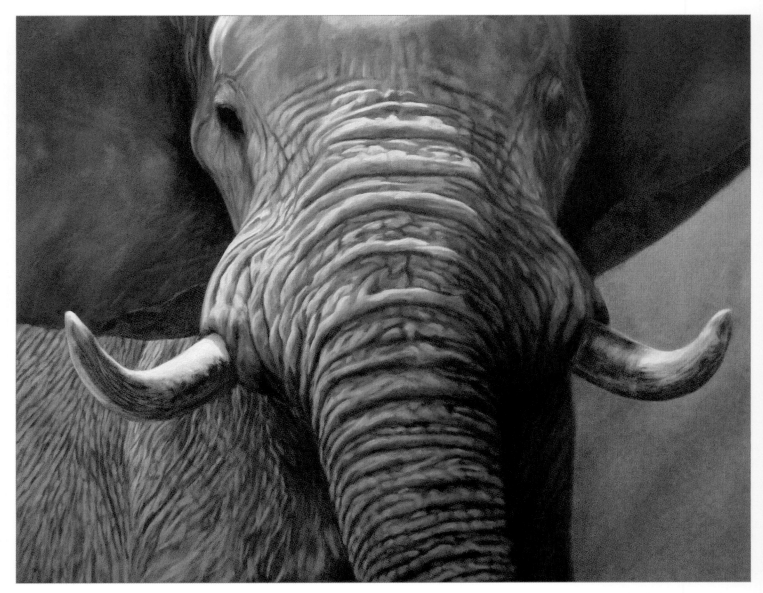

Step 9 The next stage is one of refinement. The major work has been done, and the elephant now has a solid form. I paint the highlighted areas with much thicker paint, which gives the elephant a more solid appearance. I also paint a thin glaze of ultramarine blue and black mixed with medium and apply it to the right side of the trunk to enhance the appearance of light coming from the top left. I then leave the painting for a few days so that I can look at it with fresh eyes before calling it "finished."

Artist's Tip

Have a few brushes readily available at any given time so that you don't have to wash
the brush for each paint mix change. This is especially useful for light, midtone,
and shadowed areas.

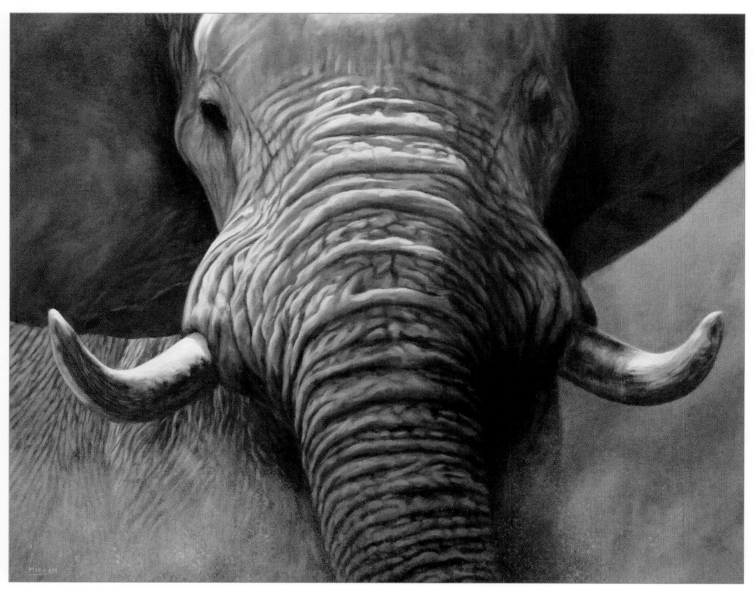

Step 10 Coming back to the painting, I feel that it lacks movement. I decide to add some dust along the bottom using a very light brown. Because the painting is fully dry, it is relatively easy to scumble with light brushstrokes and spatter with a toothbrush.

Hippo *with Jason Morgan*

Painting a hippo is very similar in technique to painting an elephant; they both require the use of opaque paints, which reduces the number of layers needed. The most important part of this painting is to achieve the look of wet skin.

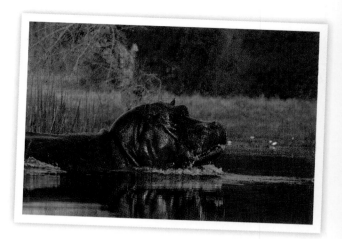

Color Palette

burnt sienna • burnt umber • cadmium orange
cadmium yellow deep • lamp black • Naples yellow
titanium white • ultramarine blue
Winsor yellow • yellow ochre

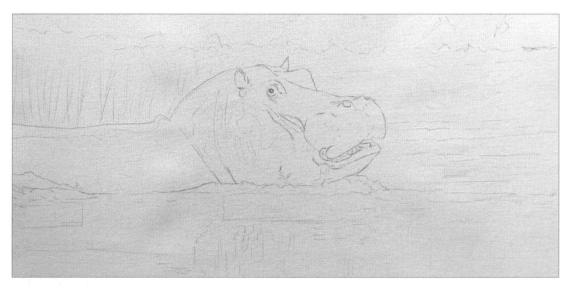

Step 1 Once the composition has been worked out, I transfer the drawing to the canvas using a standard graphite pencil by drawing directly onto the canvas. (You can also use transfer paper.) I then give the sketch a light spray of permanent fixative to seal it to the canvas.

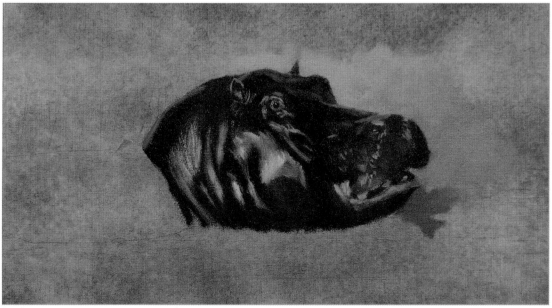

Step 2 It can be difficult to judge tones on a white canvas, especially when painting very dark subjects such as this hippo, so I tone the canvas with a mix of burnt sienna acrylic paint thinned with water using a wide synthetic brush. I use a hair dryer to speed up the drying process. I then begin to block in the head of the hippo using oil paint, with mixes of burnt sienna, burnt umber, and ultramarine blue for the dark areas, and burnt sienna, burnt umber, and titanium white for the lighter areas. The blue highlights are a very important part of the painting, which appear on the back of the neck and areas on the nose.

Artist's Tip

Block in the darkest areas in the painting first, so that you can judge all the other areas against it.
This is especially useful if you are painting a dark foreground subject.

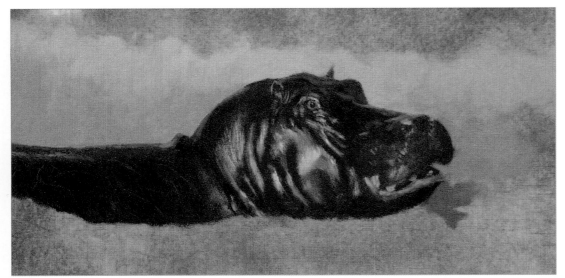

Step 3 I start by painting in the hippo, which allows me to better judge the lighter areas in the background. To make the hippo "pop" I continue to paint in the hippo's body and start to block in the background with very muted, cool colors.

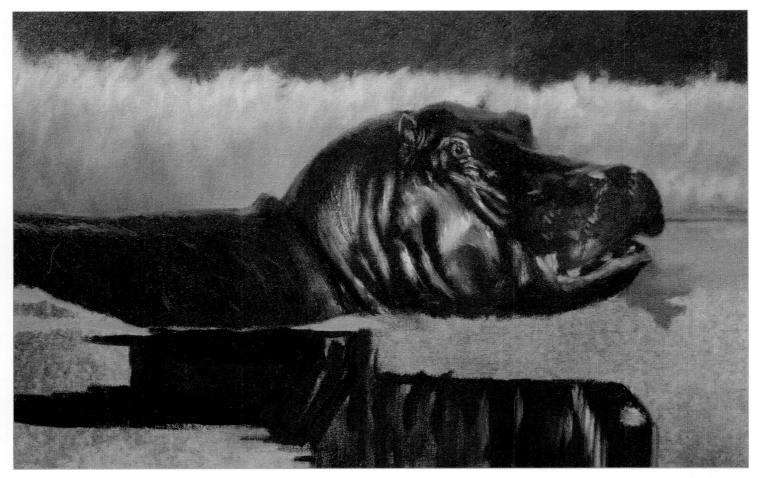

Step 4 I then block in the suggestion of trees and bushes at the top part of the canvas using mixes of Winsor yellow, ultramarine blue, and cadmium yellow. For the darks, I use the same mix with burnt umber added to it. Many artists find painting reflections very difficult, but in reality it should be no different than painting the subject itself. I use exactly the same color mix for the reflection as I did for the actual hippo.

Artist's Tip

It is sometimes easier to turn the canvas and reference photo upside down to paint the hippo's reflection in the water. Visually, this makes more sense to the eye.

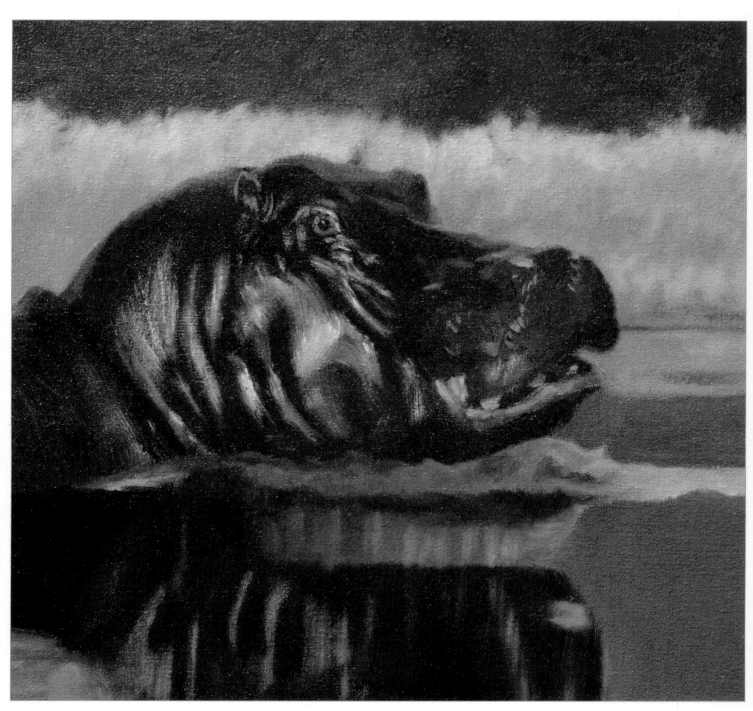

Step 5 With the hippo and reflection blocked in, I start to block in the base color for the water, using mixes of Winsor yellow, ultramarine blue, titanium white, and a little cadmium orange. I then block in a dark blue (lamp black, ultramarine blue, and titanium white) to represent the shadowed area of the water below the hippo's head. If I paint this blue too light, the highlights won't show up in the next stage. I let the painting dry overnight.

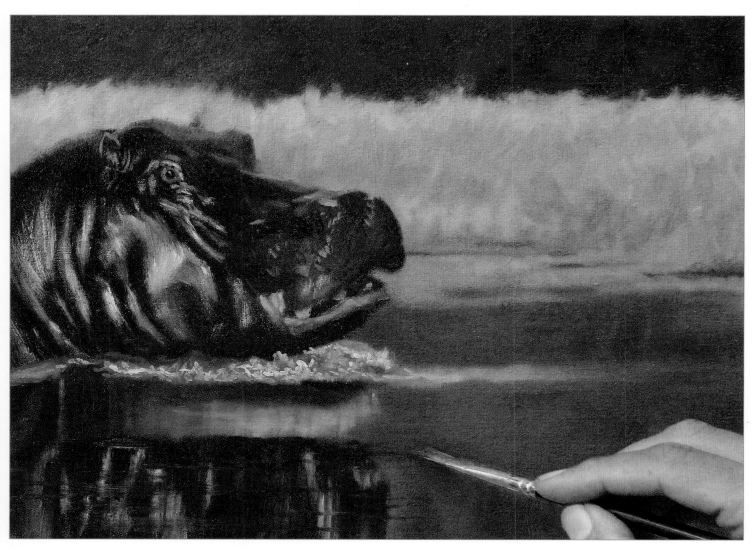

Step 6 I paint the water highlights with titanium white with just a touch of blue in it, using a small, round synthetic brush to dab on the highlights with thick paint. I then use some horizontal strokes on the water to give the appearance of ripples and small waves caused by the movement of the hippo.

Step 7 Everything I painted before this stage was to build a solid base, or underpainting. Now I can paint over it with more accurate colors and tones; the underpainting also allows me to use thinner paint without too much of the toned canvas showing through. I adjust areas throughout the painting, increasing the contrast on the hippo and adding more texture to the background bushes and grasses.

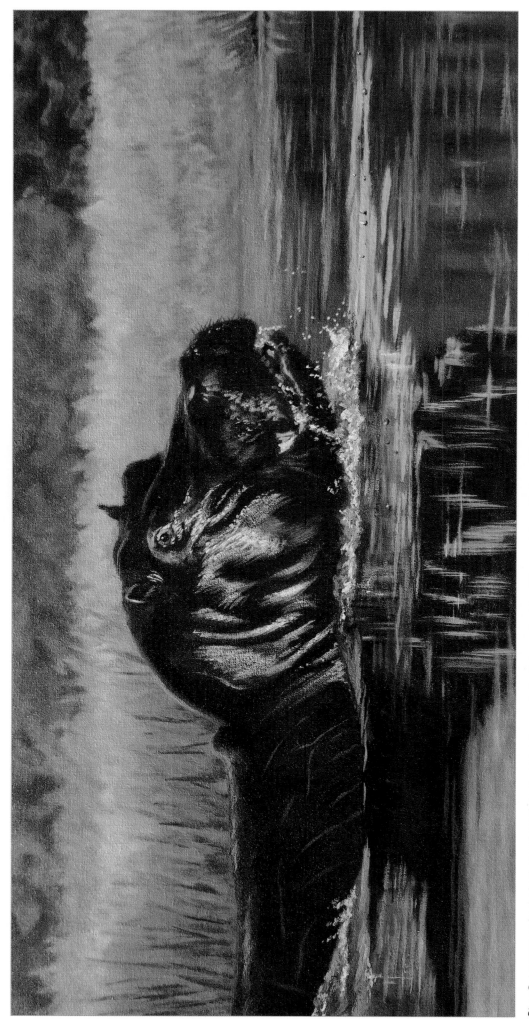

Step 8 I want to make the background recede more, so I make a cool mix of ultramarine blue, Winsor red, lamp black, and titanium white and apply it to the grass and bushes. I then increase the contrast of the dark areas on the hippo before adding the lightest lights to the wet skin areas using pure white. Finally, I increase the blue light reflections on the hippo using ultramarine blue and white.

Shih Tzu *with Lorraine Gray*

Choose a reference photo that truly captures your animal's personality. In this photo, Benji the dog emanates his sweet and playful nature.

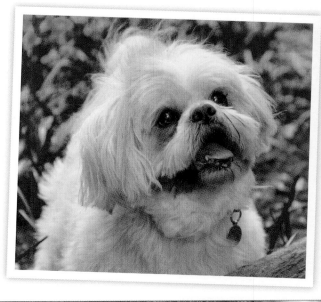

Color Palette

burnt sienna • cadmium red • Naples yellow
olive green • raw umber • ultramarine blue • white
yellow ochre

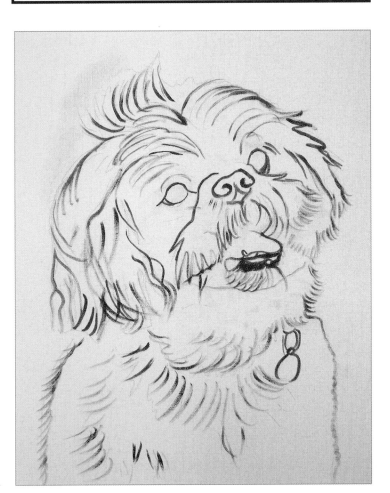

Step 1 I sketch in this cute dog using an HB graphite pencil. Using a small round brush and raw umber, I paint over my sketch. I do this so that I don't lose my pencil sketch once I start painting over it.

▲ **Step 2** Once my outline is dry, I use a large flat brush to paint a thin layer of burnt sienna around it. I like to do this to cover the white of the canvas and add warmth to the overall painting.

Artist's Tip

While the background is still wet, I use an old rag to rub off excess paint. This also blends the brush marks.

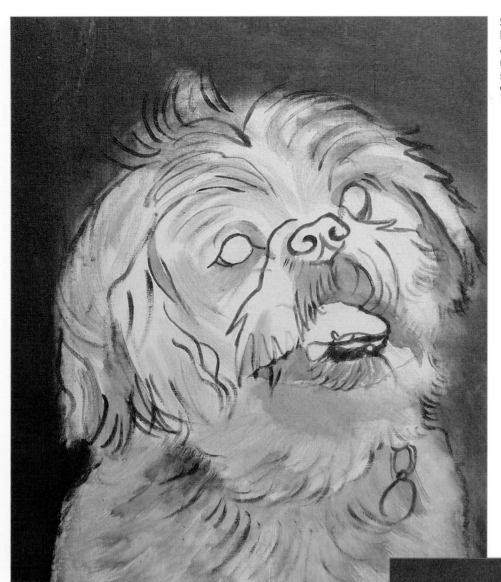

Step 3 Next I paint the shadowed areas of the body and face. Using a medium flat brush and a very thin mix of ultramarine blue mixed with raw umber, I roughly brush in the values for the shadows. Make sure to keep the paint very thin—you are just staining the canvas at this stage.

Step 4 Using a large flat brush, I paint on a slightly thicker consistency of olive green mixed with Naples yellow on the background in a crisscross motion. While the background is still wet, I apply a second thicker layer of the same mix in the same crisscross motion. I make the lower background darker by using more olive green. You will find that your brushstrokes become less apparent as your paint gets thicker. In the top area, I brush in some Naples yellow. It mixes with the first layer and blends nicely, leaving no brushstrokes.

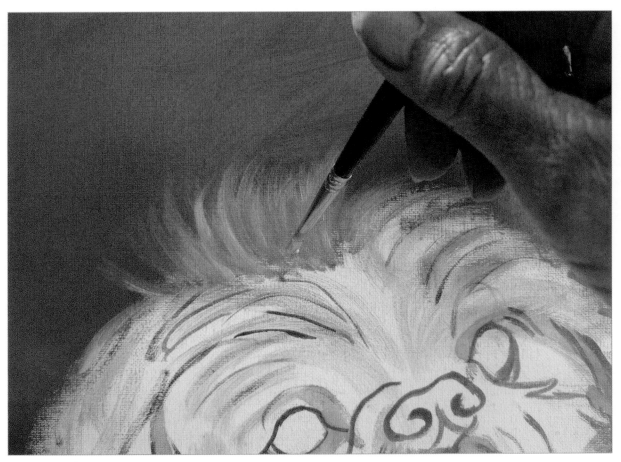

Step 5 While my background is still wet, I mix white and a tiny bit of raw umber and yellow ochre to make a pale cream (almost white). With a small round brush, I flick in the fur all around the edge of the dog so that it blends into the background. This softens the edges so that the dog doesn't look like it's been cut and pasted onto the canvas.

Step 6 Using a small round brush and a mix of ultramarine blue and raw umber (to make black), I paint the dark area around the eyes, nose, and nostrils. Then, using a dry, small round brush and a little raw umber, I scrub in the brown area around the eyes and under the chin. Then I leave it to dry.

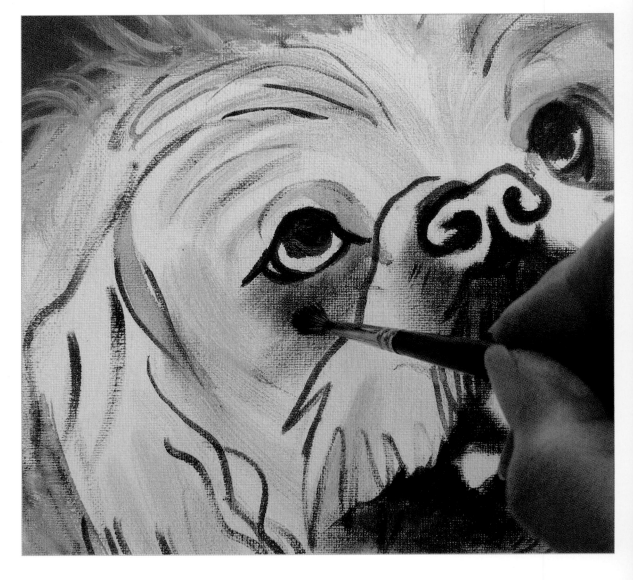

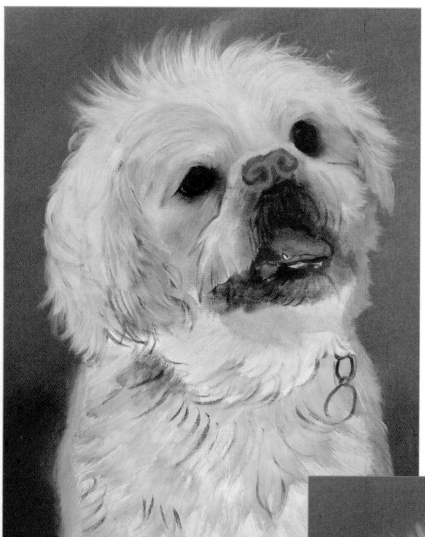

Step 7 Using cadmium red and a little raw umber, I apply a thin layer of paint over the tongue and mouth. This is the base color for the tongue. I also put a thin layer of burnt sienna in the eyes. Then I start filling in the fur texture on the head, using a medium round brush and some white mixed with a little yellow ochre to make a light cream. Be careful not to put the paint on too thickly or overwork it, as there will be more layers on top of this one.

Step 8 I continue detailing the fur over the face and body using the cream color. Don't worry if the drawing lines show through, as they will be covered up with more layers. I mix a very thin layer of ultramarine blue and raw umber to darken the area around the eyes. Then I apply dry brushstrokes in the shadow of the tongue. Returning to the body and neck, I paint a mix of ultramarine blue and raw umber in the darker, shaded areas. At this point, I'm more interested in the fur tones rather than individual strands. Since the body fur isn't as light as the face, I make another cream color by mixing white with just a bit of raw umber. Then I apply rough fur strokes on the body.

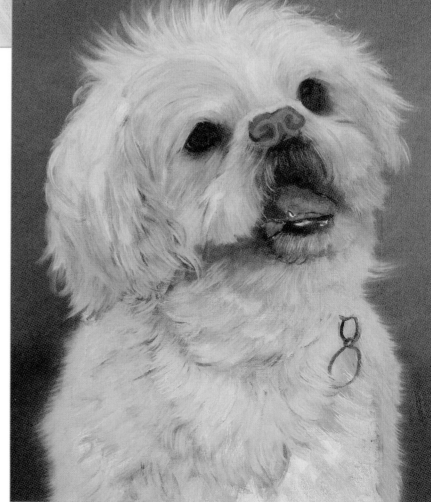

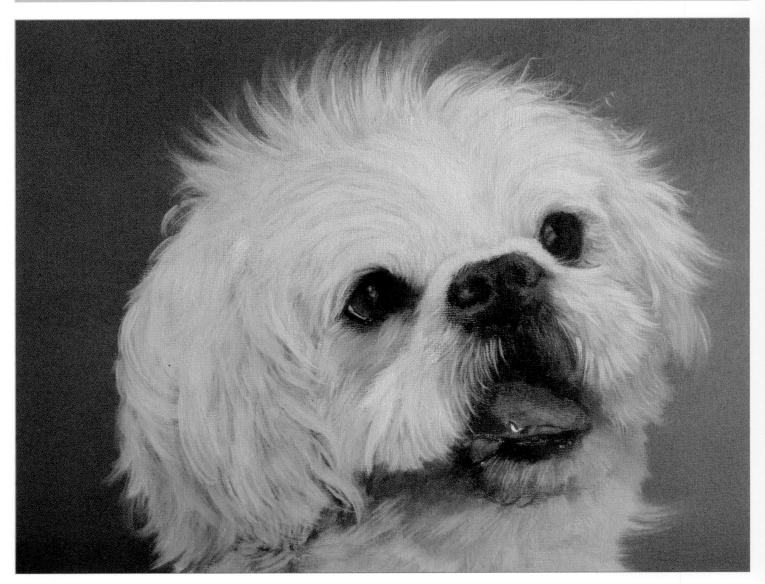

Step 9 Using a small round brush, I paint a thin layer of raw umber over the nose. For the nostrils, I thicken the paint with ultramarine blue, which makes it darker. Then, with the same brush and a thicker mix of white and ultramarine blue, I dab some highlights on the nose. Using a small round brush, I paint in more detailed fur strokes on the face and ears using a pale cream (white mixed with yellow ochre). I then darken the eyes with a layer of raw umber. While the paint is wet, I put a small amount of yellow ochre at the lower edge of the pupil to suggest highlights. For the light in the eyes, I use ultramarine blue mixed with white and dab a little white for the bright highlight.

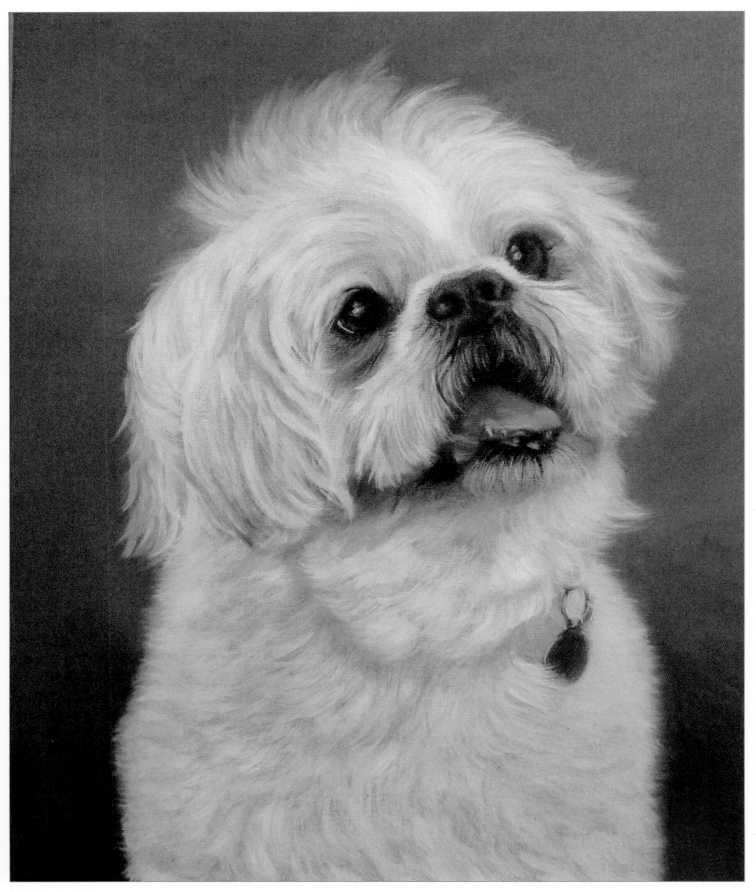

Step 10 Using a large round brush and the very pale cream from step 9, I cover the body with the fur texture. I then leave the painting to completely dry. Once it's dry, I continue adding fur detail using several different-sized round brushes, which gives variety to the fur strokes. Then I add more background color and blend the fur edges into the background while it is still wet. Once this layer dries, I continue to add fur detail on the body until I'm happy with it. Then I place highlights on the tongue, using a small round brush and cadmium red mixed with white. Finally, I put a small dab of cream for the tooth, and I tone down the gold tag with a thin layer of raw umber mixed with ultramarine blue.

Boxer *with Lorraine Gray*

This boxer has loyal, expressive eyes that easily serve as the focal point in my portrait.

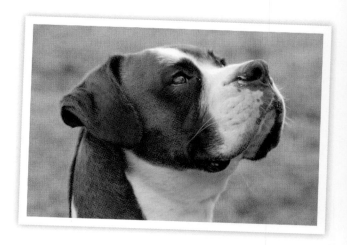

Color Palette

burnt sienna • cadmium red • Naples yellow
olive green • raw sienna • raw umber • sap green
ultramarine blue • white • yellow ochre

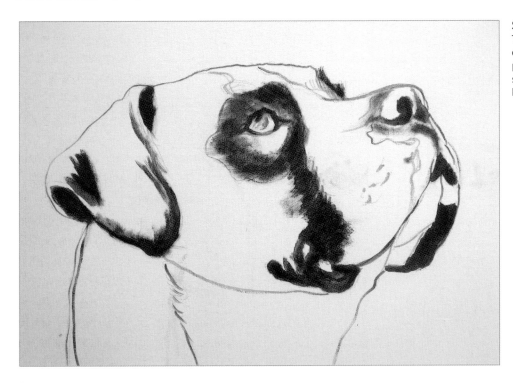

Step 1 I use an HB pencil to sketch the dog. Then, using a small round brush and a thin mix of raw umber and ultramarine blue, I roughly paint in my outline and the darker areas. I do this so I won't lose the drawing when I paint in the background.

▶ **Step 2** Using a large flat brush and a very thin mix of burnt sienna, I cover the background and part of the dog's face. This forms my underpainting. Then I mix cadmium red and white to make a very thin, pale pink for the undercolor of the mouth and muzzle area. This pink will show through when other layers are applied. I use a smaller round brush for this. I also roughly paint in a very thin mix of raw umber and ultramarine blue for the undercolor of the neck shadows.

Artist's Tip

The size of your painting determines the sizes of your brushes. This painting is only 10 x 12 inches, so I use a smaller range of brushes than I would use on a large-scale painting.

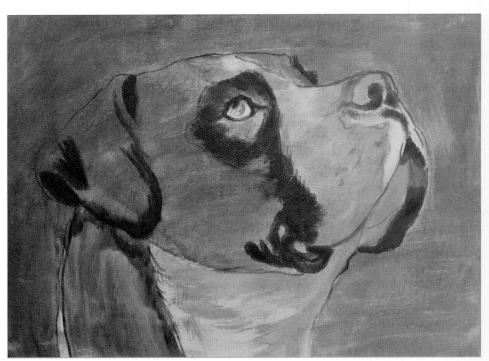

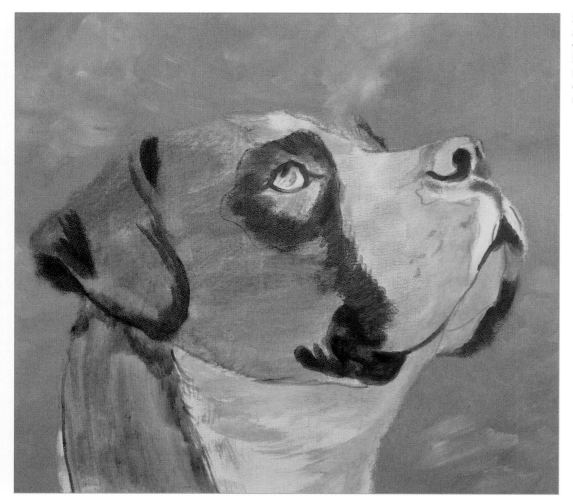

Step 3 Using a medium brush and a mix of sap green and Naples yellow, I paint rough crisscross brushstrokes over my background. I don't mix the two colors together completely, which produces a mottled look.

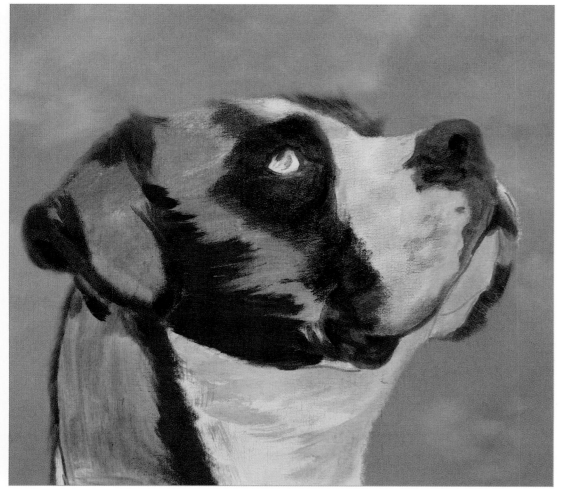

Step 4 I use a large, dry, soft varnish brush and very gently brush over the background to soften it and the edges of the outline. While the background is still wet, I mix some raw umber and ultramarine blue and paint another layer on the dark areas around the eyes, nose, and ear.

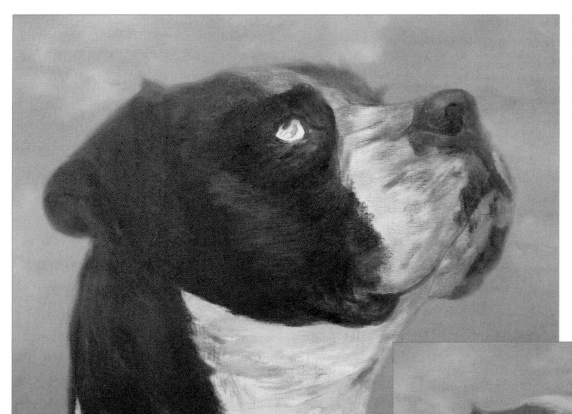

Step 5 With a mix of burnt sienna, raw umber, and raw sienna, I use a medium brush to paint in the darker brown areas next to the ear and down the neck. While this layer is still wet, I paint a thin mix of raw sienna and a tiny bit of burnt sienna on the lighter parts of the neck and head areas.

▶ **Step 6** Using a small, dry brush and a dry mix of raw umber and ultramarine blue, I rub over the muzzle area. (By "dry brush," I mean that there is very little paint or thinning medium on the brush.) Then I start building up the white layers on the face. Using a medium brush, I mix a medium consistency of white with touches of raw umber and yellow ochre to create a yellowish cream. I then brush rough fur strokes over the forehead, face, and neck, allowing the pink on the muzzle to show through.

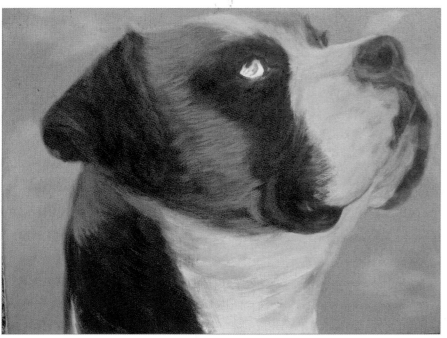

Step 7 When my painting is dry, I create another mix of the yellowish cream (yellow ochre, white, and a touch of raw umber) and use a medium round brush to paint in the lighter fur strokes. At the same time, I use another medium round brush and a thin mix of raw umber to blend the cream edges. Using the same brush with the raw umber mix, I rough in some dark fur texture on the neck; I want this layer to be wet when I paint it over the cream-colored fur.

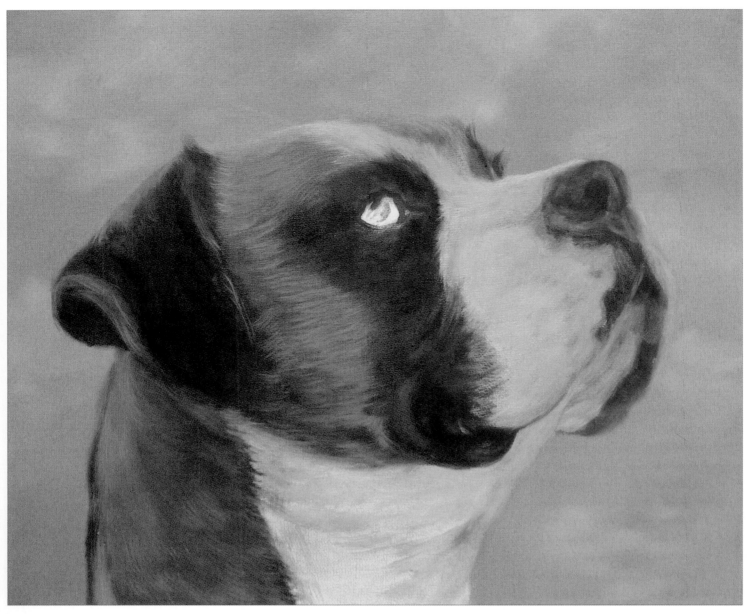

Step 8 I build up the fur texture on the neck using two brushes and colors (one for the brown and one for the cream). Notice how the neck colors blend together nicely as I apply them at the same time. Then I paint the lighter colors on the ears.

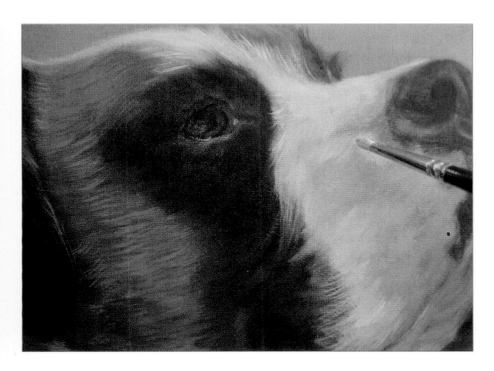

▶ **Step 9** Using a small round brush and a fairly thin mix of white with a tiny bit of yellow ochre, I brush the thin strands of white fur on the face. Then, using a larger round brush, I paint in a white topcoat on the face. I use white toned down with a small touch of yellow ochre. I also put a thin mix of burnt sienna in the eye as the base color.

Artist's Tip

Working with two brushes and colors at the same time is a good way to create soft blends within the wet paint.

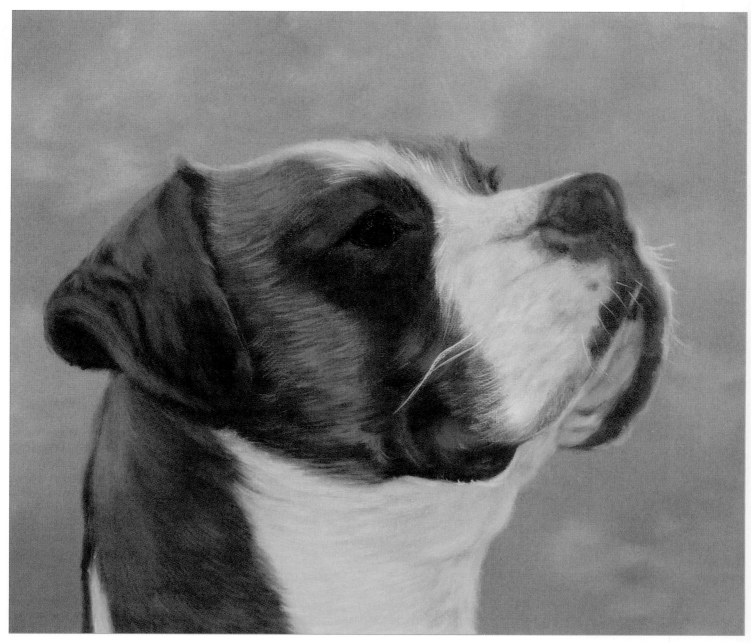

Step 10 Using the same brush, I apply the white mix from step 9 onto the neck. Then, using a rigger brush and a thin mix of white, I flick in the whiskers. With a medium round brush and white mixed with a tiny bit of yellow ochre, I paint an extra layer on the middle and lower neck to lighten it. I also paint a layer of raw umber to tone down the eye color.

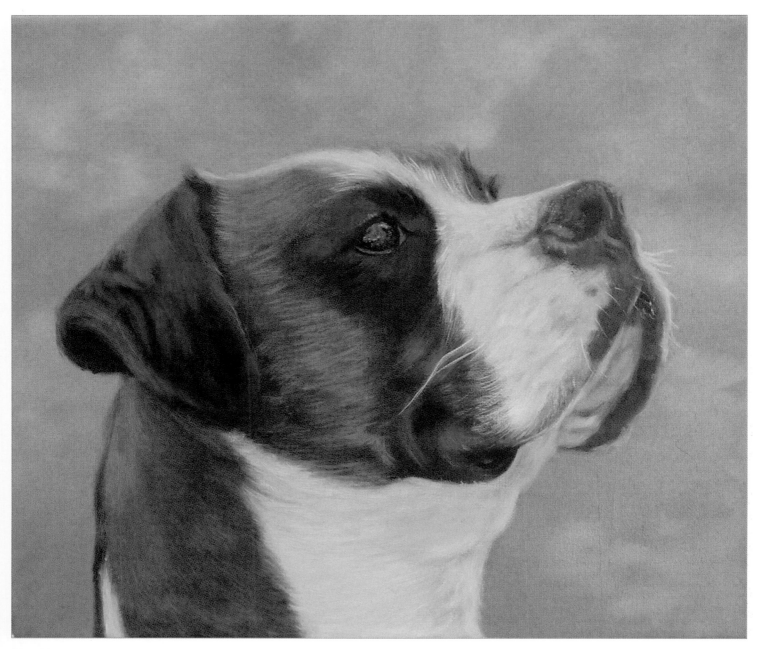

Step 11 I paint in more of the dark color on the ear and nose, using a small round brush and a mix of raw umber and ultramarine blue. While this is still wet, and using the same brush, I add some white to the mix and place the highlights on the ears and nose. I then blend the highlights with a soft, dry brush. Then I work on the eyes and place a bluish highlight, using a very small round brush and a thicker mix of ultramarine blue with a tiny bit of white. While this is still wet, I paint a tiny bit of white for the lightest highlight.

Rabbit *with Lorraine Gray*

In this pet portrait, I focus on achieving a realistic, soft, fluffy coat of fur.

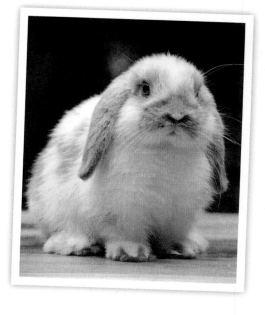

Color Palette

burnt sienna • Naples yellow • olive green
raw umber • ultramarine blue • white • yellow ochre

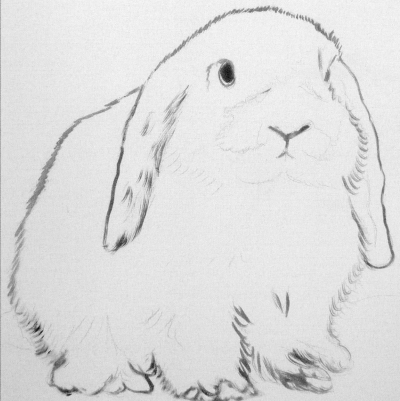

◄ **Step 1** I sketch in the rabbit using an HB pencil. With a small round brush and raw umber, I roughly paint over my outline. This helps maintain the drawing when I paint in my background colors. I mix a little raw umber with ultramarine blue to create black for the eye.

Step 2 I paint in my undercolors, using a small flat brush and a thin mix of raw umber and ultramarine blue to make a bluish gray. I thin my paint to achieve the light gray color. Then I put a thin mix of burnt sienna, yellow ochre, and raw umber around the nose. This will be toned down later when I apply the fur texture over it.

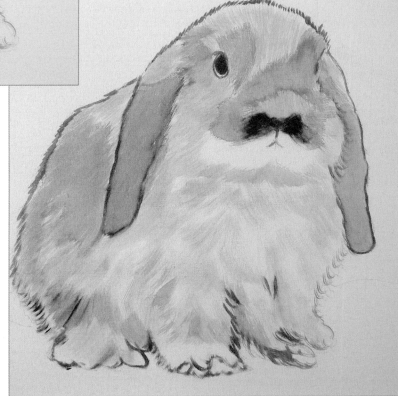

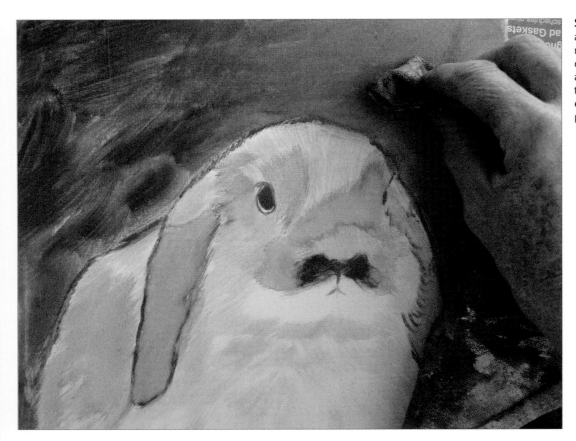

Step 3 With a large flat brush and a thin mix of burnt sienna, I very roughly brush in my background color. While this is still wet, I rub an old rag over the background to smooth it out and remove any excess paint. I then leave the painting to dry.

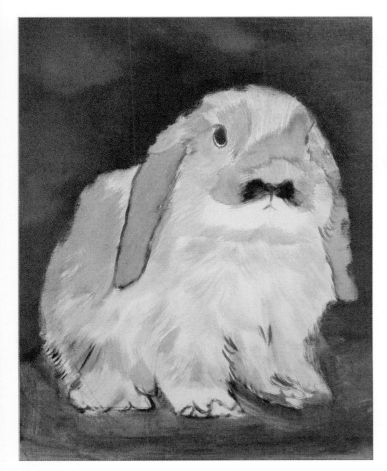

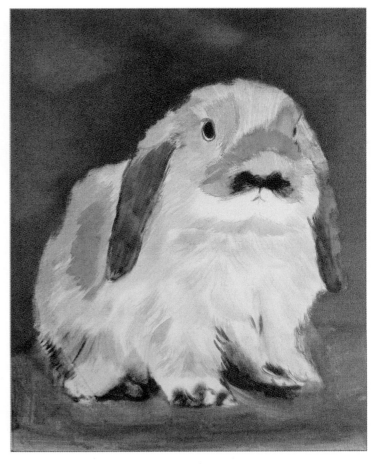

Step 4 Using a large flat brush and much thicker paint, I apply rough brushstrokes with a mix of olive green and Naples yellow. I also apply some Naples yellow in patches to create light in the background. I go over the background with a large, dry varnish brush to soften it, barely touching the canvas with the brush.

Step 5 Using a medium brush and a mix of ultramarine blue and raw umber, I paint in some more dark undercolors on the ears, nostrils, and eyes. I paint another layer onto the background using the same colors from step 4.

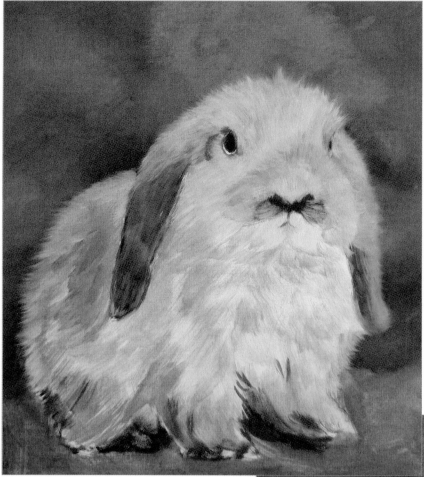

Step 6 While my background is still wet, I mix some white with raw umber to make a dark cream and, using a large brush, gently blend the edge of the rabbit with the background. Using a small round brush and a mix of white and a tiny bit of yellow ochre to make a very pale off-white, I gently flick on the fur texture all around the edge of the rabbit while the background is still wet. Using the same color mix and a larger round brush, I paint the rough fur texture on the face.

Artist's Tip

Flicking on the fur texture with a brush while the background is still wet keeps the strokes soft and the fur looking fluffy instead of spiky.

▶**Step 7** Using the cream paint mix, I brush in more fur texture on the ears and on the back of the rabbit with a small brush. Don't overwork this step—other layers will follow this once it's dry. I continue adding fur texture all over the body. Then, using a large flat brush and a mix of Naples yellow, raw umber, and white, I paint a thicker layer over the foreground. Then I leave the painting to dry completely.

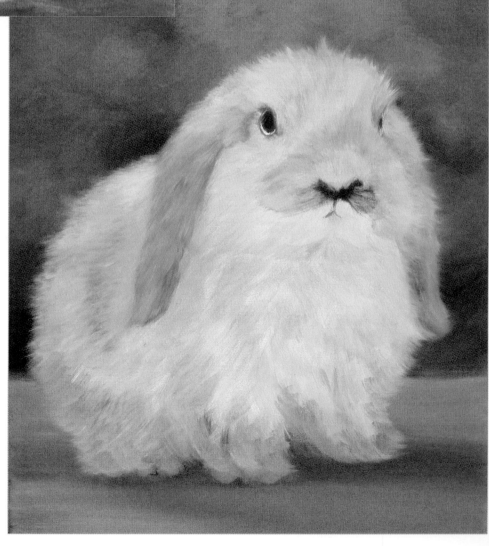

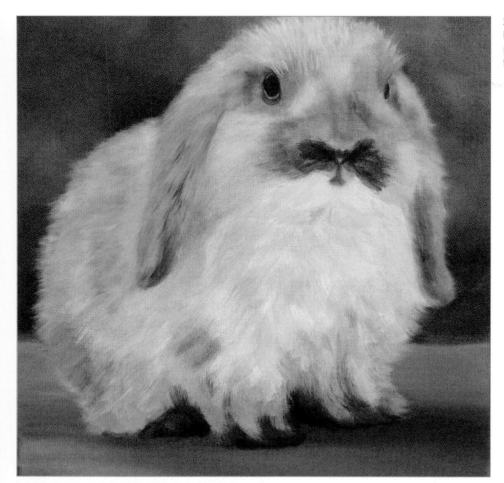

Step 8 Using a small round brush and a thin mix of burnt sienna and raw umber, I paint a thin layer on the paws and around the nose. Then I darken the ears and face by drybrushing with a thin round brush.

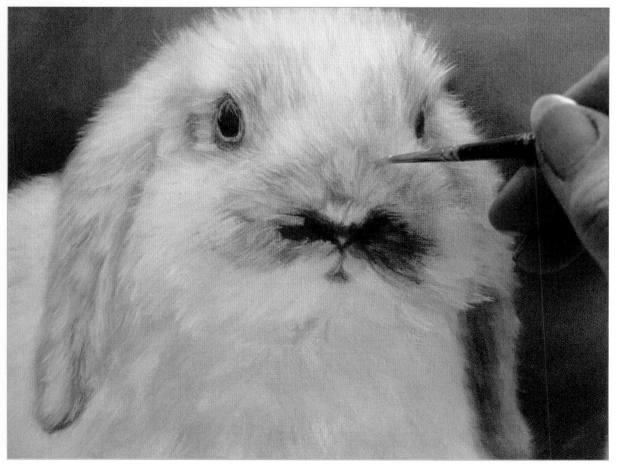

Step 9 For the next layer of fur on the face, I make a lighter cream than the first layer, using more white mixed with a bit of yellow ochre. I use #2 and #6 round brushes, stroking in the direction of the fur growth and alternating between brushes to achieve different effects. Then I brush in the lighter fur on the ears using a very small round brush and a pale cream color.

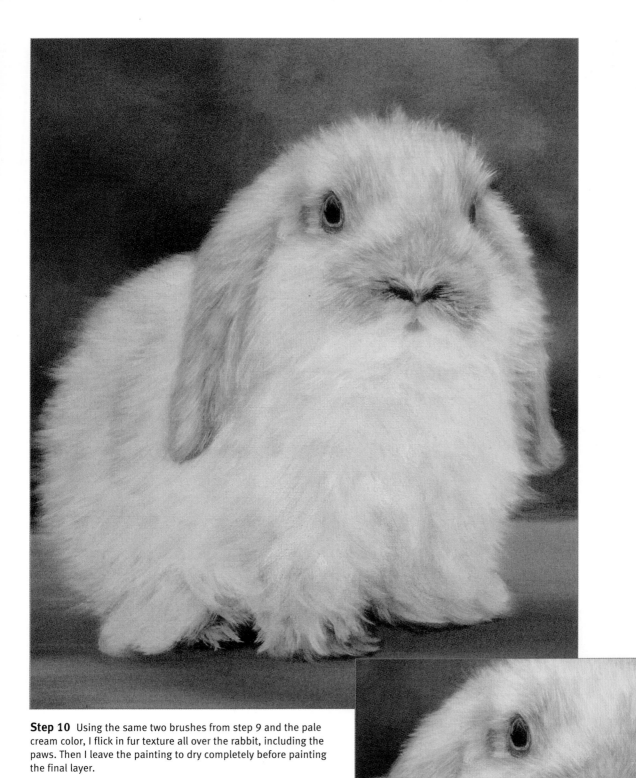

Step 10 Using the same two brushes from step 9 and the pale cream color, I flick in fur texture all over the rabbit, including the paws. Then I leave the painting to dry completely before painting the final layer.

Step 11 I mix some burnt sienna and yellow ochre and paint another layer on the nose. Then, using a small brush and a mix of white and yellow ochre, I place some fur strokes on the nose.

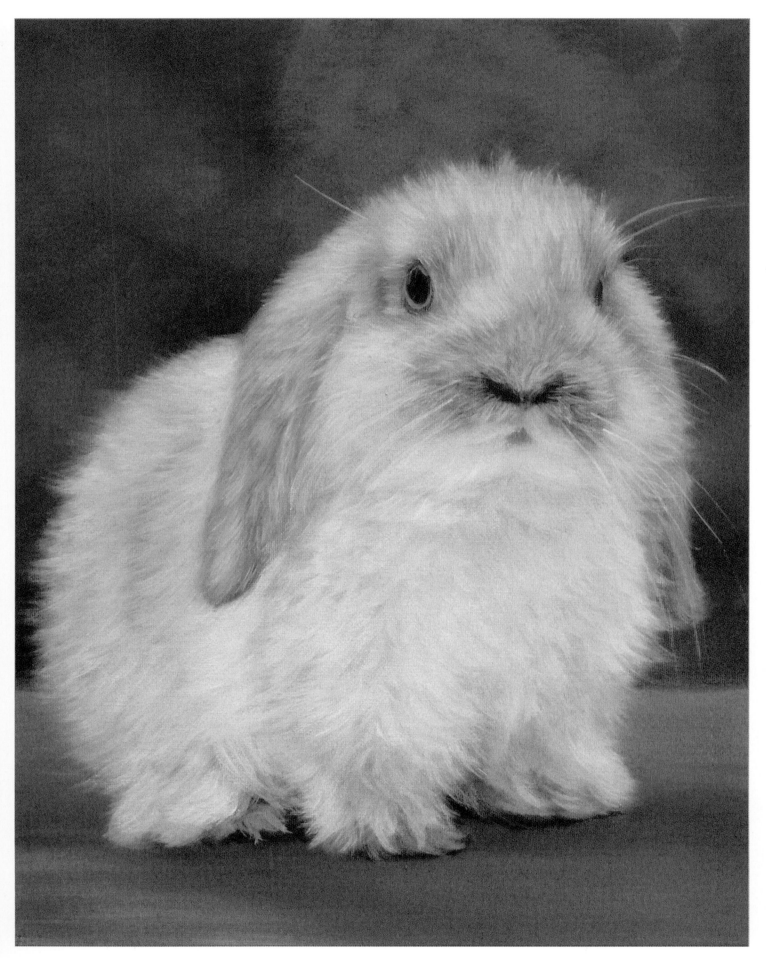

Step 12 For the final layer, I use the same cream color and a larger brush. I place more fur texture on the chest, legs, and feet. I also paint some whiskers using a rigger brush. To finish the eye, I create another mix of ultramarine blue and raw umber and paint another layer over the pupil. Then I paint a pale blue line around the edge of the eye to create a highlight.

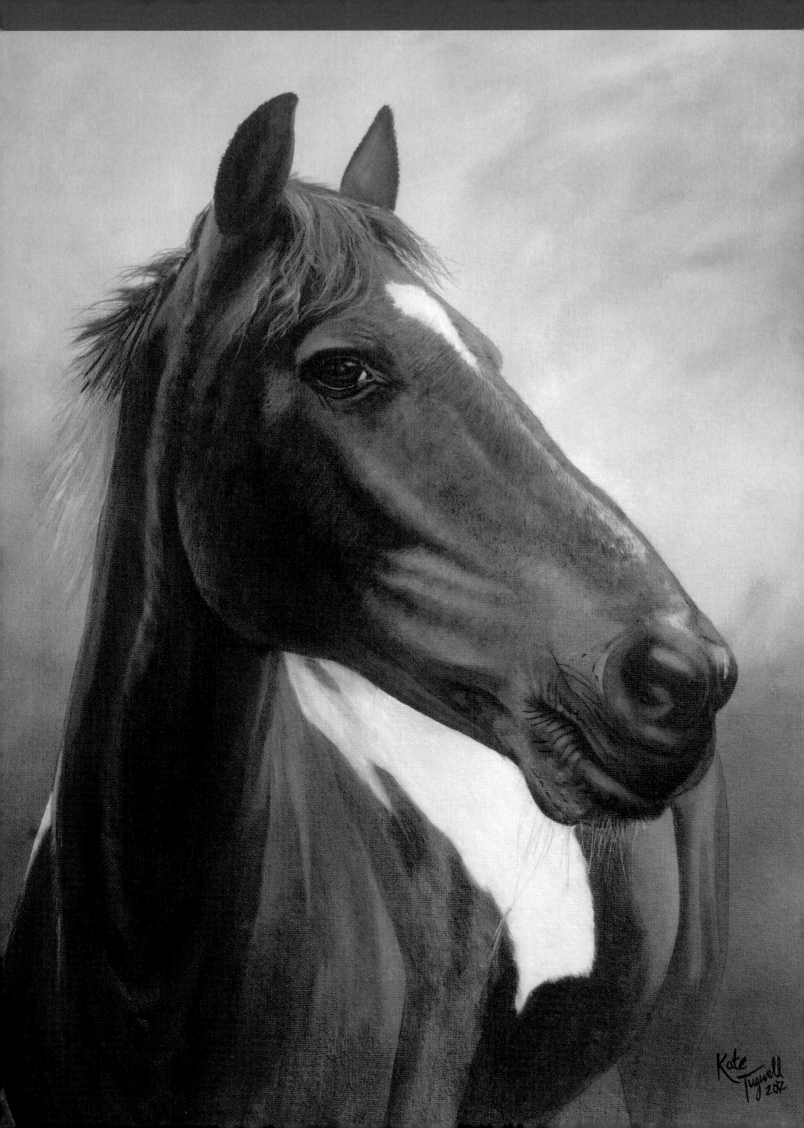

Painting Animals in Acrylic

with Toni Watts & Kate Tugwell

Acrylic is an extremely versatile medium and wonderful for painting animals. Unlike oil, acrylic dries quickly, so you don't have to wait long between applying layers. It encourages loose and lively strokes and discourages overworking. Follow along with Toni Watts and Kate Tugwell as they guide you in how to paint a realistic selection of animals in acrylic.

Barn Owl *with Toni Watts*

We are fortunate to have a healthy population of barn owls where I live in Lincolnshire, England. For this painting, I work from a photograph of a rescued owl and place him on a familiar street post. I was drawn to my reference because I am particularly fond of the angle of its head.

Color Palette

burnt sienna • burnt umber • cobalt blue
permanent rose • raw umber • titanium white
ultramarine blue • yellow ochre

Thumbnail Process: Establishing the Composition

I prefer not to place the subject directly in the center of the painting. It is more visually interesting to place the focal point elsewhere.

Placing the owl on the left side of the composition makes it appear as though the bird is looking at the frame!

Placing the owl in the right third of the painting makes a much more natural composition.

I also tried this same composition in a landscape format. There are some buildings across the field from this location, and while I like the look, the winter fields are dully and muddy.

I decide to keep the portrait format and add some seed heads to suggest the terrain.

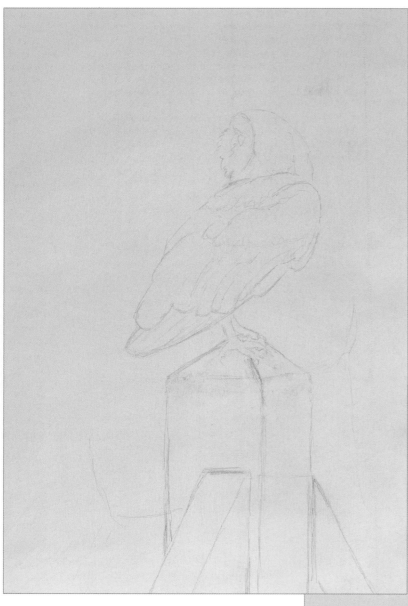

◄ **Step 1** I make an initial sketch based off my thumbnail, looking at shapes and placement rather than anatomical accuracy. I paint the sky with a mixture of titanium white and cobalt blue, making it slightly darker at the top. I lightly sketch the owl again. Don't worry if your sketch isn't perfect. You can cover up mistakes later.

▶ **Step 2** Next I loosely block in the main shapes. I paint the owl with yellow ochre and white and the post in raw umber and white. Both of these mixes are opaque, completely covering the underlying blue.

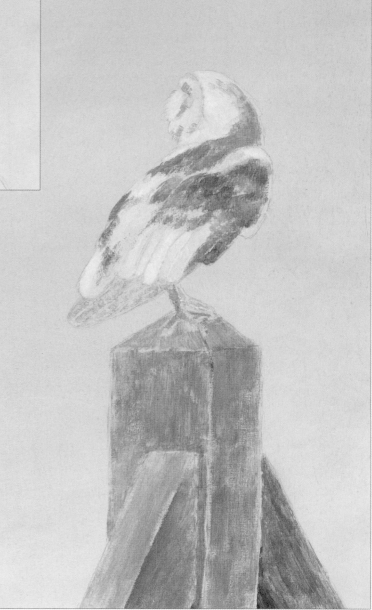

Artist's Tip

The easiest way to achieve uniform color is to mix plenty of a color and apply it with a fan brush, blending quickly in all directions.

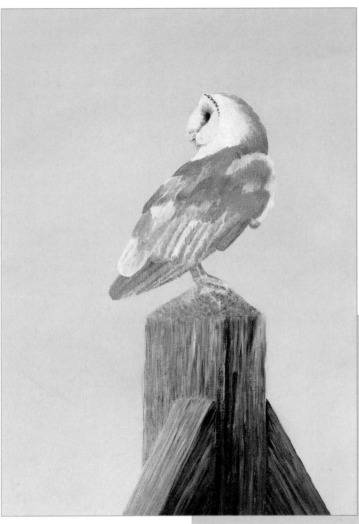

◄ Step 3 I add a little pink to the lower third of the painting, using a pale mix of permanent rose and titanium white, to suggest a late afternoon winter sky. I study the feathering, ensuring that I note where each feather group falls. It isn't necessary to outline each individual feather; an impression of softness and direction is all that is needed. I use rough vertical strokes to paint the post with raw umber, mixing dark and light strokes for irregularity. I paint the right side of the post darker to indicate the light source coming from the left.

► Step 4 The owl is a bit too yellow, so I add very diluted burnt sienna across the feathers. Next I paint the feather markings with white paint and a dark brown mix of burnt umber and ultramarine blue, making sure that they mimic the twist in the bird's body. Note the visible change in direction of the markings from left to right.

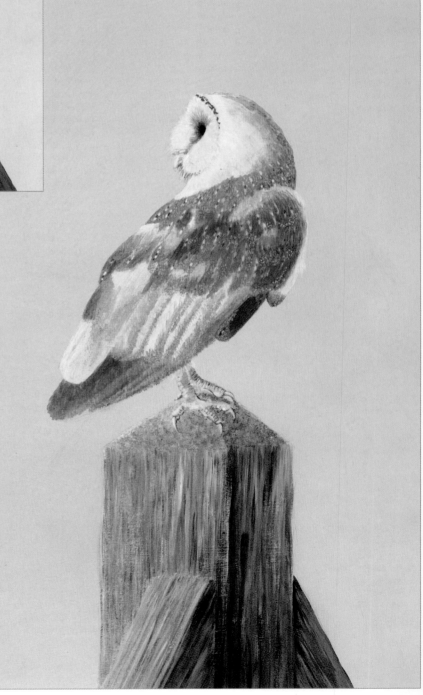

Artist's Tip

If you like, you can add some plants, but I like this clean, uncluttered painting of a beautiful bird on a stark winter's day.

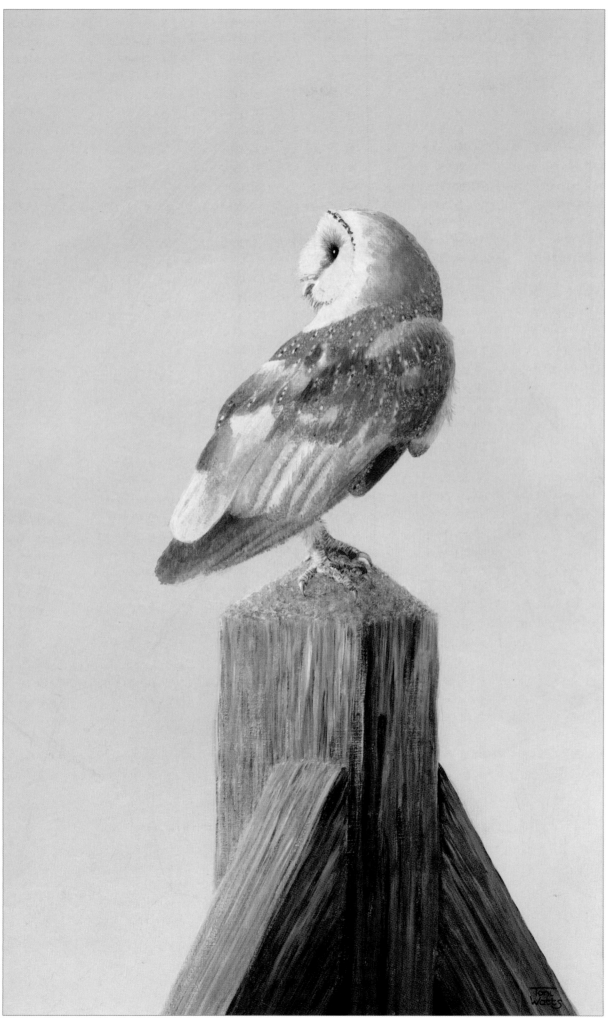

Step 5 Because the light is coming from the left, I shade the right-hand side of the owl's body with a thin wash of dark blue (ultramarine with a touch of burnt umber). I apply the same mix just under the edges of the wing feathers, as if each is casting its own shadow onto the feather beneath. I also paint the dark blue wash on the feet, which are cast in shadow by the body. I add some yellow ochre to the head feathers. To finish, I add a small, bright light in the eye.

Ducklings *with Toni Watts*

I live in a village that dates back to medieval times. It has a small duck pond, and each spring the ducks that live there are joined by ducklings. These beautiful little balls of fluff not only bob around on the water, but they also follow their parents in a line, waddling around the village. In this painting, I decide to depict the ducklings resting on the grass by the pond.

Color Palette

burnt sienna • burnt umber • cadmium yellow
cobalt blue • Hooker's green • permanent sap green
raw sienna • raw umber • titanium white
ultramarine blue • yellow ochre

Artist's Tip

When painting birds, there is no need to copy feather patterns perfectly—just make some marks to give an impression.

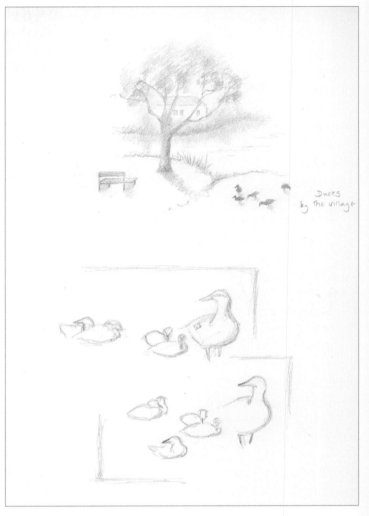

Step 1 First I experiment with several compositions in my sketchbook.

Step 2 Once I settle on a sketch, I transfer it onto my painting surface. Using a large brush, I block in the background with a diluted wash of sap green. I determine that the light will come from the top right. I block in the ducks very loosely with a mixture of raw umber and titanium white, looking both at where the light would fall and some of the feather patterns.

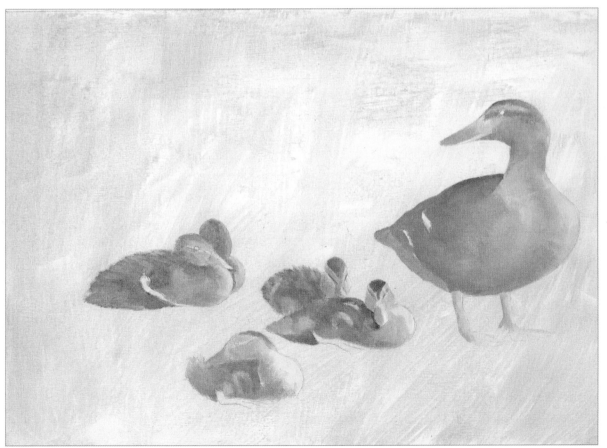

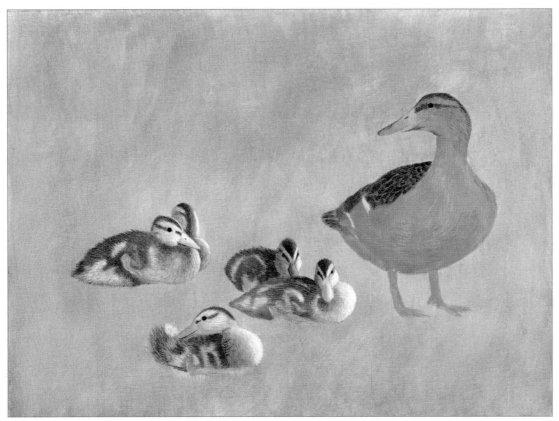

Step 3 I apply a deeper background wash of sap green. Once dry, I wash a dark blue mix of ultramarine blue and burnt umber over the lower part of the painting. Then I start to add detail on the birds' feathers. These ducklings are not old enough to have any straight-edged flight feathers, so they are all fluff! I use small strokes of paint in raw umber and white. I apply a wash of raw sienna over mother duck's breast, and then I paint the feathers on her back in a dark brown mix of burnt umber and ultramarine blue, allowing the underpainting to form the pale edges of the feathers.

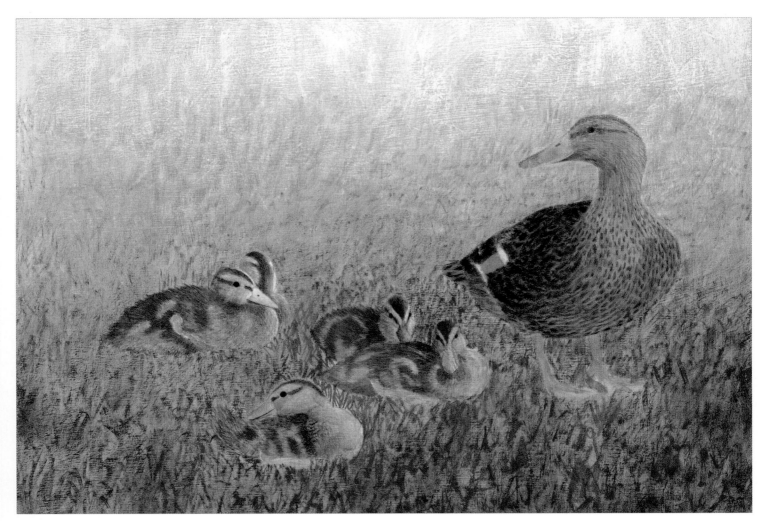

Step 4 I continue to focus on adding feathering. I use the same dark brown mixture from step 3 to paint the dark marks on the mother duck's chest, using a fairly dry brush to make the feathers look softer. I apply a wash of raw sienna over all the ducks to achieve a soft yellow color, more noticeable in the lighter areas. I also scrub in the underpainting for the grass with a random mixture of sap green, ultramarine blue, and burnt umber.

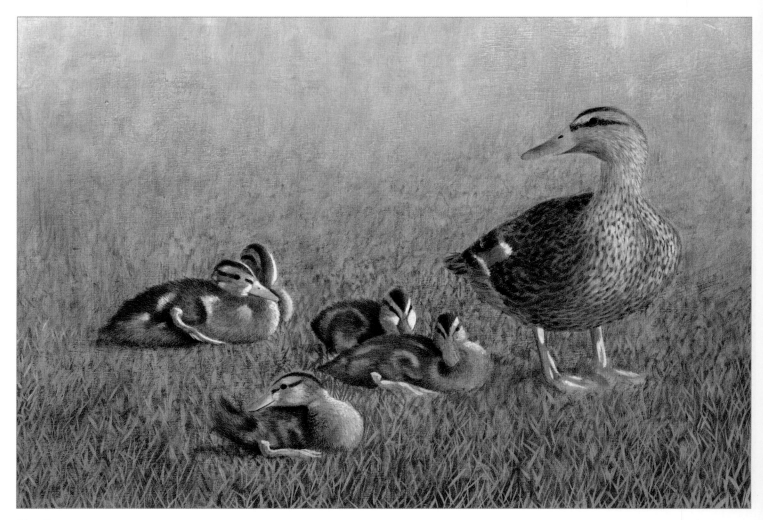

Step 5 Now it's time to make the ducks start to look more three-dimensional. After studying my photographic reference, I make all the darks darker (with a mixture of ultramarine blue and burnt umber) and all the lights lighter with titanium white. I add shadows using the dark mixture to anchor the birds in their environment.

Artist's Tip

When painting grass, it's easiest to paint each blade from root to tip, lifting the brush off as you go.
You might try working with the painting turned upside down to make it easier.

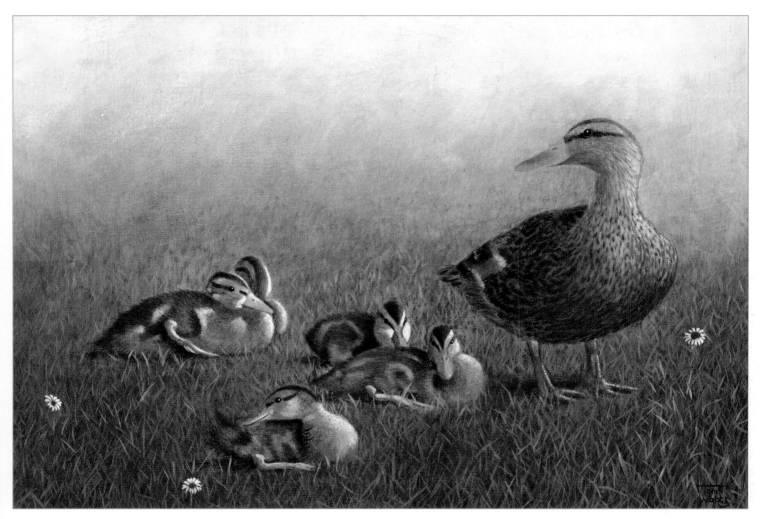

Step 6 I paint a wash of yellow ochre over all but the lightest areas of the mother duck's chest and legs. Then I turn my attention to the grass, painting the blades with a pale mixture of titanium white, sap green, and a tiny touch of burnt sienna. As you move toward the horizon line, make the blade lengths shorter so the grass appears to recede into the distance. Next I paint a wash of sap green over the lower two-thirds of the grassy area, painting around the ducks. I add more blades of grass, followed by a wash of cadmium yellow, as well as a second wash over the lowest part of the painting in Hooker's green and burnt umber. I use a big brush to paint a soft wash over the top part of the painting with a pale blue mix of cobalt blue and titanium white, allowing it to fade into the green. Finally I add a smattering of daisies in the grass and catchlights in the ducks' eyes.

Fallow Deer *with Toni Watts*

Although most of the land where I live is used for farming, there are still pockets of old woodland. Sherwood Forest, home of the legendary Robin Hood, is just down the road. For this project, I decide to paint an autumnal scene of a native deer in the woods. I combine multiple reference photos to help me create an accurate deer and setting.

Color Palette

burnt sienna • burnt umber • Hooker's green
ivory black • permanent sap green • raw sienna
raw umber • titanium white • ultramarine blue

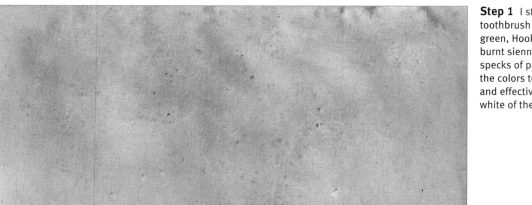

Step 1 I start by using an old toothbrush to splatter permanent sap green, Hooker's green, and a little burnt sienna on my paper. I spray the specks of paint with water, allowing the colors to blend. This is a simple and effective way to eliminate the white of the paper.

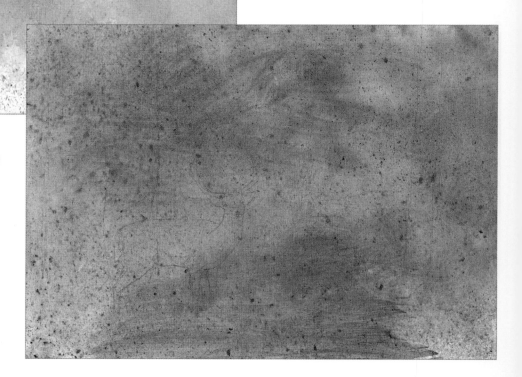

Step 2 I splatter and spray some more. Then I let the paint dry before I sketch in the basic composition. I add a diluted wash of burnt sienna over the area that will become the path.

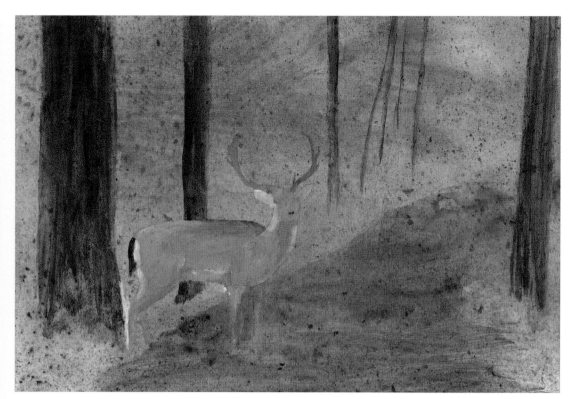

Step 3 I block in the main shapes of the deer and the tree trunks with a mixture of raw umber and white. When painting woods, I make sure all of the trunks are not perfectly vertical, which would make the scene look unnatural.

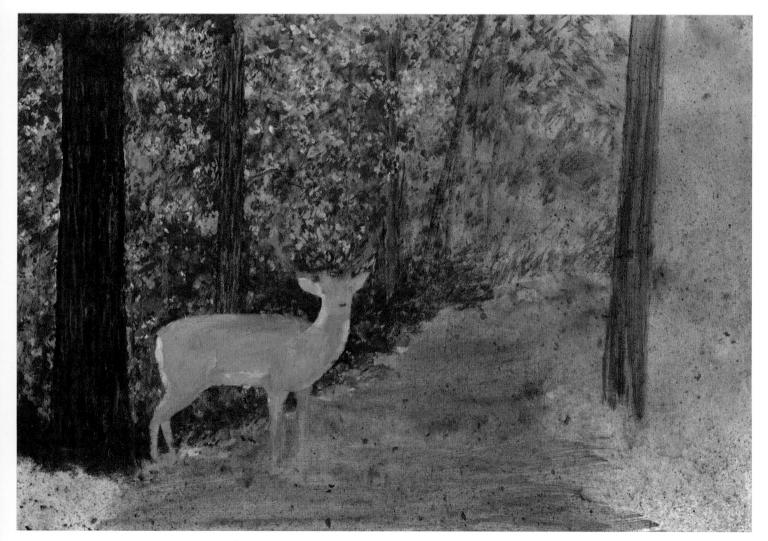

Step 4 I begin developing the woodland, which looks more difficult to paint than it actually is. For the leaves, I simply apply random dabs of paint using sap green, raw sienna mixed with titanium white, Hooker's green, and burnt sienna. For the darker greens, I add some burnt umber to Hooker's green. I create vertical texture on the tree trunks using the tip of a ½-inch flat brush loaded with a mixture of burnt umber and ultramarine blue. I dab the mixture onto the brown underpainting, allowing some to show through. I suggest the distant trees with a mixture of raw umber and white.

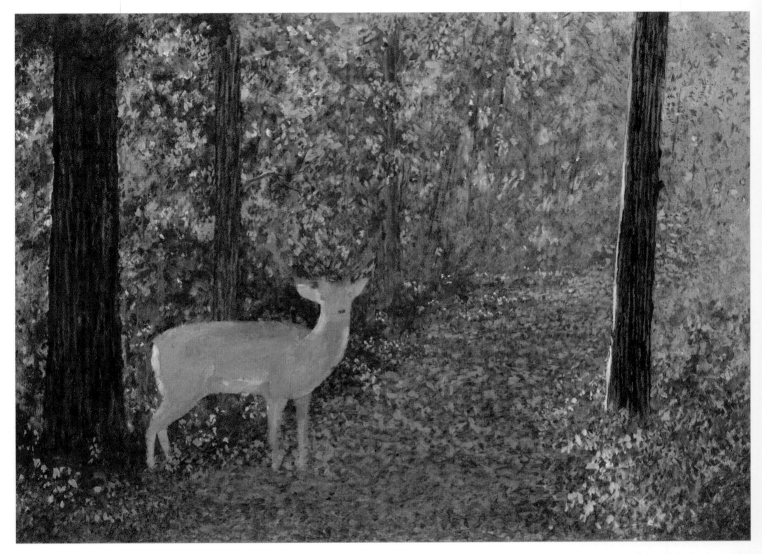

Step 5 To give the impression of distance, I make the leaves much less distinct as I work toward the back of the scene, allowing more of the original splattered background to show through. Where the path narrows, it becomes less red and appears to recede into the distance. To mimic this, I add raw umber to burnt sienna to tone down the color and paint the far end of the path.

Artist's Tip

Use less burnt sienna on the distant leaves—any red color (or
warm color in general) tends to "jump forward"
and spoil the impression of distance.

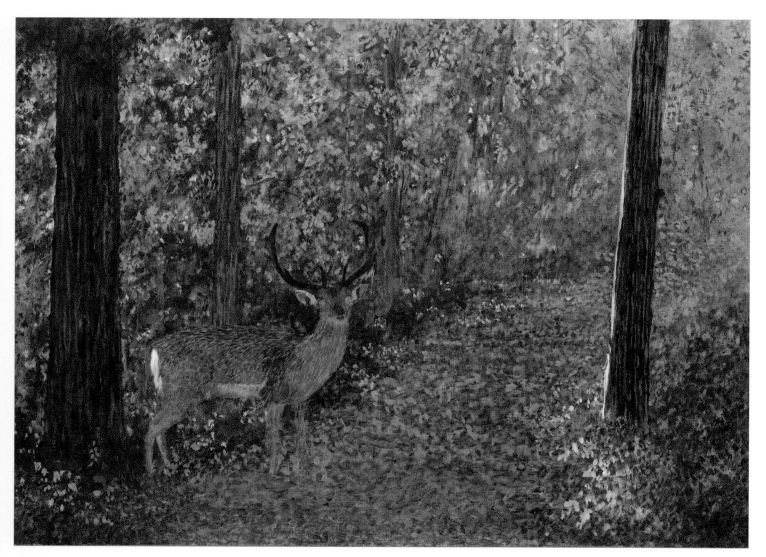

Step 6 I add the first layer of strokes for the deer's coat using raw umber. Note the longer hair on the deer's back—natural weatherproofing! I also add a diluted wash of dark blue (made from burnt umber and ultramarine blue) over the distant trees and foliage to push them into the distance.

Detail
Notice how the fur is rendered with thick, short brushstrokes.

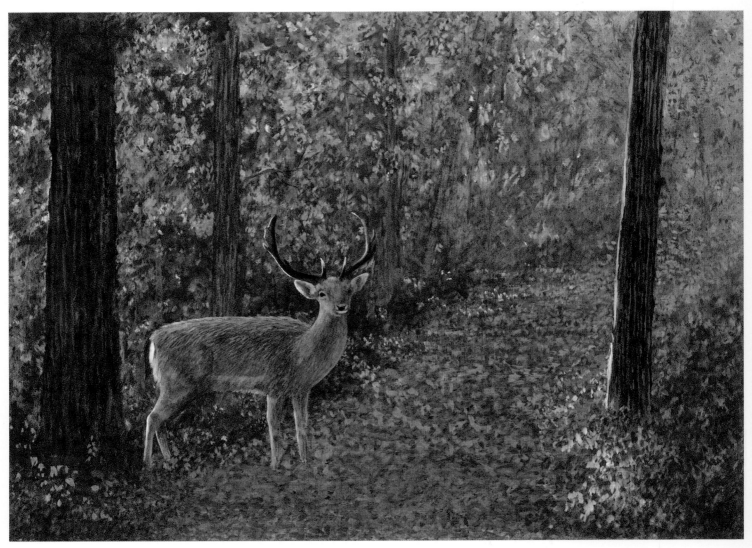

Step 7 Building the deer's coat, I add both lighter (raw umber and titanium white) and darker (raw umber and black) hairs. Because the original photograph of the deer was taken on a different day than that of the woodland, I had to imagine where the light would fall—the top of the back, one side of the turned neck and head, and the back of the legs—and add a greater number of light hairs in those areas. I apply a glaze of dark blue over the areas of shadow—the far side of the deer's chest and the front of the legs. I use the raw umber and white mixture to paint the antlers, imagining the light falling to one side of them.

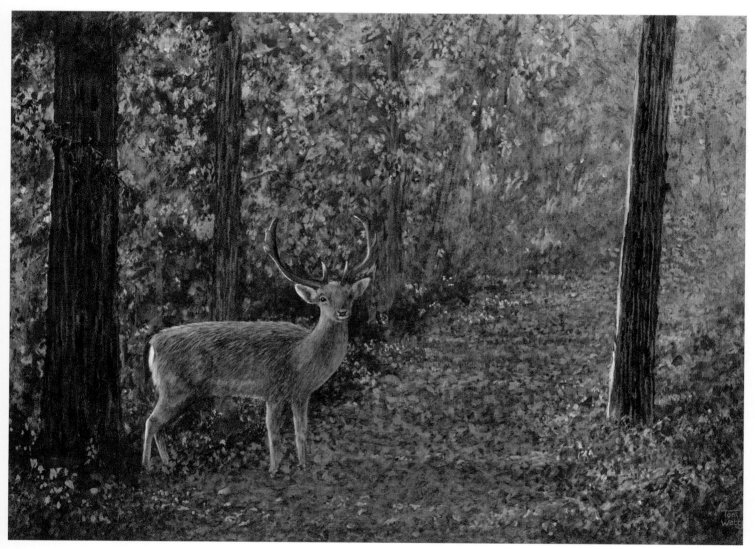

Step 8 I soften some of the hard-edged transitions between darker and lighter areas of the deer's coat and darken the far side of his muzzle with a touch of dark blue. Then I add a loosely painted branch on the left to break up the solid brown of the main tree trunk. I use washes of dark blue to create the shadows on the path. Finally, I highlight some bright edges of the foreground leaves with a mixture of raw sienna and white and add a light in the deer's eye.

Brown Hare *with Toni Watts*

Here is our village, just peeking out from under the trees. The surrounding land is almost entirely devoted to arable farming, growing cereals, vegetables, and sugar beets. We often see brown hares in the cornfields, and I thought a hare amongst ripening wheat would make a lovely painting.

Color Palette
burnt sienna • burnt umber • ivory black • raw sienna
raw umber • titanium white • ultramarine blue

Step 1 I start by sketching the hare onto my painting surface.

Step 2 I use a 2-inch brush to loosely paint the background, mixing diluted washes of burnt sienna, burnt umber, raw sienna, and ultramarine blue randomly on the page. Note that I paint over the edges of the hare, rather than trying to end the brushstrokes neatly.

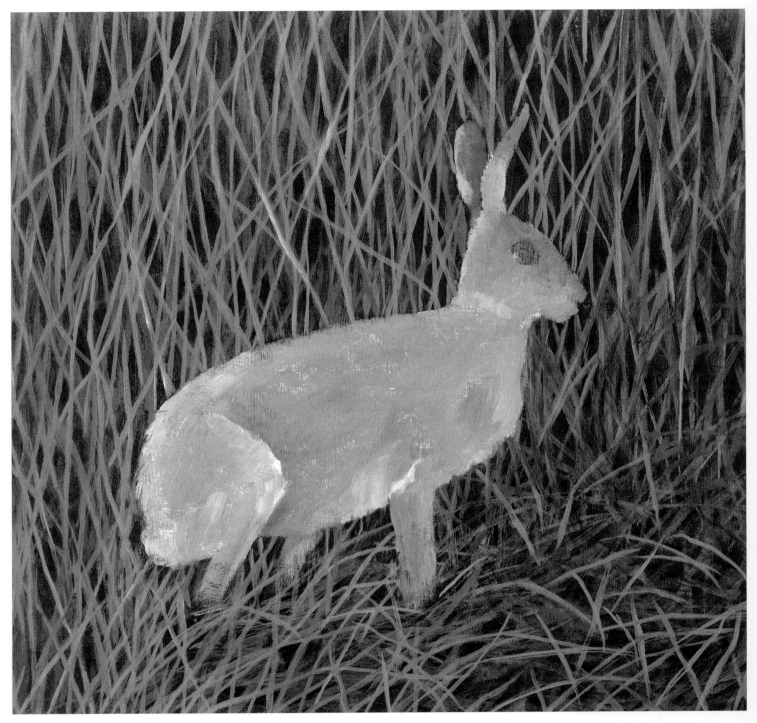

Step 3 I roughly block in the basic shape of the hare with a mixture of raw umber and titanium white. I also start painting stems of wheat—just narrow, overlapping stripes with a mixture of titanium white and raw sienna. I don't make the stems too uniform. Instead, I vary the darkness of the paint mix and allow some stripes to have smudged edges.

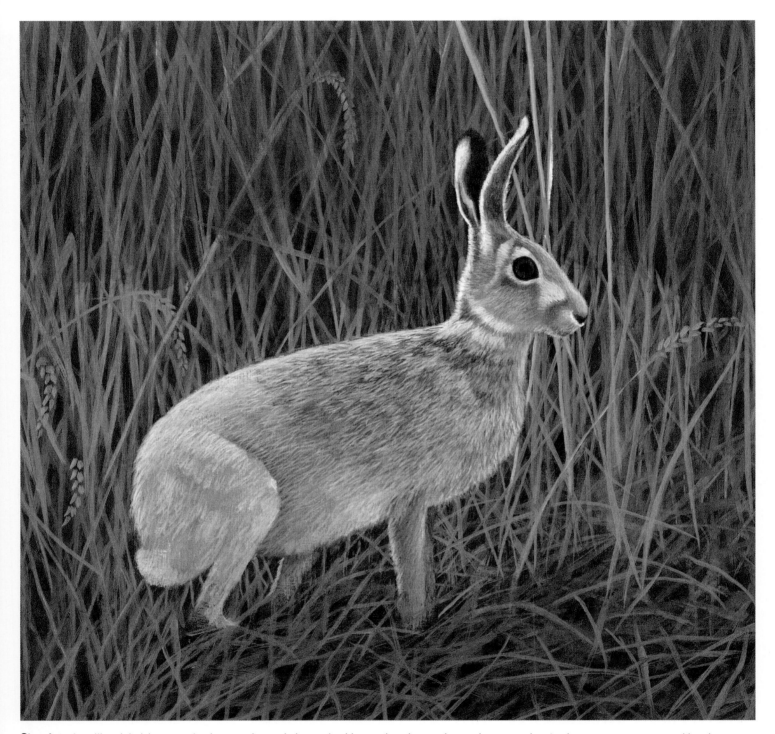

Step 4 I mix a diluted dark brown, using burnt umber and ultramarine blue, and apply a wash over the stems; then I paint new stems on top, making them lighter at the ends to give the impression of light hitting them. I begin to paint the hare's fur with raw umber. For the lighter hairs, I add white paint to the raw umber. For the darker hairs, I add ivory black. This variation in color implies of the roughness of the hare's coat. I also paint the iris of the eye with burnt umber and the pupil with black.

Artist's Tip

Add interest to the background by creating some variation. Pick out areas of lights and darks, include subtle changes in color, and change up the flow of lines by adding diagonals.

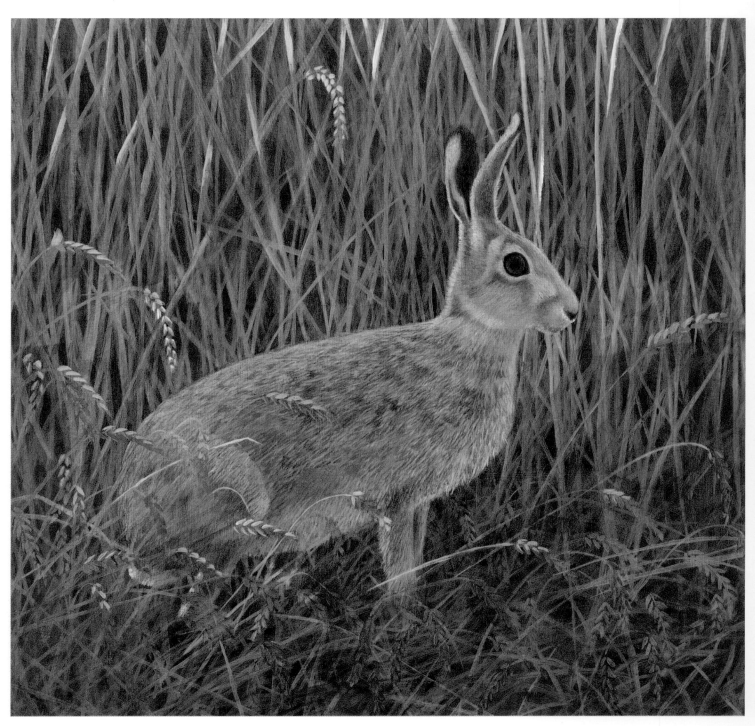

Step 5 I add more heads and stems of wheat in the foreground, with some overlapping the hare's body. Then I finish the hare's fur with raw umber, following the direction of the fur growth with my strokes. I apply a diluted wash of raw sienna over the whole painting to unify it and give the impression of warmth from the summer sun.

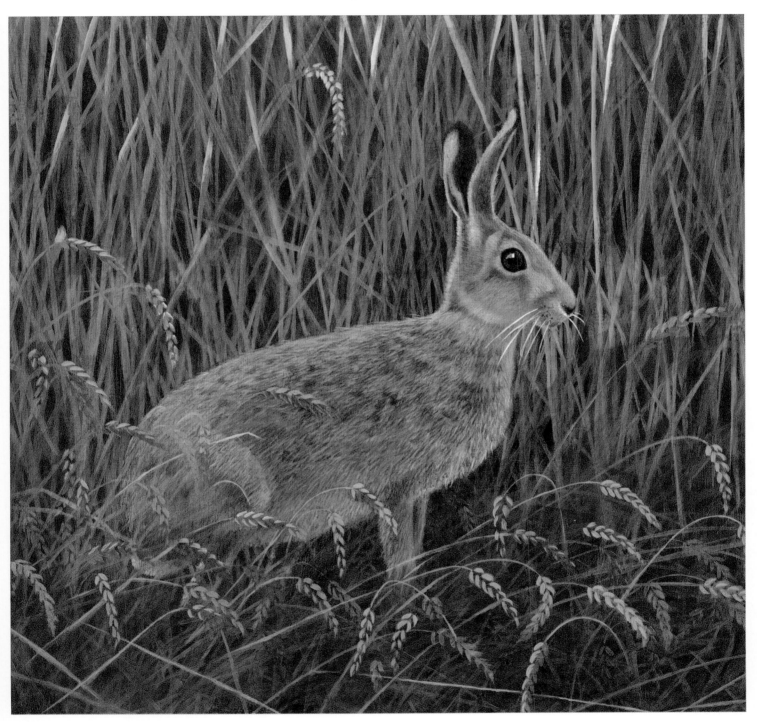

Step 6 Now I apply the finishing touches. First I glaze another thin coat of dark brown paint over the foreground and allow it to dry before adding a few more wheat stems. Then I use titanium white to add whiskers and a catchlight in the eye, making the hare come to life.

Horse *with Kate Tugwell*

This portrait is of a beautiful horse named Saffie. There were a number of fabulous photos to choose from, but I particularly like the way the eye connects with the viewer in this shot.

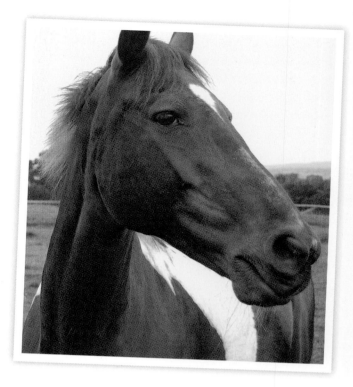

Color Palette

cadmium red • cadmium yellow • cerulean blue
burnt sienna • burnt umber • flesh tint
Mars black • Payne's gray • raw sienna
raw umber • sap green
titanium white • yellow ochre

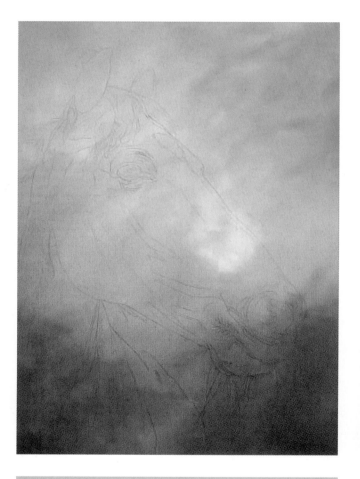

◄ Step 1 I begin by painting the whole background with white, sap green, raw umber, cerulean blue, and Payne's gray. I use a large hog-hair (coarse-bristled) flat brush to paint wet-into-wet, using flowing brushstrokes in all directions. I'm not painting anything specific—just filling the background with natural, earthy colors. Once the paint is dry, I sketch the horse.

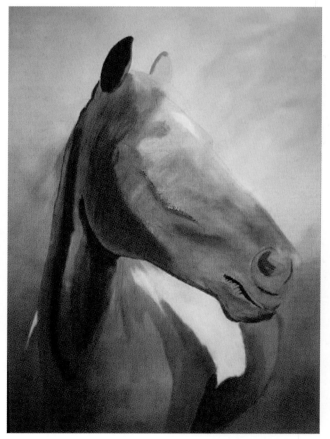

Step 2 Next I begin to block in color, using thin paint at first because I want the back of the horse to eventually appear to fade into the background. I use burnt sienna blended with flesh tint and yellow ochre for lovely warm hues that contrast with the cool notes of the background. I add white on the horse's flank, which contrasts nicely with the dark muzzle.

Artist's Tip

Begin the painting with large brushes and switch to increasingly smaller brushes as the portrait progresses. Doing so will prevent you from getting bogged down with details too early in the process.

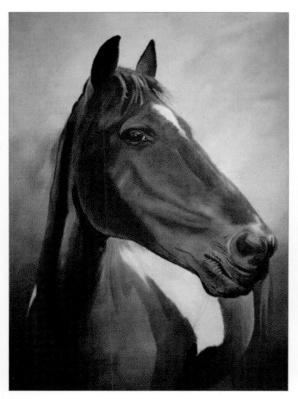

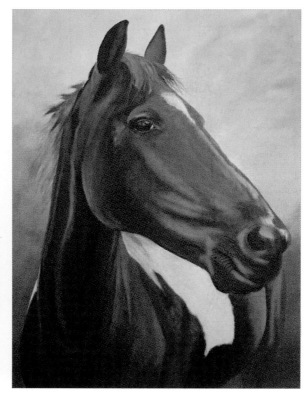

Step 4 Next I focus on the shapes of the shadows, using a small round brush to fill in the midtones with various umbers, siennas, and other brown hues. To emphasize the lovely warm areas of burnt sienna on the muzzle and flank, I mix ultramarine blue and cadmium red into the surrounding shadows to create more depth. I add white highlights on the left side, indicating a glossy coat.

Step 3 Next I develop the strong tonal values of the head, which is the main area of focus in the portrait. I often like to mix my own blacks, but in this step I use mostly Mars black with some ultramarine and burnt sienna on the eyes, ears, and nose.

Artist's Tip

Similar to a rigger brush, a sword liner brush is often used in sign writing, as it can create beautiful flowing marks for calligraphy. When wet, it is shaped like a sword. To effectively use this brush, mix a fair amount of watery paint and heavily load the brush. Unlike a rigger brush, this brush does not need to be reloaded with paint every few strokes.

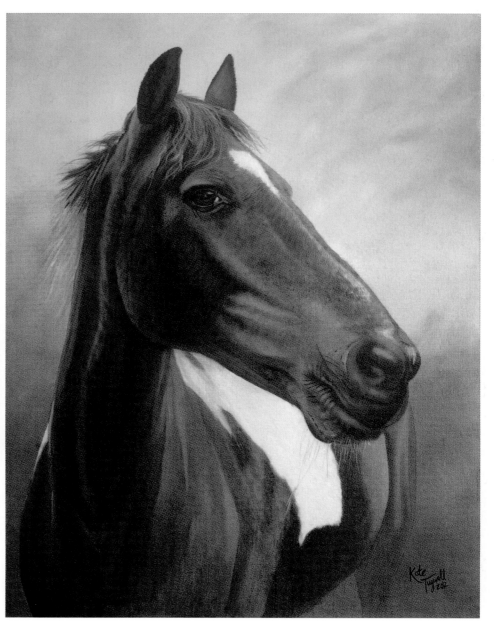

Step 5 Finally, I use a sword liner brush to sweep in the lovely, fine hairs that make up the frizzy fringe, mane, and whiskers. Then I use an old, small round brush to stipple in fine dark and light lines for the slightly longer hairs on the bridge of the nose and to create surface texture to illustrate fine hairs.

Tabby Cat *with Kate Tugwell*

A beautiful tabby cat named Tabatha is the subject of this painting. Whenever I paint a pet portrait, I ask for multiple of photos taken at different angles and different times of the day. Viewing several photographs taken in different lighting helps you judge the colors you need for your portrait.

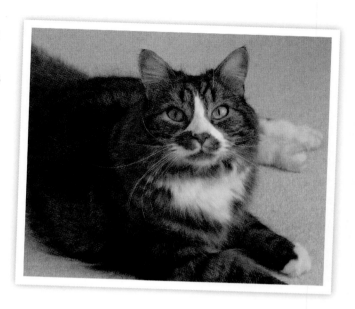

<div style="border:1px solid black;">

Color Palette

alizarin crimson (hue) • bright green
burnt sienna • burnt umber
cadmium red • cadmium yellow
flesh tint • Mars black
Payne's grey • quinacridone maroon
raw sienna • raw umber
titanium white • ultramarine blue
yellow ochre

</div>

Step 1 After working out my composition, I sketch a close-up of Tabatha's face onto the canvas. I mix cadmium red, alizarin crimson hue, quinacridone maroon, and flesh tint to create the vivid red background color. Then I use a wide, flat hog-hair brush to paint in different directions, achieving a mottled yet blended effect. Next I outline her eyes and nose with Mars black and put a base color of bright green on her eyes.

Step 2 Tabatha's eyes have an amazing variety of green shades; I pick a bright midtone to start with, and then I blend a tiny bit of cadmium yellow, yellow ochre, and burnt sienna with a fine brush. The right eye is cooler in temperature, so I introduce a little ultramarine blue and white to the other colors. I map out blocks of color in the fur with Mars black, burnt sienna, burnt umber, and raw sienna, painting in the direction of the fur growth. Cadmium red mixed with white creates the perfect pink for her nose.

Step 3 I use flesh tint and browns to create shadows in the white fur. Whites are reflective, and since the background is red, the white fur reflects some of that color. Flesh tint is the perfect color to use because it contains white and is quite opaque, with great correcting abilities. Using it in the white fur warms up the shadows without making them look pink. I also apply this color in the lighter areas around the eyes, on the top of the head, and in the ears.

Step 4 Next I paint the midtone area, using yellow ochre, cadmium yellow, and cadmium red. I refer to the photograph as I work to ensure I place the markings in the right places.

Step 5 After completing this first layer, I decide the fur on the back is too high, so I paint more of the background color to create a more pleasing shape. I also apply a second layer of the background color all over to ensure even, seamless blending. Then I darken the dark markings and add white to the light areas in the fur. To build a fluffy texture into the fur, I use an old, damp synthetic brush to flick various fur color mixes into her coat.

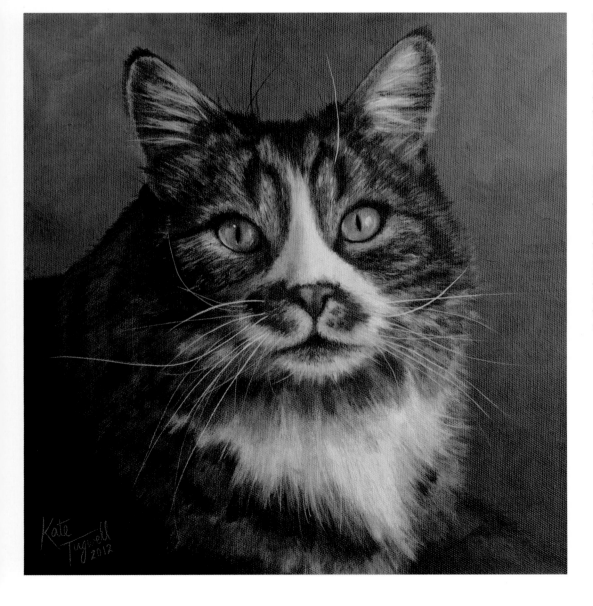

Step 6 The last thing I paint are the whiskers—the trickiest part! Tabatha has incredibly long white whiskers that curl in multiple directions, as well as one single white whisker over her left eye. I use a rigger brush and paint a test whisker on a separate piece of paper each time I reload the brush with paint, so I don't get any blobs or too-thick whiskers on the painting. I also add whiskers in her ears and black whiskers at the top of the head. When I'm completely satisfied, I add my signature and the date in a color that stands out but matches the painting. I think she's gorgeous!

Collie *with Kate Tugwell*

This bright-eyed, intelligent-looking dog named Otto is destined to be painted on a large canvas board. I'd been itching to start this project for some time, as I think this photo sums him up well—an outdoor-loving companion who is always eager to play.

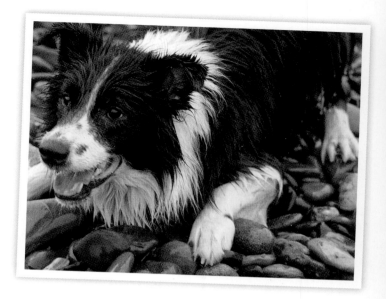

Color Palette

alizarin crimson (hue) • burnt sienna • burnt umber
cadmium red • cadmium yellow • cerulean blue
flesh tint • Mars black • Payne's gray • raw sienna
raw umber • sap green • titanium white
ultramarine blue • yellow ochre
Optional: Texture paste

Step 1 | I start with a sketch to work out the composition and proportions, as well as some of the fur patterns.

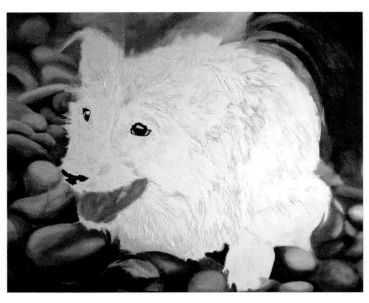

Step 2 I spend a good amount of time sketching out the fur onto the canvas. I establish the eyes, nose, and mouth first, to act as anchor points. I also roughly paint in Mars black at the back of the body. Then I begin painting the pebbles, using earthy colors and immediately conveying their rounded forms.

Step 3 I continue blocking in the pebbles with earth tones. Then I unify all the pebbles by adding some greens. I can adjust these colors and tone them down later on in the process if need be, but this helps establish the basic highlights and shadows.

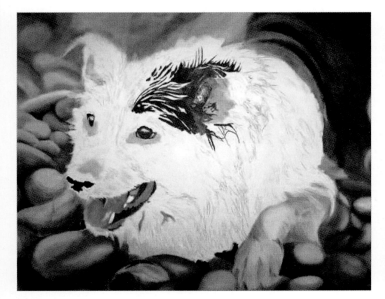

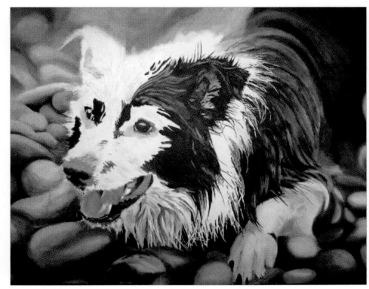

Step 4 To suggest clumped strands of wet hair, I first stroke on texture paste and allow it to dry, which will give the coat coarseness and dimension. Then I start painting the shadows start painting the shadows in Otto's fur and lay down base colors of pinks and browns in the ears, under the eyes, and along the mouth. I also apply another layer of black on the back of Otto's body and use flesh tint and a touch of black on the front paw.

Step 5 Contrary to how I usually paint—starting loose and becoming more detailed—in this project I create layers of detail at the beginning to make it easier in the later stages to navigate the large canvas and the expanse of wet fur. Rather than simply blocking in the colors and shapes, I actually begin painting the black fur, following my sketch.

Artist's Tip

When painting fur, try using texture paste at the beginning to create a raised surface that will add depth to your painting. Texture paste, or modeling paste, comes in tubs and tubes and can be applied with palette knives or brushes, drying to a hard finish overnight.

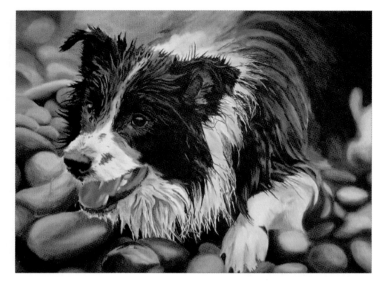

Step 6 I carefully observe the reference photo as I paint the areas of black and gray with a fine brush. I paint the blackest shadow areas first and use diluted Mars black and Payne's gray for the shine on the black areas, gradually working around the face.

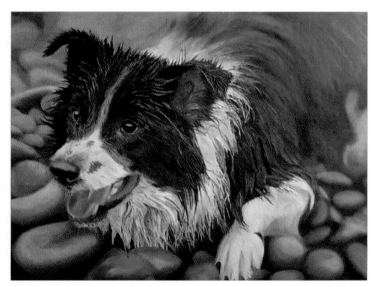

Step 7 I start to embellish the details, add more colors in the coat, and correct the tonal values. Nothing seems to change much at this stage, as the canvas is already covered and the colors are subtle, but it's worth spending time painting glazes of cool blues and warm browns over the black areas to create interesting values. I adjust the tonal values on the pebbles to make them cooler in color and less bright. Then I paint finer detail on Otto's head, using warmer tones to bring him forward.

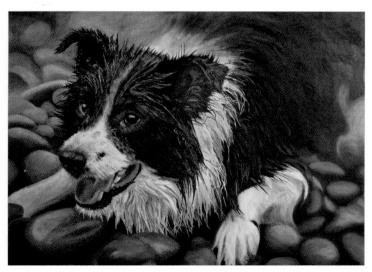

Step 8 After stepping back to view the portrait, I realize Otto looks a little imbalanced. Then I notice his right paw in the reference photo, which looks like a light pebble! Luckily, this is an easy fix. I paint in the paw and scuff white and blue paint over texture paste to enhance the highlights.

Detail

Note how the texture paste makes the fur look wet and course in contrast to the softness of Otto's tongue.

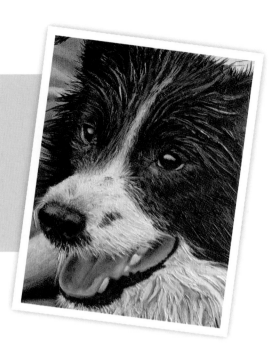

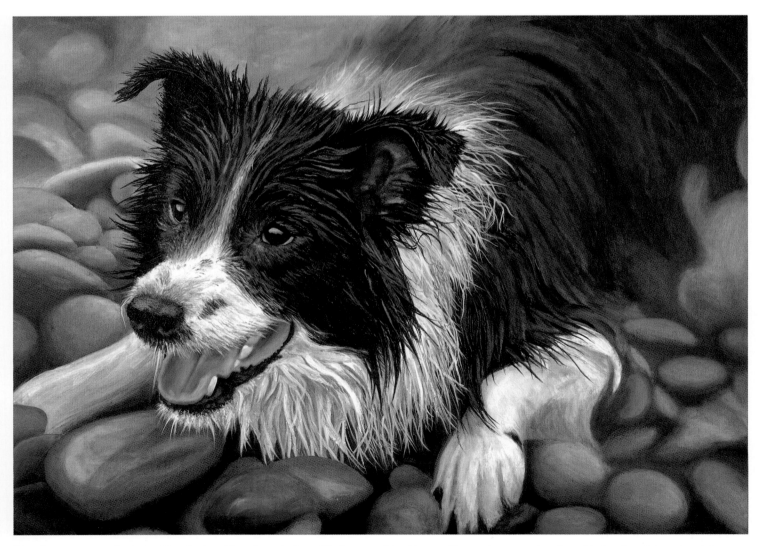

Step 9 In this step, I finish detailing the fur with various shades of black, gray, white, blue, and brown. I use a watercolor sable brush and rigger brush to achieve the long, fine, wavy look of Otto's fur. I also continue to use texture paste to give the fur a shiny, wet appearance. Lastly, I scumble more pinks, reds, purples, and browns onto the mouth for depth, paint the white fur on his muzzle, and add definition to the eyes. Now Otto looks like he's about to leap off the canvas!

West Highland Terrier

with Kate Tugwell

This painting of a west highland terrier named Buttons is going to be a highly detailed head portrait. In this project, I use heavy-body acrylic paint, which allows me to both apply the paint in thick, impasto strokes and dilute it to paint thin glazes.

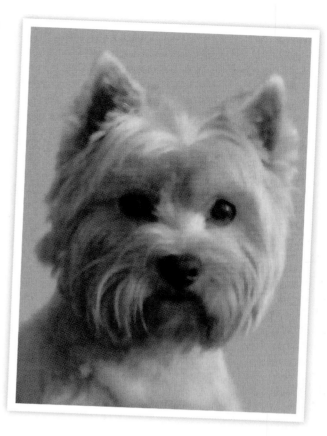

Color Palette

alizarin crimson (hue) • burnt sienna • burnt umber
cadmium red • cadmium yellow • cerulean blue
flesh tint • Mars black • Payne's gray • quinacridone
maroon • raw sienna • raw umber • sap green
titanium white • ultramarine blue • yellow ochre
Optional: Texture paste

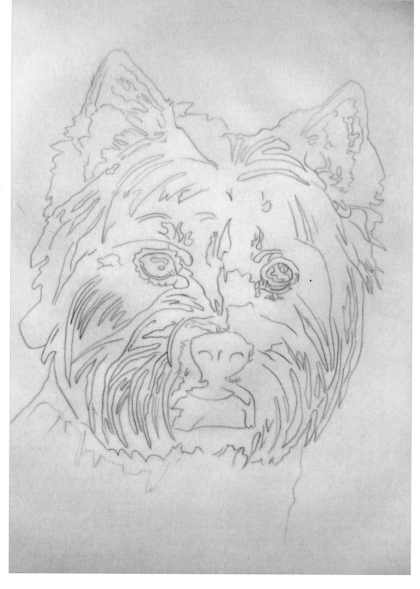

Step 1 I start by sketching Button's features onto canvas board. You can do this in pencil or paint, depending on how comfortable you are with the subject. For demonstration purposes, this sketch is much more detailed than I would normally begin with, so you can adjust your own sketch according to your needs. Feel free to be as basic or as detailed as you'd like.

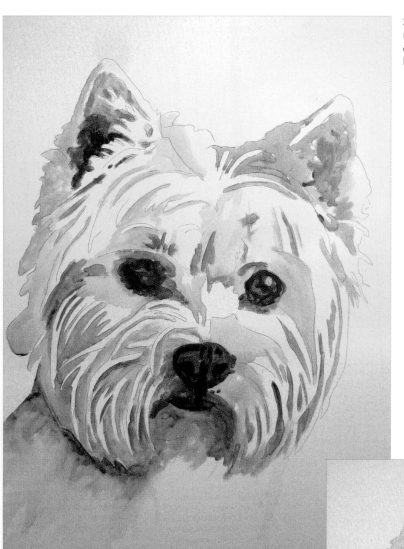

Step 2 I create a rough tonal underpainting to block in areas of shadow using Mars black, burnt umber, and cadmium red.

Step 3 Next I add texture paste to the fur to create highlights by raising the lighter areas.

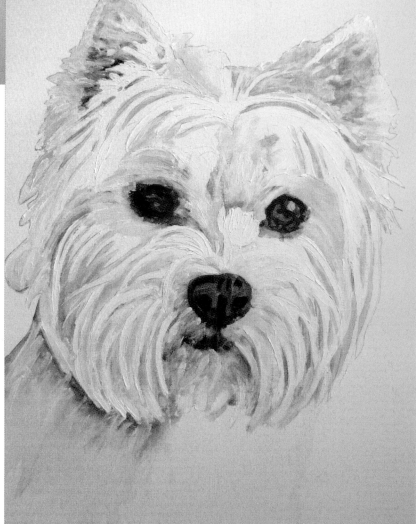

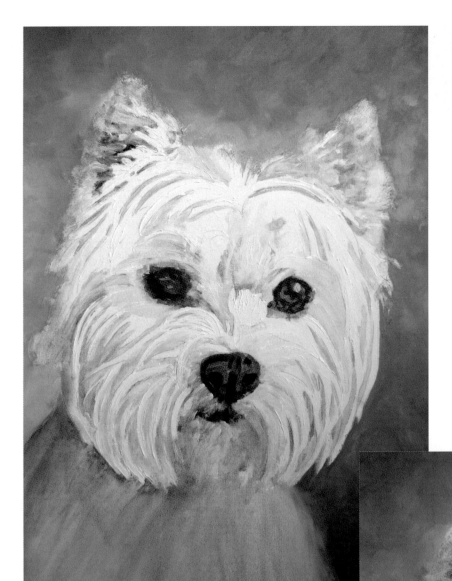

◀ **Step 4** To enhance the shape of the dog's head, I apply a strong background color, using alizarin crimson. I use a wide, hog-hair flat brush to cover the large background areas, and I paint with a crisscross motion.

▶ **Step 5** I begin adding shadows to create depth, using hues of yellow, orange, brown, purple, blue, and even green in the fur. I use a variety of round nylon brushes and keep the paint quite thin to create glazes.

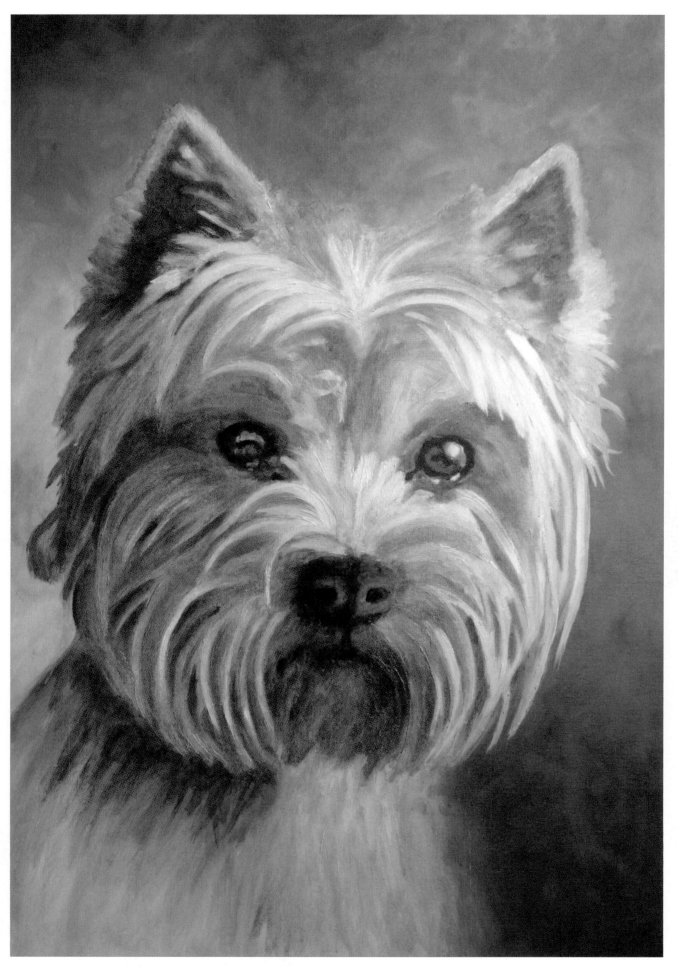

Step 6 Next I add more depth and texture to the background. Then I add grays, reds, and browns on the shadow side of the face. The texture paste I applied in step 3 guides me to see where to paint the shadows. I work on painting fine details and creating subtle shifts in the shadows. At this stage in the painting process, new layers of paint appear subtle. Continue to persevere in building up glazes to achieve the desired depth.

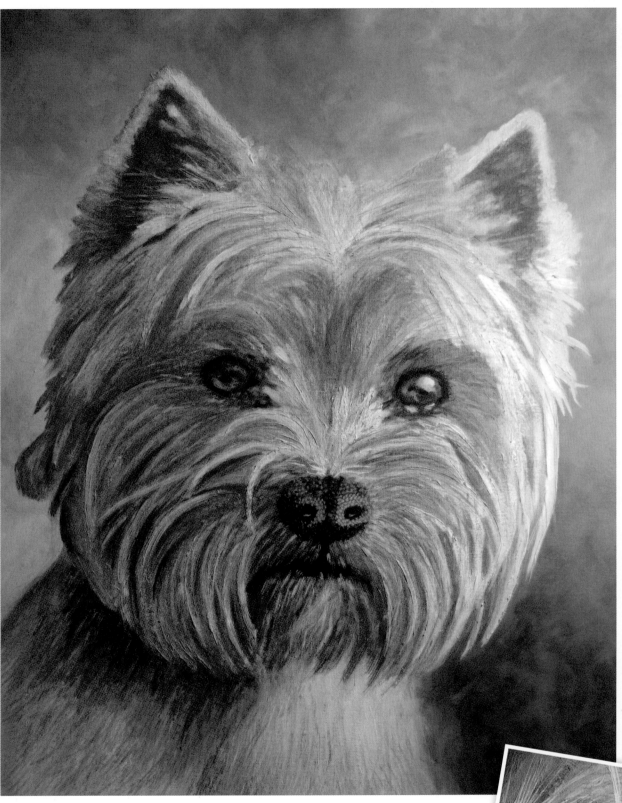

Detail

I use a few brown mixes to paint the iris, making it darkest at the lower corner and the upper edge that is shadowed by the brow. I use a little black for the pupil and the rim of the eye. Once everything is dry, I finish with a white highlight.

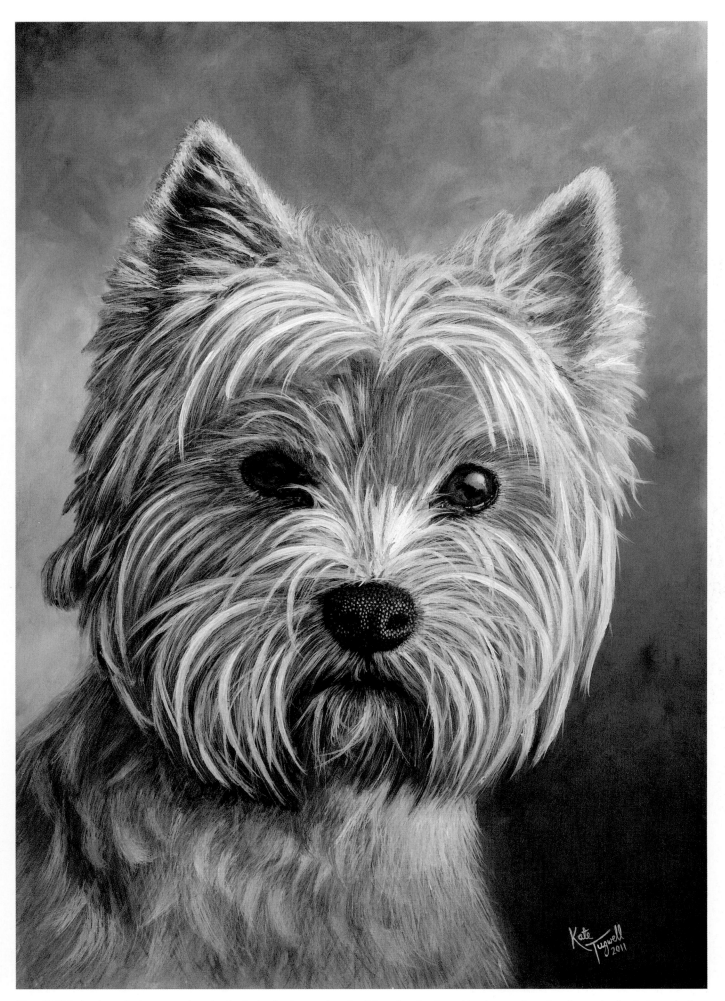

Step 8 With the deep shadows complete, I paint in the fur that catches the light using titanium white. I use a rigger brush to paint fine hairs and a fan brush on the chest where I want to cover the area with more than just one hair at a time!

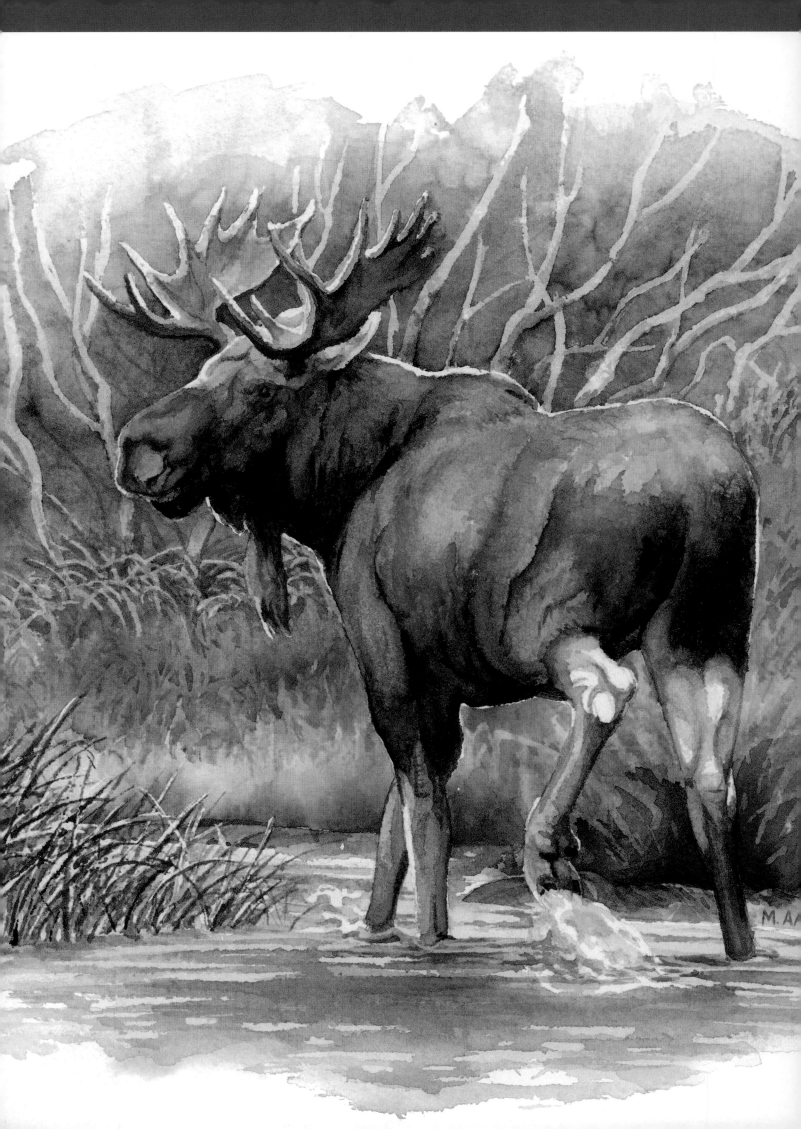

Painting Animals in Watercolor

with Deb Watson & Maury Aaseng

The airy and atmospheric qualities of watercolor set it apart from all other painting media. Its ability to quickly capture an essence, suggesting form and color with just a few brushstrokes, is just one of the many reasons that make this medium so special and unique. In this chapter, Deb Watson and Maury Aaseng will introduce you to this ethereal medium and how to use it to paint lifelike animals.

Appaloosa Colt *with Deb Watson*

The outline of a horse can show its age and breed—like the long-legged form of this colt. The color of the horse, with highlights and shadows, is what brings that outline to life. Building up color and value step by step is an easy way to paint beautiful, realistic horses.

Color Palette
burnt sienna • cerulean blue • lemon yellow
raw sienna • ultramarine blue

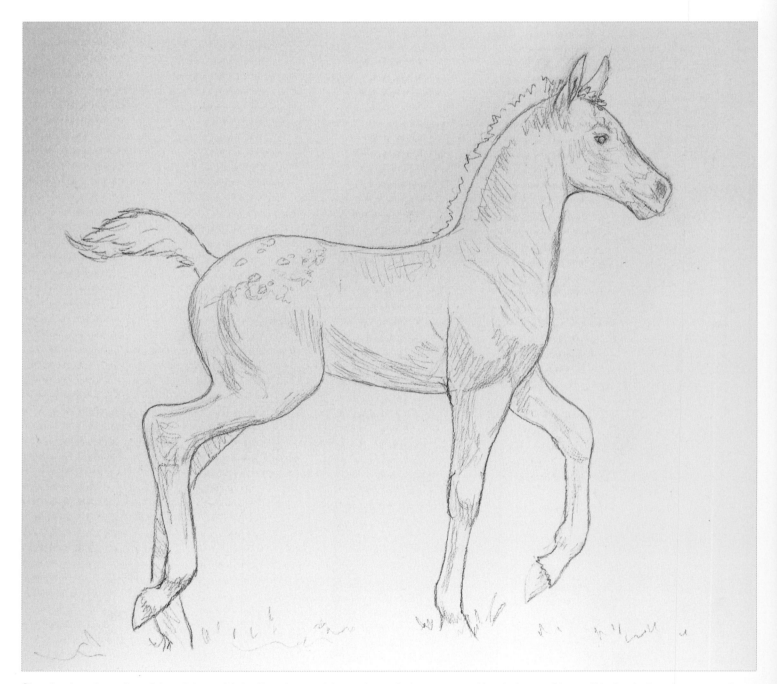

Step 1 I draw the outline of the colt in careful detail, paying special attention to the eyes, ears, and head. Then I softly pencil in the shadowed areas to make an easy-to-follow guide when painting. The layers of paint will cover the pencil lines in the finished painting. I mix the following puddles of color: brown (burnt sienna + raw sienna), black (burnt sienna + ultramarine blue), and green (cerulean blue + yellow).

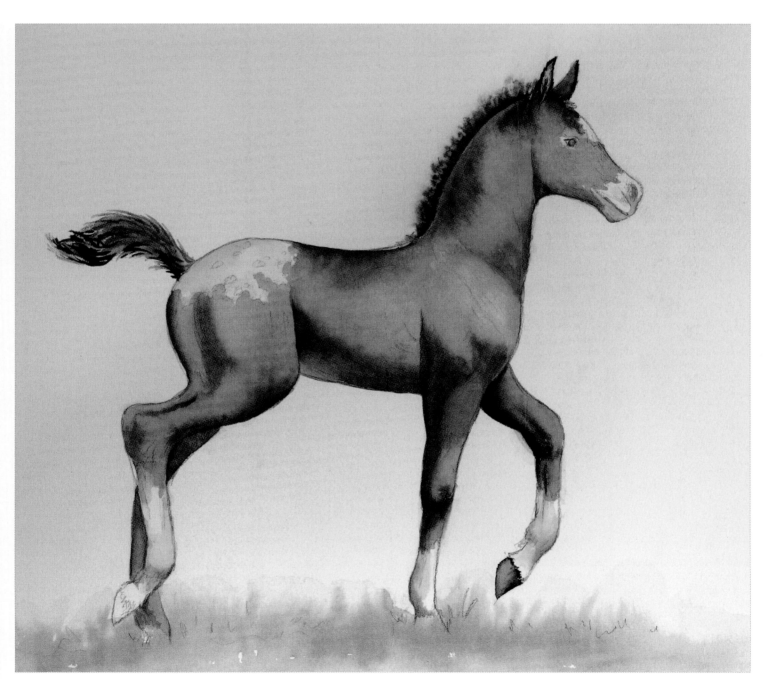

Step 2 I paint a light wash of brown over the colt for the base coat of color, leaving the white socks, star, muzzle, and rump unpainted. I paint the mane and tail black. While that dries, I wet the bottom of the paper and paint a light wash of green grass wet-into-wet. With the colt's shape and color established, I am ready to begin painting the shadows. I paint one shadowed area at a time, using brown for the brown areas and gray (black + water) for the shadows on the white areas. I paint the eye, nostril, hooves, and line of the mouth with black or gray.

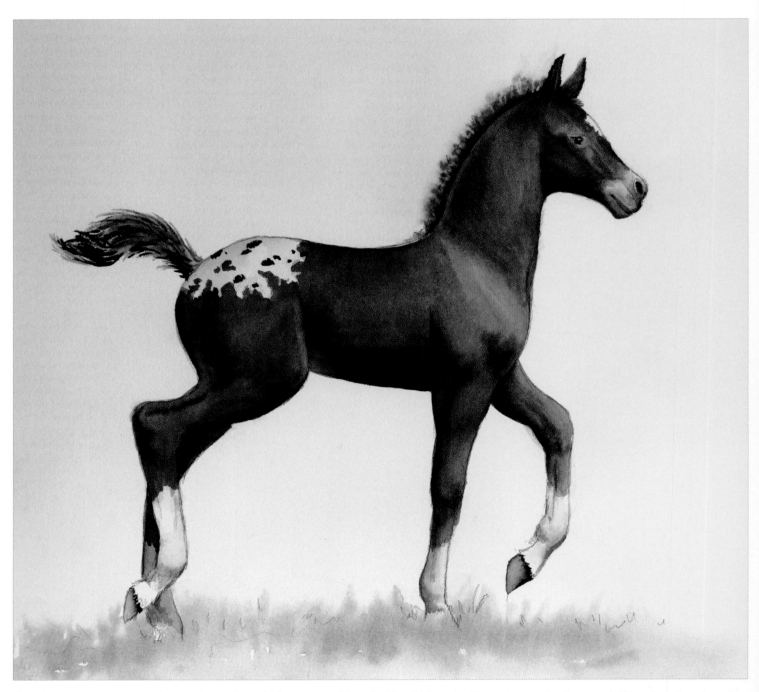

Step 3 Once the shadows are dry, I wash over the entire brown area of the colt with a thicker mix of brown (more paint, less water). This softens the edges of the dark shadows to blend and unify the colt's coat. I also paint the appaloosa spots with this brown mix. When the unifying wash is dry, I make adjustments to the value as needed. I then darken shadows that dried too light or lighten areas that seem too dark by rewetting and lifting up the color with a paper towel. I allow this to dry and paint another brown wash to build up the rich brown color of a real colt. Then I let the paint dry completely.

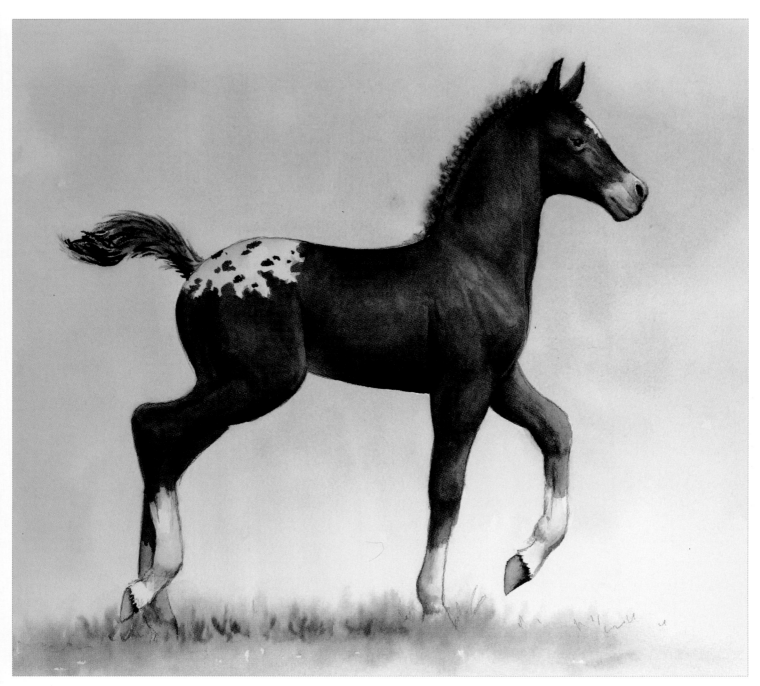

Step 4 I wet the paper around the colt and drop in cerulean blue. I let the blue spread on the paper for a soft, atmospheric look and let it dry. I mix a dark green with ultramarine blue and yellow, wet the bottom of the paper, and paint dark green under the colt to suggest his shadow in the grass. By just suggesting a background, I include a sense of reality for the colt, while leaving him the star of the painting. Just as a young horse often looks awkward at different stages of growth, a painting may look awkward at some stages of completion. Don't hesitate in your process. Paint the colt step by step and enjoy the beautiful, realistic results.

Rooster *with Deb Watson*

Roosters come in a wild variety of shapes and colors—all fun to paint! Whether you're a complete beginner or a practiced professional, roosters are the perfect subject for a great painting. The body language of roosters is much like humans, and capturing an attitude can add great interest to your painting.

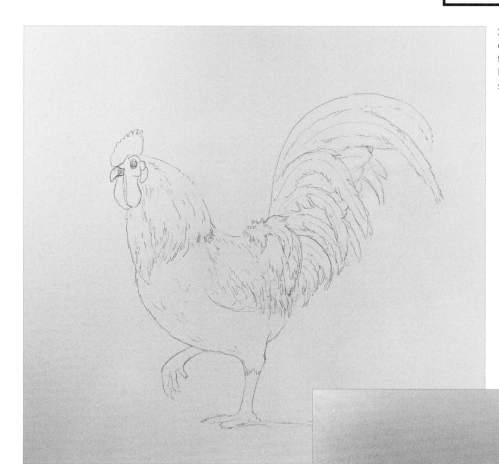

Step 1 I create a basic sketch of my subject, being careful to capture the position of the head and tail feathers that show off its haughty walk.

Step 2 I wet the area around the rooster and drop in some well-diluted color to tone down the white of the paper. I drop cerulean blue at the top, green (cerulean + yellow) around the rooster, and raw sienna at the bottom. I tilt the board to let the colors mix on the paper and let it dry completely.

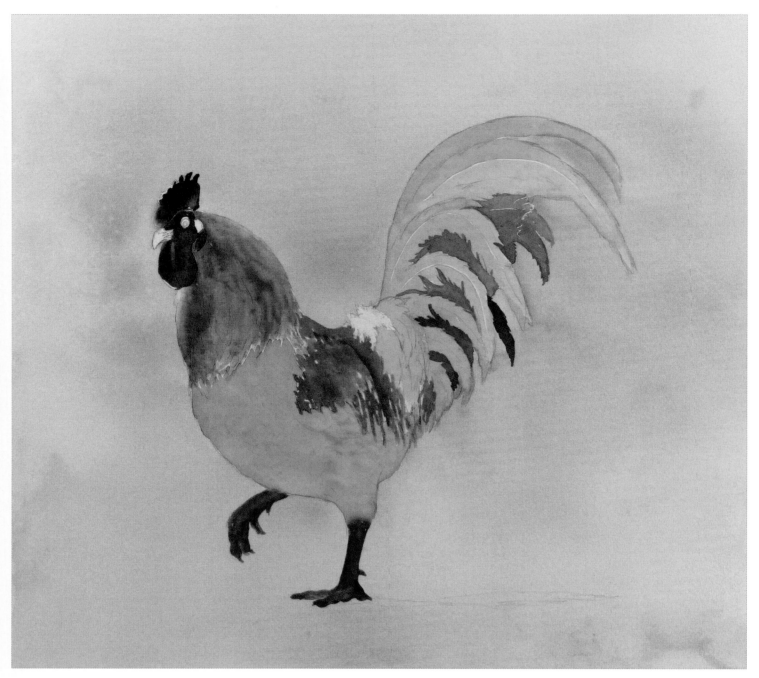

Step 3 I put a base wash of color over all parts of the rooster: alizarin crimson on the comb and face, raw sienna on the neck feathers, a thin wash of phthalo blue and raw umber violet on the body and tail feathers, a mixture of raw sienna and raw umber violet on the legs, and burnt sienna on the back feathers. I mix a big puddle of thick, dark phthalo blue and raw umber violet for the areas behind the front tail feathers.

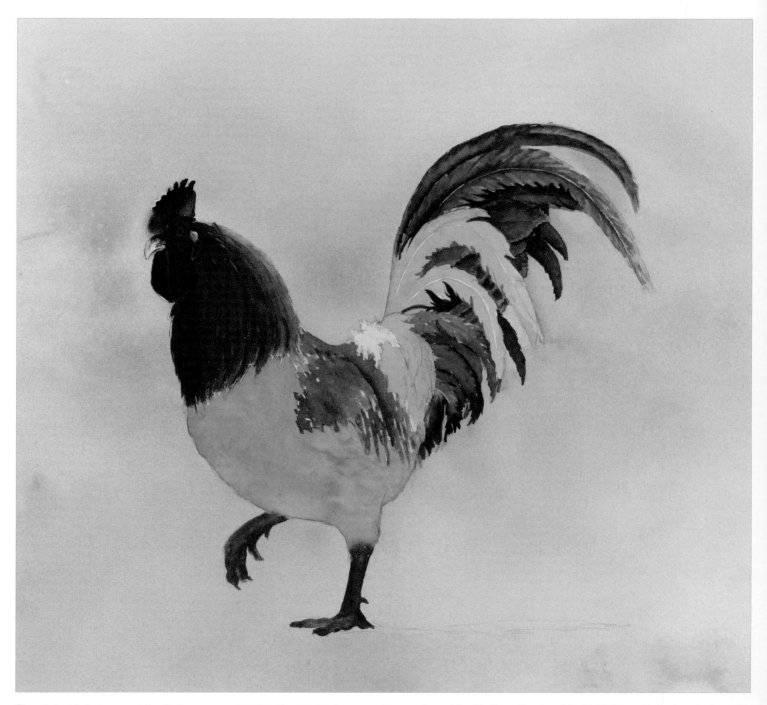

Step 4 I add shadows and details for a sense of reality. Then I paint the rooster's eye yellow with a black pupil and a white highlight. I add shadows in the red areas with red plus the dark blue feather mix. I deepen the color on the neck feathers with more raw sienna and short strokes of burnt sienna and add shadow to the neck with burnt sienna and dark blue. The tail feathers are a rooster's pride and deserve careful attention. I paint each feather, keeping the ones in the very front light in value and adding cerulean blue on the light feathers to give them a glossy shine.

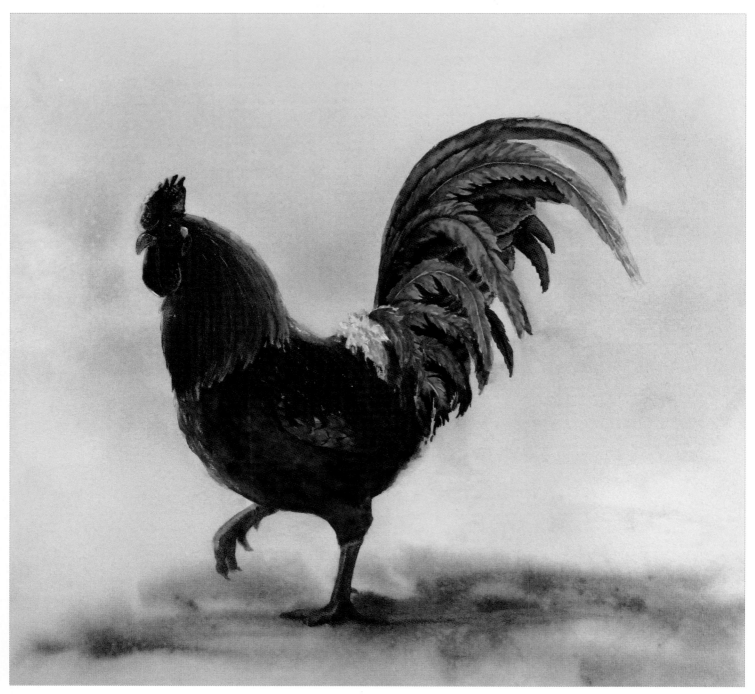

Step 5 I paint the body of the rooster with the dark mix, leaving the wing slightly lighter. I paint the back feathers with thick burnt sienna with raw umber violet dotted in wet-into-wet for a mottled look. I rewet the bottom quarter of the paper around the bird and add a couple of quick strokes of raw sienna. As the paper starts to dry, I add a shadow under the rooster with the dark mix and then spatter on some of the dark mix by tapping the brush with my finger. Whether your rooster is a study in perfect detail or made with wild washes of color, capturing the attitude of your bird will yield a successful painting.

Lamb *with Deb Watson*

Soft, white lambs are defined by their surrounding colors—a robin's egg blue sky, spring green grass, and yellow buttercups. The deeper the surrounding color, the whiter the lamb seems. Add shadows to give the lamb form and soft round doodles for the fleece, and your lamb will be irresistible.

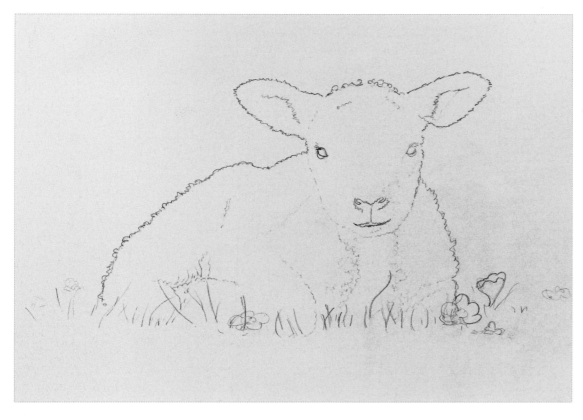

◀ **Step 1** I draw the outline of the lamb, careful to get the eyes, nose, and mouth in the correct positions. I look closely at the pattern of hair and wool. Short, curly wool covers from the top of the lamb's head to the top of its legs, while the face, ears, legs, and chest have silky, straight white hair.

▶ **Step 2** I paint the edges of the lamb with liquid masking, making sure that the outside edge of the masking follows the hair or wool pattern. I plan three areas of buttercups and mask their forms as well.

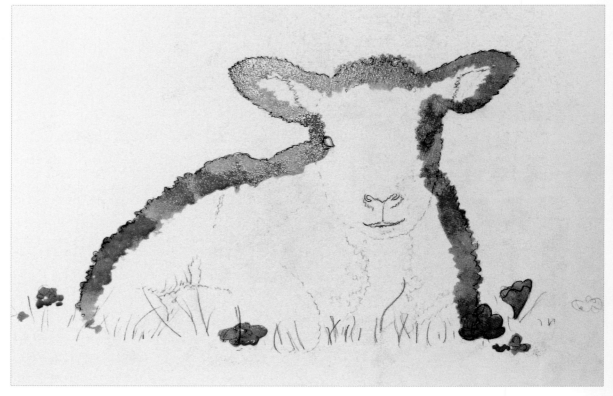

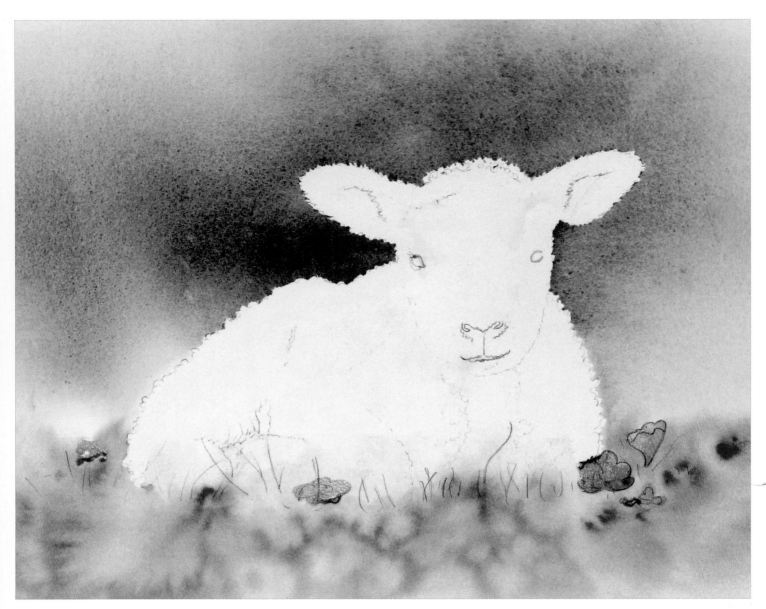

Step 3 I wet the paper so it is evenly damp but not dripping. I mix a large amount of cobalt blue with lots of paint and only a little water, making sure there are no chunks of paint in the mix. I drop the blue onto the wet paper around the top of the lamb and tilt the paper to spread the wash out. I mix cobalt, phthalo blue, and lemon yellow with plenty of water to make a light, spring green. I paint the green onto the bottom quarter of the paper and add a few dashes of yellow to suggest flowers. Once the washes are dry, I rub the masking off the lamb and redraw any lines the masking lifts up.

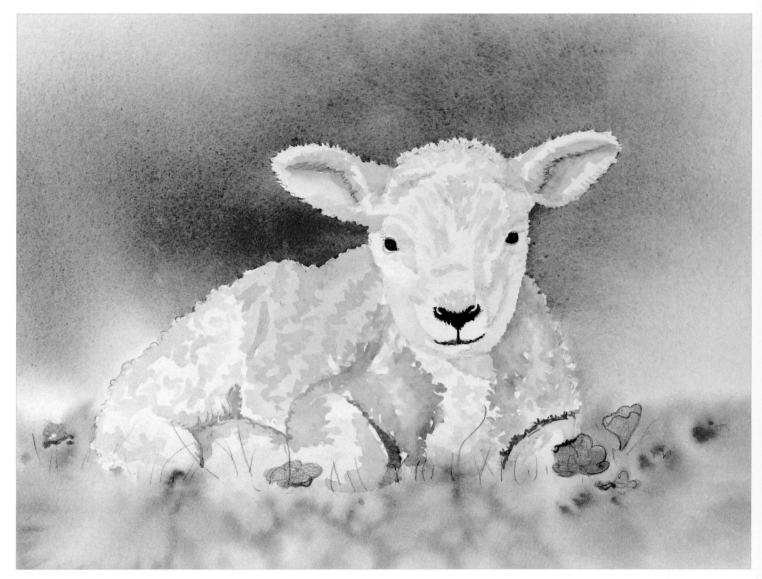

Step 4 I mix lemon yellow, permanent rose, and cobalt blue to create different shades of gray—blue gray, purple gray, etc. I paint the main shadowed areas on the lamb with the gray mixes. I mix permanent rose with a little yellow for the inside of the ears, making it darker just under the top edge of the ear and lighter toward the bottom. I mix phthalo blue, permanent rose, and a little yellow for a warm black (using mostly paint and very little water) to paint the eyes, nose, and mouth line.

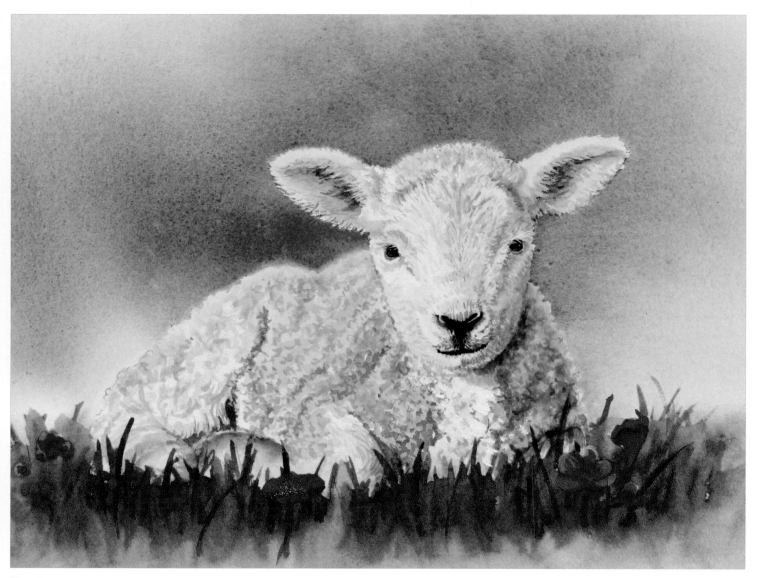

Step 5 I continue building up shadows in the wool and the hair using the gray mixes. To finish the eyes, I paint the pink and yellow ear mix from step 4 in a semicircle under the eyes. I rewet the outside edge of the eyes and dab with a paper towel to lift up a bit of shine and use white paint to add eyelashes. I rewet the outside edges of the back and ears and then dab with a paper towel to soften. I paint the grass area with a light mix of green from step 2 and then add a few darker, individual blades of grass on top. I remove the masking from the buttercups and add more yellow to the pink and yellow mix to paint them. Then I add the green centers. With a baby lamb and buttercups, you can almost smell spring!

Moose *with Maury Aaseng*

The moose is one of my favorite animals. It may seem ungainly with its oversized nose and stilt-like legs, but I find it to be genuinely impressive. I wanted to take my own photographs of a bull moose, and I was delighted to photograph this majestic animal in the wild as it walked along the edge of a lake in Isle Royale National Park.

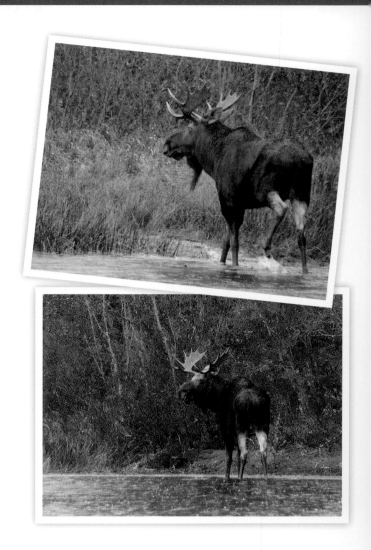

Color Palette
alizarin crimson • burnt sienna • burnt umber
cerulean blue • Hooker's green • Prussian blue
purple lake • raw sienna • sap green • sepia
ultramarine blue • yellow ochre

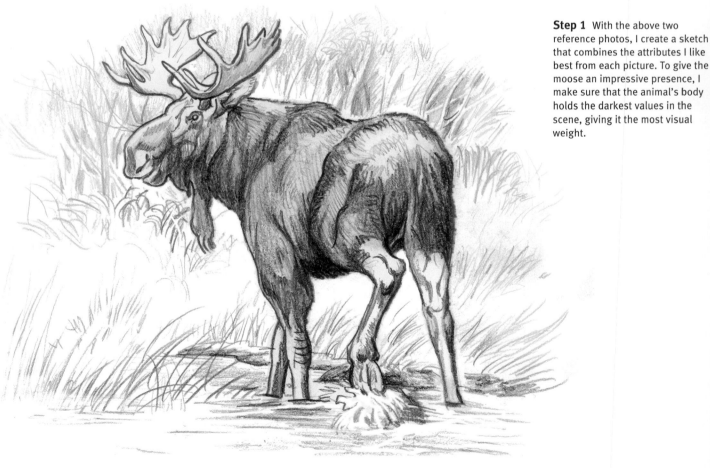

Step 1 With the above two reference photos, I create a sketch that combines the attributes I like best from each picture. To give the moose an impressive presence, I make sure that the animal's body holds the darkest values in the scene, giving it the most visual weight.

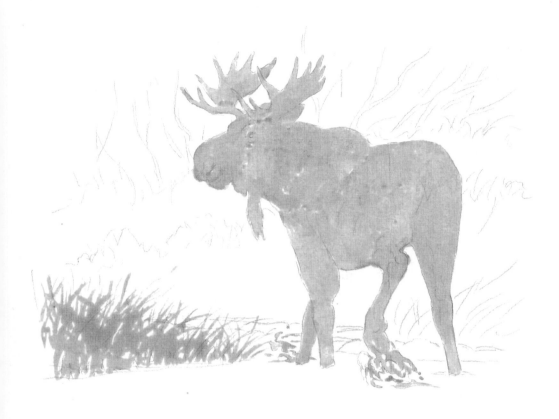

Step 2 I use a light table to trace the outline of my moose onto watercolor paper, pressing lightly. After taping the paper to my art board, I use an old brush to apply masking fluid over the moose and the splash of water around its feet. I use a palette knife to apply finer lines of masking fluid over the grass blades in the water; then I set it aside to dry.

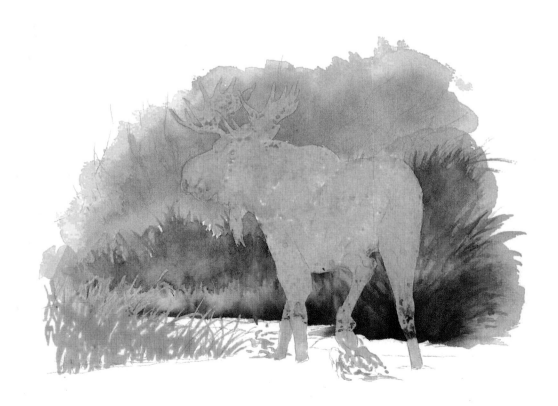

Step 3 With a large flat brush, I wet the shoreline area behind the moose with water. Then I apply a mixture of sap green and burnt umber to the wet paper, along the bottom edge of the shoreline. I tilt my art board upside down to allow the pigment to flow upward into the grass. I add burnt sienna and yellow ochre to the middle layer of the grass, Hooker's green along the top, and a patch of burnt umber to the bottom-right edge. Once dry, I load a large brush with a watered-down mixture of Prussian blue and burnt umber to paint an irregular-shaped, wet-on-dry wash above the grassline.

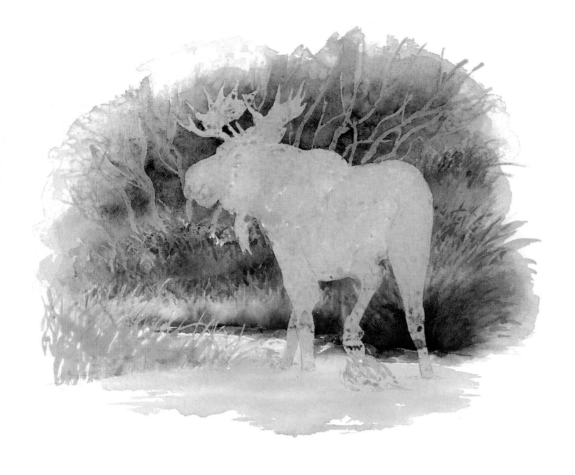

Step 4 I use my palette knife to apply masking fluid in curved lines along the back edge of the shoreline, as well as lines that will later become the trunks of small trees. Once dry, I wet the background around the tree trunks and add a more concentrated wash of Prussian blue and burnt umber. I also lightly wet some of the area in the grass below and dull the color with burnt sienna. I paint the water beneath the moose by applying a light mix of cerulean blue with purple lake. While still wet, I add more purple to the middle of the wash and diluted yellow ochre to the edges for warmth.

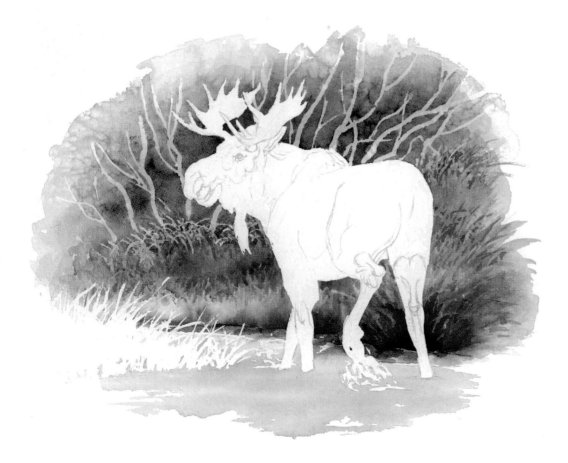

Step 5 Once my paper is completely dry, I use a rubber eraser to remove the masking fluid from the painting. The white paper is now exposed within the moose and foreground grass. I use a pencil to lightly sketch some details in the moose. To add a little more contrast, I use a small brush to sweep in some Prussian blue grass just above the line of grass at left.

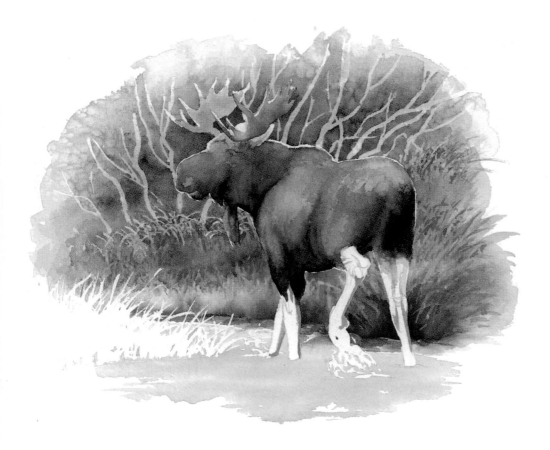

Step 6 Now I'm ready to add the moose's base color. For the antlers and forehead, I mix yellow ochre with raw sienna. For the body, I make two mixtures: one of alizarin crimson, burnt sienna, and a touch of sepia, and the other of ultramarine blue and sepia. I use a round brush to sweep water over the animal's shape. Then, working from the antlers toward the rump, I add the mixtures and allow them to mix with each other. Once this wash is partially dry, I add more layers of value to the moose's fur, including dark tones under the neck and belly and a wash of burnt sienna to the neck for warmth. Finally, I brush in some of the ultramarine and sepia mix along the backs of the legs to serve as a marker for shading in the steps to come.

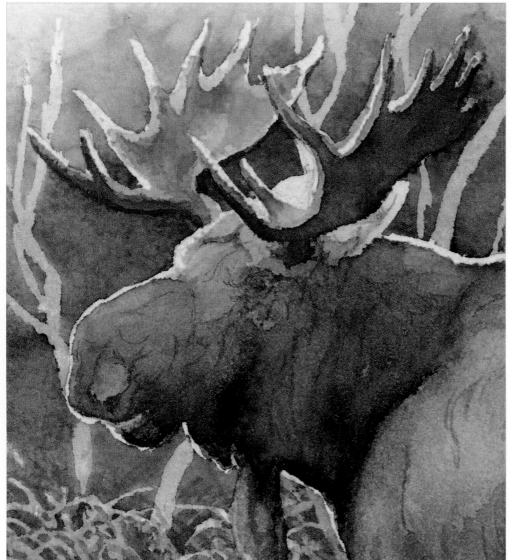

Artist's Tip

I add light sketch lines to the face again, as the paint has covered most of it up. This provides a map for applying details in the next step.

Step 7 I paint burnt sienna lightly over the dark areas of the antlers. I dilute the mixture and paint a lighter wash on the inside of the left antler, again leaving some areas of the lighter color to peek through. While both antlers are still wet from the burnt sienna, I mix in some ultramarine blue to create some cool spots. I dab in some blue along the bottom edge of the antlers, and let the color spread into the wet brown paint to create some subtle color changes. I also dab this blue into the dark brown areas of the antler tips, and again I allow these darks to flow into the rest of the antler.

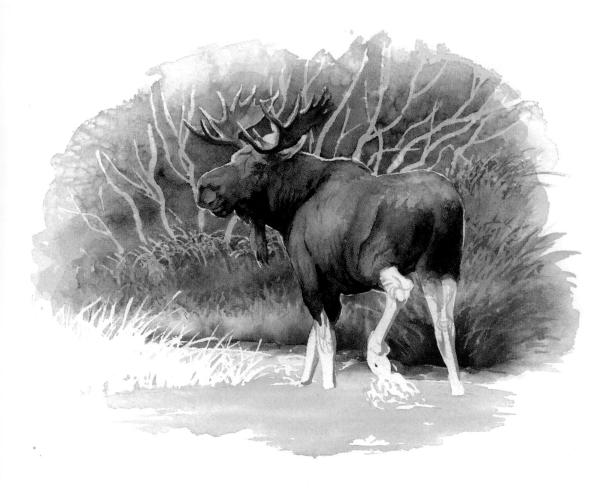

Step 8 I now focus on adding details to the body and antlers. I use the same color mixtures I've been using, but now I use more pigment and less water to make the values darker. To complete the antlers, I continue using a mixture of mostly burnt sienna and some ultramarine blue to add dark shadows to the tines and the undersides of the antlers. For the rest of the moose, I use less watered-down colors for the details. I establish where the dark "edge" is on each feature, and then I use water to fade the color away from the darkest area. This provides a natural shadow gradient. I do this most notably along the snout, under the neck and chin, and along the muscles in the raised back leg.

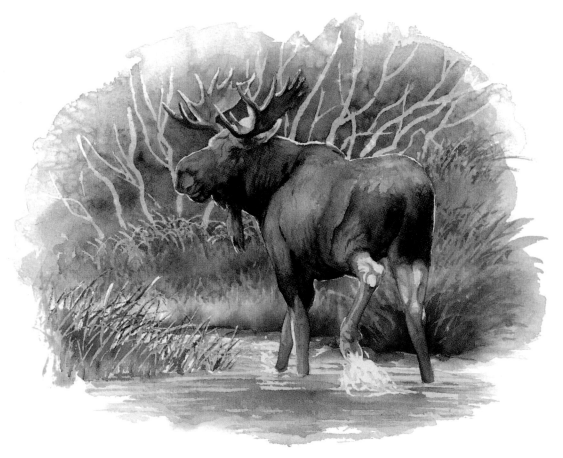

Step 9 I use my palette knife to apply masking fluid in sporadic, curved strokes to suggest grass in the white of the foreground. I also use it to mask out horizontal lines in the water below the moose to preserve some highlights. Once dry, I use Prussian blue to create the abstract reflection of the moose in the water. While still wet, I add colors from the moose body in horizontal swipes, keeping the darkest colors close to the actual legs. I warm up the water by adding yellow ochre to the edges, allowing the colors to intermingle. Now I coat the foreground with yellow ochre, adding burnt sienna along the top and Hooker's green along the bottom. Using a warm gray made of burnt sienna and cerulean blue, I add shadows to the legs.

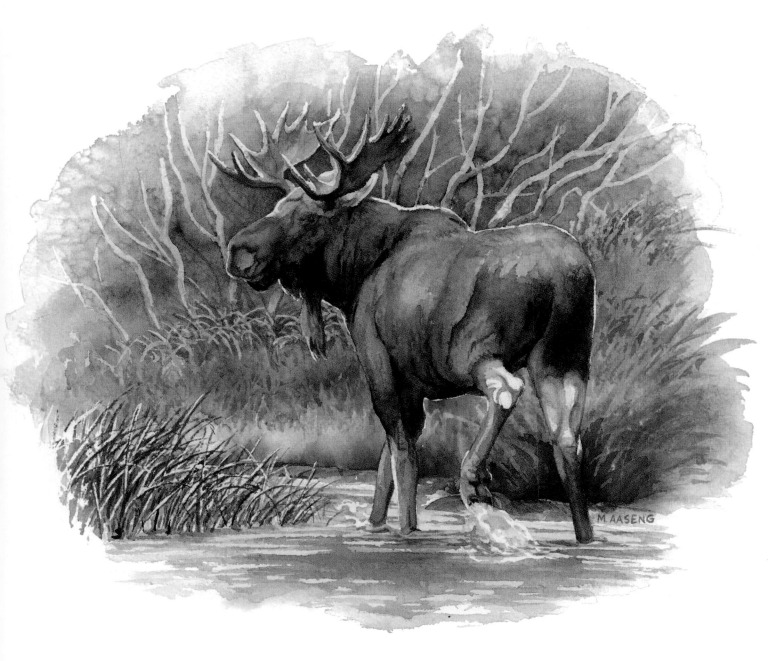

Step 10 I remove the masking fluid from the water and grass. To visually balance the foreground grass with the weight of the moose, I use my palette knife to apply dark arches of brown and green. Behind the grass, I use a liner brush and diluted blue-gray to create fine tree branches. I use this same color to fill in the white tree trunks, which pushes them into the distance. I add dark strokes of purples and crimsons to enhance the moose's reflection. For the final touches, I look over the entire piece to hunt for areas that need further darkening. I also lighten some areas by adding water and using a paper towel to soak up pigment.

Lynx *with Maury Aaseng*

Unless you are among the extremely lucky or live in a very remote area, you are unlikely to ever take a photograph of a lynx in the wild. But with artistic license, you can turn a photograph of a lynx from a zoo into a watercolor rendering of a wild lynx roaming the northern reaches of the globe. Using a variety of textures in your background can help create a scene that looks natural but still stands apart from the patterns used to create the elusive animal itself.

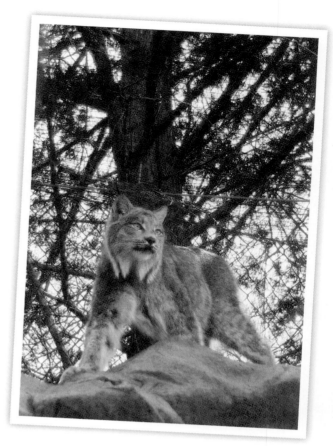

Color Palette
burnt sienna • burnt umber • cerulean blue
cobalt blue • Hooker's green • permanent rose
phthalo blue • Prussian blue • purple lake
raw sienna • sepia • yellow ochre
ultramarine blue
Additional: white gouache

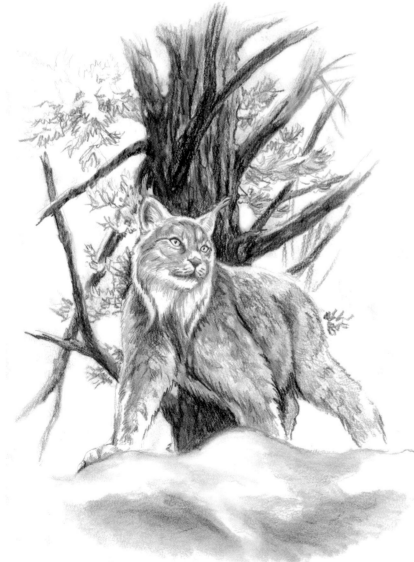

Step 1 First I make a preliminary sketch to establish my values and gain some familiarity with my subject. From my sketch, I've established that I want the foliage on the pine tree to be the lightest value in my painting and the tree trunk to be the darkest. Against this dark shape, the cat will take center stage.

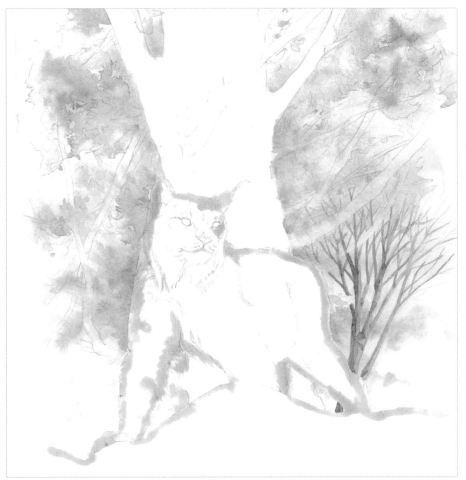

Step 2 I begin by lightly sketching the outlines and basic details. I add masking fluid around the lynx and along the top of the rock ledge to preserve the white of the paper. Then I apply cerulean blue to the wet paper by the tree and pull it out toward the edges, varying my strokes. While still wet, I use a flat brush to add a thin wash of Hooker's green over the pine boughs. Once dry, I use a small round brush and a mix of cerulean blue and sepia to create a simple, leafless tree.

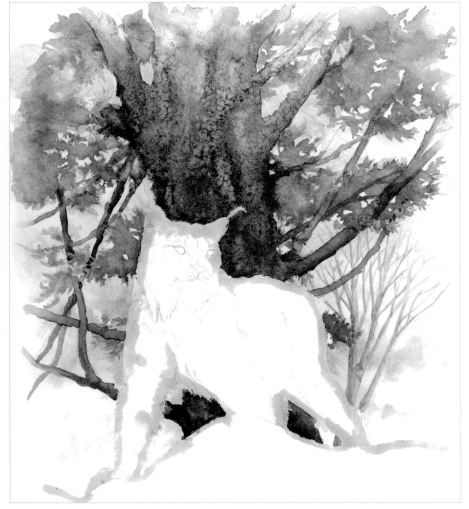

Step 3 Using a small flat brush, I apply a mix of cobalt blue and Hooker's green. I dab and twist the brush to create varying edges and contours. While still wet, I add yellow ochre to areas of the foliage. Once dry, I wet the tree trunk and branches and then use a large round brush to add combinations of burnt umber and Prussian blue. As I allow these colors to flow together on the paper, I add purple lake to enrich areas of the bark. While still wet, I sprinkle salt on the tree to create interesting texture patterns. Note that I add more salt to the upper trunk.

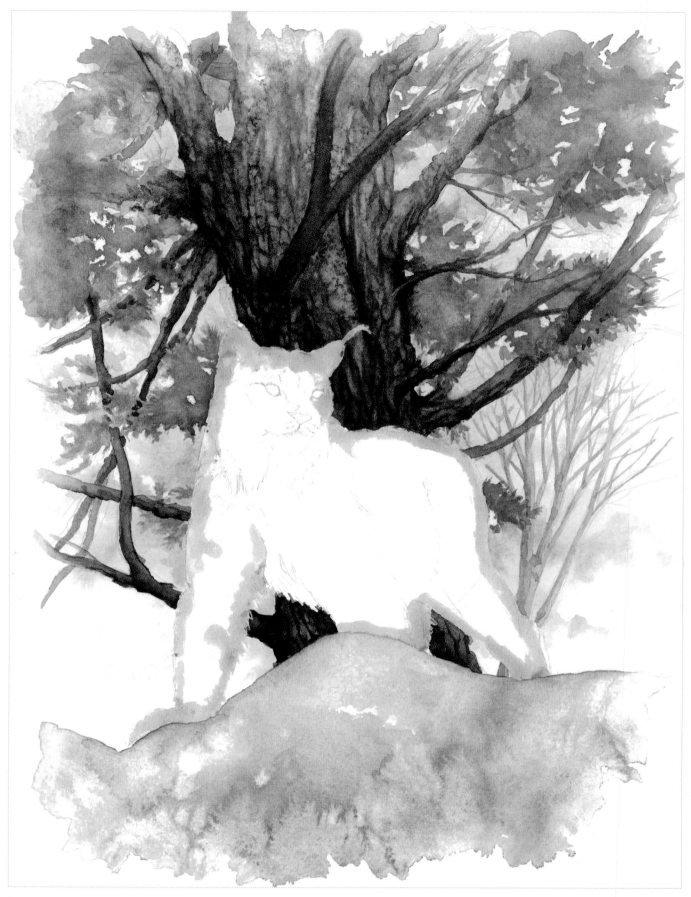

Step 4 Next I add detail to the pine's bark, adding cracks of shadow using a thick mixture of burnt umber and Prussian blue. Once I've established the texture, I create puddles of watered-down purple lake, burnt umber, and Prussian blue and add color and value to areas of the bark between the cracks. I add most of the detail work on the left side of the tree and areas around the lynx silhouette. Next I work wet-into-wet over the rocks, removing the masking fluid and brushing clean water over the edges. I mix a subtle warm gray using ultramarine blue and yellow ochre; then I apply it more heavily in some areas to suggest volume. While still wet, I add ultramarine blue below the lynx and along the bottom of the wash, letting it bleed into the wet background.

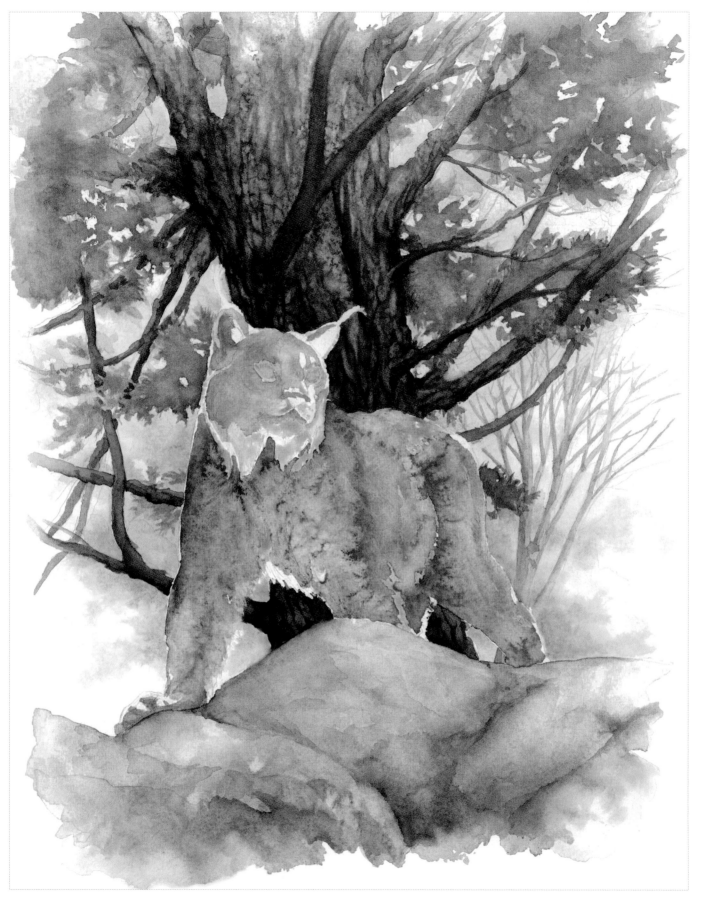

Step 5 To finish the rocks, I continue working wet-into-wet, deepening the dark areas and allowing more colors to blend on the paper. I don't worry about replicating the rocks as they appear in the photo; my aim is simply to form natural-looking fissures and textures. Moving on to the lynx, I first rub off the masking fluid and then apply masking fluid again to areas on the right edges of the legs, the eyes, the white muzzle, the edges of the ears, and the top of the rump. Once dry, I wet the lynx and add a wet-into-wet wash of raw sienna over the body. While still wet, I mix raw sienna with permanent rose and burnt umber and add it to shadows within the lynx. I allow the colors to blend together, giving the undercoat some complex light shades. Finally, I sprinkle salt over my wash and let patterns in the fur emerge.

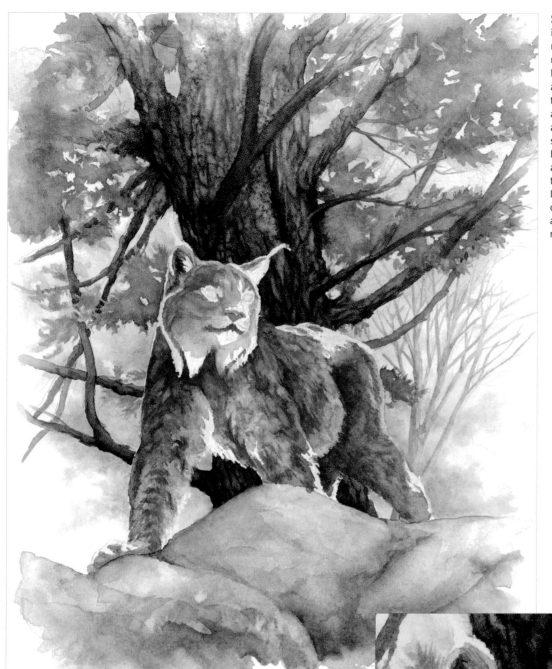

Step 6 In this step, I map out patterns in the fur. First I create a mix of burnt umber, permanent rose, and a bit of ultramarine blue. For the darker areas, I use more burnt umber; for the lighter areas, I use more permanent rose. To give the fur more volume, I add yellow ochre alongside the dark patches of fur. Now I address the fur on the cat's face, which is smoother than the thick coat of the body. I use more burnt umber in the mouth and a mixture with more permanent rose in the nose, adding yellow ochre highlights. I save the deepest darks for the inside of the right ear, below the cheek fur, and between the back legs. Once dry, I remove the masking fluid.

Step 7 I look for areas of shadow and highlight on the face. For the shadows, I layer burnt sienna and ultramarine blue; for areas of warmth, such as the insides of the ears, I add touches of permanent rose. To create the bottom jaw, I draw a thin, dark line of burnt umber and soften the color as it blends into the chin. I add a ring of ultramarine blue around the eyes and dab in some burnt umber to darken the top edges of the eye rings. For the nose, I use burnt sienna and ultramarine blue. Finally, I add ultramarine blue to the bottom of the cheek fur, diluting it with water as I work toward the face.

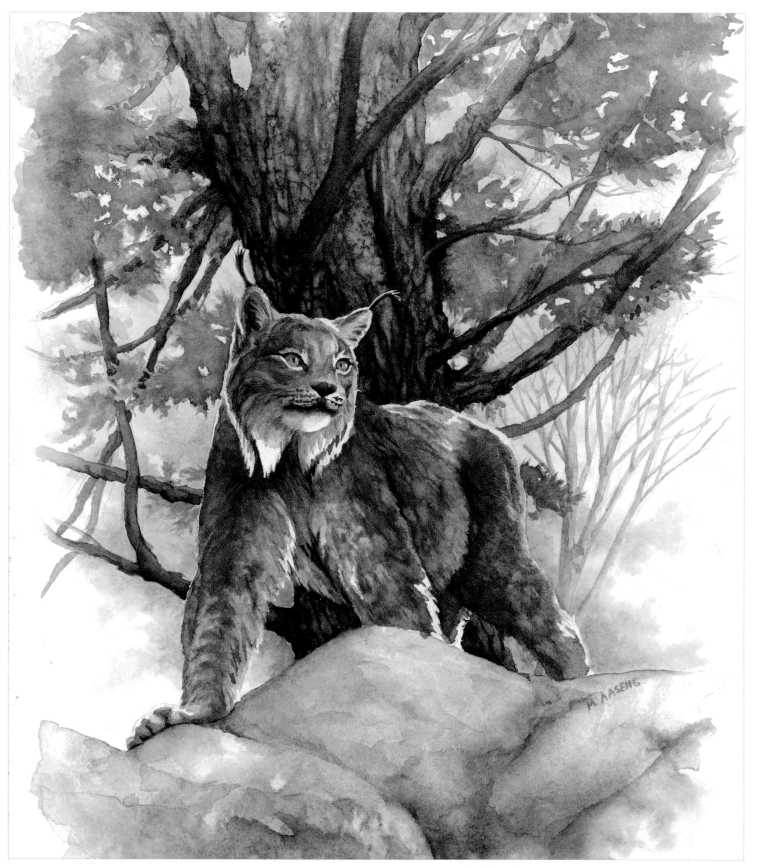

Step 8 To cool and darken areas of the lynx, I use a wet round brush to apply a blue-gray combination of ultramarine blue and phthalo blue with yellow ochre. The blue, purple, and brown combinations create deep shadows. Note that I always stroke in the direction of the fur growth. Next I mix dark purple using purple lake and ultramarine blue, which I use to paint the iconic ear tufts. I also add the deep purple to the whiskered dark spots on the muzzle and within the cheek fur. Then I outline the eyes with ultramarine blue and fill in the eyeballs with a light wash of transparent yellow. I add a thin layer of phthalo blue to the top right of each eye, followed by burnt umber for the pupils and a dab of white gouache for the highlight.

Sea Turtles *with Maury Aaseng*

The sea turtle is one of the most universally adored reptiles on the planet. Its graceful movements and tropical habitat make for a serene composition. To create this watercolor, I use two photographs for reference. In one photo, the turtle is closer to the viewer and its colorful scales are easily seen. The other photo shows a turtle farther from the viewer (in an aquarium), making it a good background sea turtle.

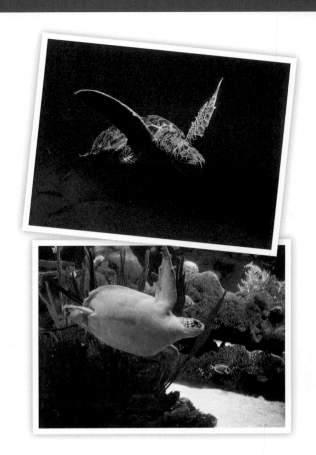

Color Palette
Antwerp blue • Antwerp green • burnt sienna
burnt umber • cadmium yellow • permanent rose
phthalo green • raw sienna • sepia • ultramarine blue
yellow ochre

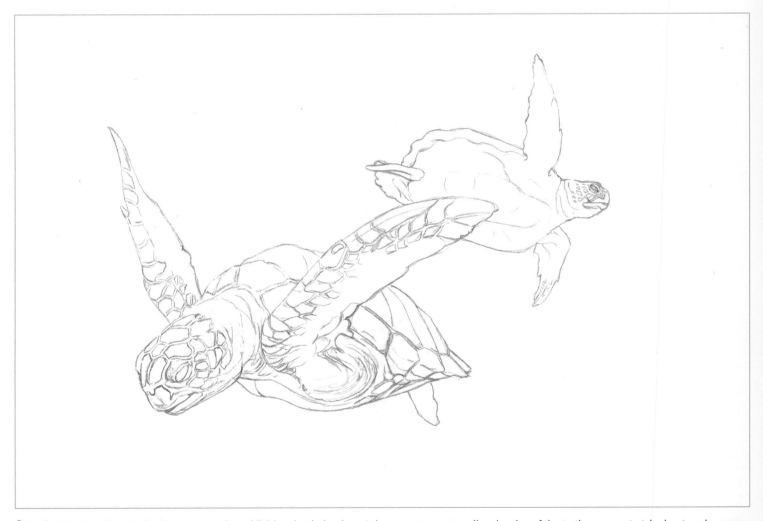

Step 1 After sketching the basic concept and establishing the dark values, I then create a contour line drawing of the turtles on my stretched watercolor paper. I also use my pencil to map out the facial features and scale patterns on the turtles as well.

Step 2 I want to create an irregular border for my painting, so I begin by saturating a large brush with water and sweeping it around the page to wet the paper. Then I use my spray bottle to further wet the edges. For this initial background wash, I mix a large puddle of phthalo green and Antwerp blue. This gives me an aqua color, and I use a large, wet round brush to apply the pigment. I use the most pigment in the bottom right corner and add more water as I pull the paint to the top left. I also leave a few highlight areas free of any pigment along the top of the foreground turtle's head, back, and flipper. Finally, I dip a stiff, flat hog-hair brush in my paint puddle and, using my finger to slide along the bristles, I flick paint around the border of my irregular wash.

Artist's Tip

A note on masking fluid removal: The longer the fluid is left on the painting, the more likely it is to tear off some of the paper when you remove it.

Step 3 Once the background is dry, I apply masking fluid over the large foreground sea turtle. I also use a stiff brush to flick masking fluid drops onto the middle part of my paper with the hopes that these will look like bubbles later. Then I repeat step 2, using a more concentrated mixture of the same colors and adding another layer to my wash. Again, I keep the darkest pigments to the bottom right, lightening my colors as I work up to the left. Next I apply masking fluid to the other turtle (a different brand and color, which I do to help keep track of separate masking layers) and spatter a little more fluid over the painting to create more bubbles. When the fluid is dry, I apply one more background wash. This time I mix mostly ultramarine blue with some sepia in order to push a darker value.

Step 4 I want my water background to look a little warmer, so I wet some of the areas around the turtles with my spray bottle. Then I use a medium-sized round brush to add some watered-down phthalo green and let the paint blend into these areas. Once this last addition to my background dries, I peel off my masking fluid. As you can see, the background turtle is a darker blue because I painted two washes over it, whereas I painted only the initial wash over the foreground turtle. Also, I am left with little bubbles that appear to be swirling around the animals.

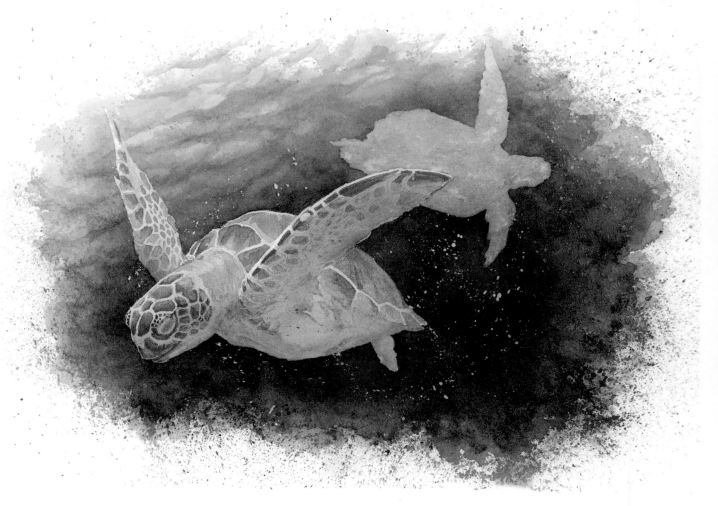

Step 5 Now I begin adding detail to my turtle shapes. I start with the foreground turtle, using a 2H pencil to place the scales around the face and flippers. With a small round brush, I fill in these areas with yellow ochre. While these areas are partially dry, I add burnt umber to provide some blended variation of color. I add burnt umber to the shell as well, but I mix it with a little permanent rose to redden the color. For the scales on the left flipper (right on the page), I use a mixture of cadmium yellow and green. On the undershell of the turtle, I add a few spots of the light green mixture. To emphasize the contrast between the areas in light and those in shadow, I switch to a medium flat brush and lay in a mixed wash of Antwerp blue and phthalo green (the same colors as my initial background wash) to the shaded part of the turtle's face, belly, flipper underside, and bottom right edge of the turtle's right flipper. Finally, using my small brush again, I add some of this blue mixture to fill in the eye.

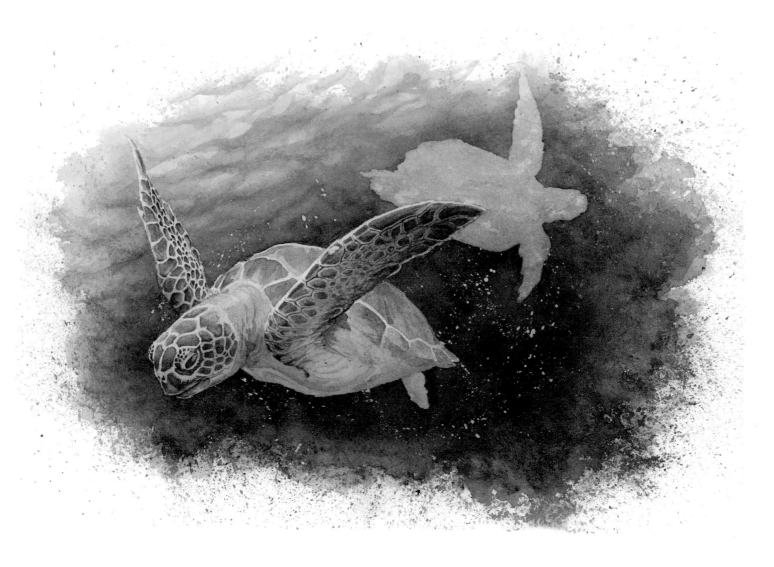

Step 6 With the turtle's general details mapped out, I deepen my dark values. Using a small round brush, I add tiny layers of burnt sienna, sepia, and phthalo blue to the face and beak scales. In my reference, I notice that the scales on top of the head appear a little redder in hue, so I warm them up with a layer of thin permanent rose. Then I use burnt umber to paint the scales of the turtle's right wing. I add mixtures of sepia and phthalo blue to each scale, emphasizing this mixture along the bottom right of the flipper and allowing the burnt umber to dominate the scales near the flipper's left edge. Then I use a very small brush to add nostrils, draw the line of the mouth, and add very thin lines on the jaw and cheek scales. Watering down my Antwerp blue, I use a flat brush to sweep in a blue shadow running along the top lip of the undershell and in the area below its neck. Next I develop the turtle's left flipper. (See detail below.) Lastly, I use a little Antwerp blue and burnt sienna to deepen the eye, leaving a circular highlight near the top right edge.

Detail
I mix in some phthalo green with the blue and use it to deepen the color on the green scales of the turtle's left flipper. I want my darkest shades to run along the right edge of the flipper but I am careful to leave a light green highlight running down the right side in order to visually separate the flipper from the background wash. I water this mixture down a little more, and with loose strokes I add hints of green shadows along the back lip of the shell.

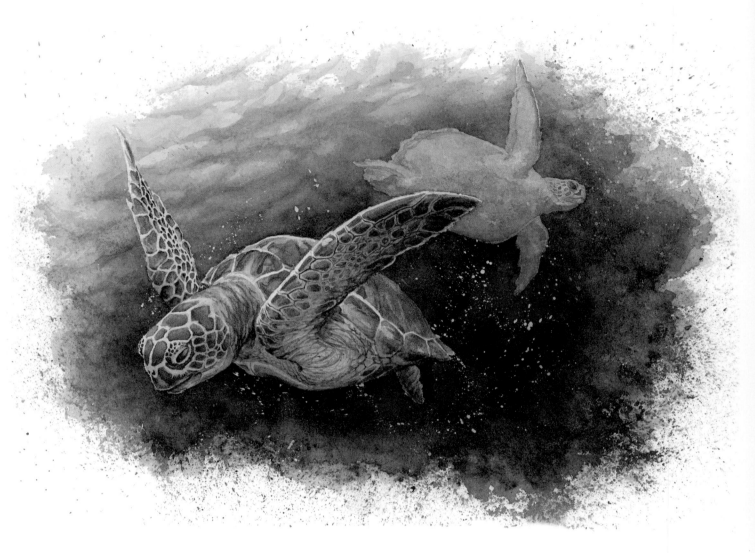

Step 7 Now I create the folded skin around the turtle's chest and base of the flipper using phthalo blue and a tiny liner brush. Turning my attention to the shell, I use phthalo green, raw sienna, and yellow ochre to capture the various colors I notice in my reference photo. In general, I use brighter, warmer colors on the part of the shell closest to the viewer; I add more phthalo green and a little bit of Antwerp blue further back on the shell. I use the yellow ochre and raw sienna mixture to extend into the pattern along the neck, keeping the colors light and thin. Next I mix more sepia into the Antwerp blue and add darker areas under the shingle-like ledge of the shell. I also use this mixture to wash over the back flipper. It is important to leave out details in the areas of the animal that are fading into the water. Finally, I address the turtle in the background. (See detail below.)

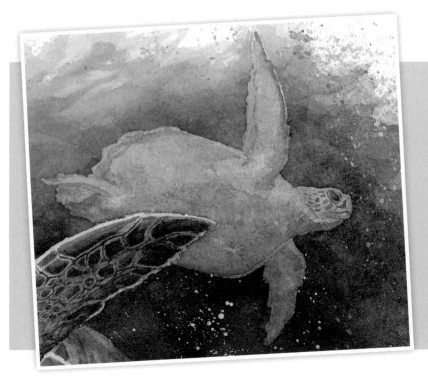

Detail

I resketch some of the details, such as the eyes, beak, back fins, and cheek scales, and then rewet the turtle's shape. I add a wash of yellow ochre over the shadowed areas. While still wet, I splash in some cadmium yellow for warmth and variation in the green shadow. Using the puddle of watered-down Antwerp blue, I add some basic details to the face, along the bottom lip of the shell, and in the back flippers.

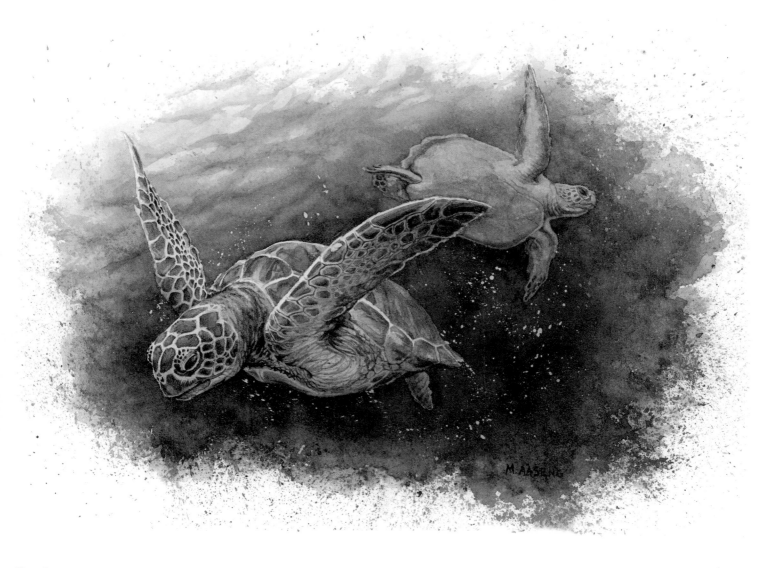

Step 8 I add more pigment to my Antwerp blue puddle to create lines and scales in the flippers and skin. Using my liner brush, I use very thin lines to show the jointed segments that make up the bottom of the shell. Further diluting this color, I shadow the edges of the flippers and underneath the shell and head of the turtle. I add concentrated cadmium yellow running along the back of the shell, beak, and flippers. Turning to my foreground turtle one last time, I add the finishing details. (See detail below.)

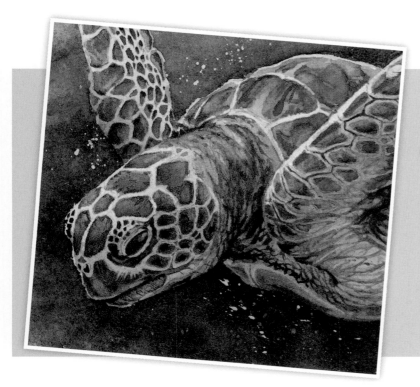

Detail

Using a small round brush, I add a deep blue mixture to the inside of the eye, along the lip of the undershell, and along the edge of the neck. I deepen the shadow on the scales at left and on the tip of the turtle's left flipper. Using my fine brush and a little more water, I add more lines in the bottom jaw and along the turtle's side and flipper bottom. I use mixtures of burnt umber and burnt sienna to add fine detail to the folds on the neck and the forehead scales. I add sepia to these brown mixtures to make the darkest brown, and I use this final color to bring out the scales around the eyes and over the cheek.

Lorikeet with Maury Aaseng

As a college student, I studied abroad in Australia and thought the rainbow lorikeets that lived there were the most cheerful and flashy-looking creatures that I had ever seen. To create this image, I use two reference photographs. I use the first photograph for the overall posture and detail of the bird's upper torso and for the foliage. I use the second photograph as a guide to create the back leg and tail.

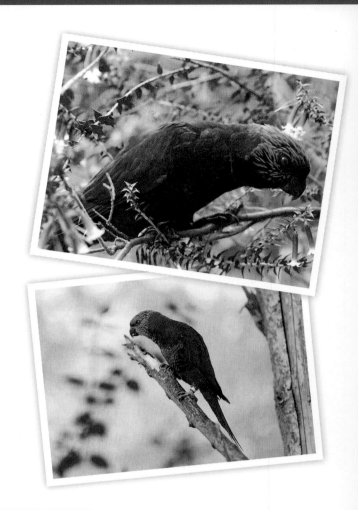

Color Palette
alizarin crimson • burnt sienna • cadmium red
cadmium yellow • cobalt blue • Hooker's green
intense green • permanent light green • phthalo blue
phthalo green • Prussian blue • purple lake
transparent yellow • ultramarine blue • yellow ochre
Additional: white gouache

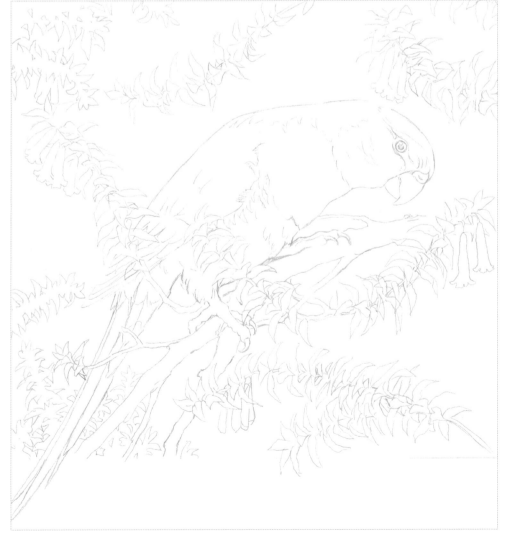

Step 1 I sketch the lorikeet using both photo references. I place the branches where I feel they make the best composition, and I tilt the head down a bit and smooth out the feathers. Finally, I extend the tail and leaves from a branch beyond the border of my drawing. Once I'm satisfied with my sketch, I use a light board to transfer my drawing to watercolor paper.

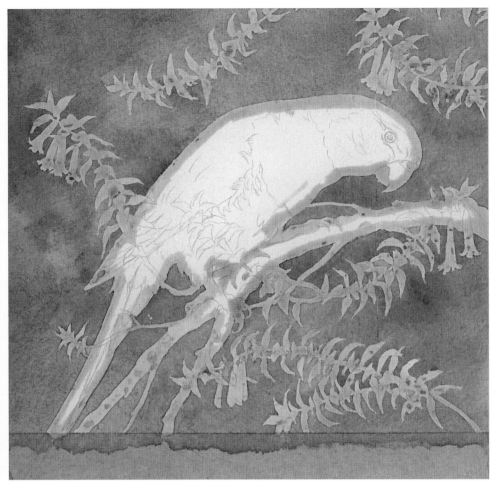

Step 2 After taping the watercolor paper onto a painting board, I wet the surface and let it dry. Then I use an old brush and masking fluid to block out the branches, leaves, and outside edge of the lorikeet to keep these areas free of the background washes. Once dry, I create a thin mix of Hooker's green with yellow ochre. I wet the entire paper with water and then use a large flat brush to lay down the mix loosely, working from top to bottom. While still wet, I add transparent yellow and Hooker's green to brighten and darken where desired, creating multiple values of yellows and greens. I allow the paint to dry completely.

Step 3 Next I apply masking fluid over more leafy branches on the outside edges, along with a thin, multi-pronged branch above the bird's head. Once dry, I wet the paper again and create four heavily pigmented puddles: Prussian blue, burnt sienna, Hooker's green, and yellow ochre. Using a medium round brush, I add colors to the background wash, placing the darkest values in the corners and along the main branch. I dab and twist the brush, allowing the colors to mix on the paper. I leave some areas light and dab away pooled paint with a paper towel. When the wash is partially dry, I sprinkle salt over it and let it push pigment away from the darker colors. I let it dry completely and then brush off the salt.

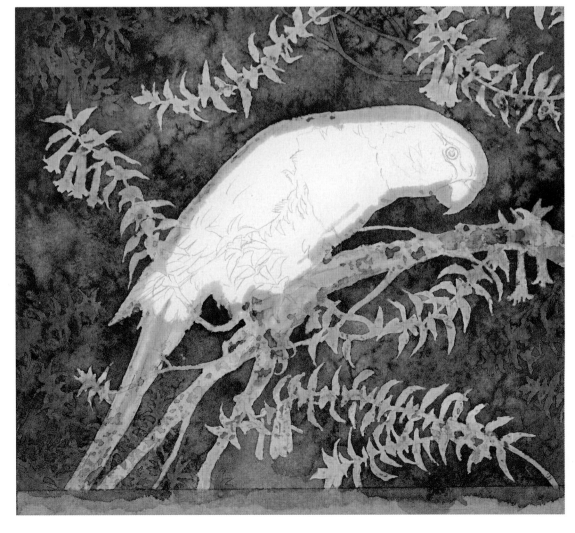

Step 4 Now I remove the masking fluid from the leaves, branches, and bird. I add another layer of masking fluid over the bird's red breast. Moving my focus to the feathers, I wet the bird with water and stroke in a mix of cobalt blue and ultramarine blue. I place the darkest values under the wing, on the bottom of the face, and around the eye. Next I add cadmium yellow to the nape of the neck, tail, and foot. While still wet, I add intense green and burnt sienna where the leg feathers meet the wing, intense green to the tail tip, and combinations of intense green and cadmium yellow over the wing, back, and neck. I add ultramarine blue to the bottom edge of the wing and sprinkle salt over this for texture. Then I paint the branch with purple lake, burnt sienna, and a bit of ultramarine blue, leaving the top of the branch lighter with a white edge.

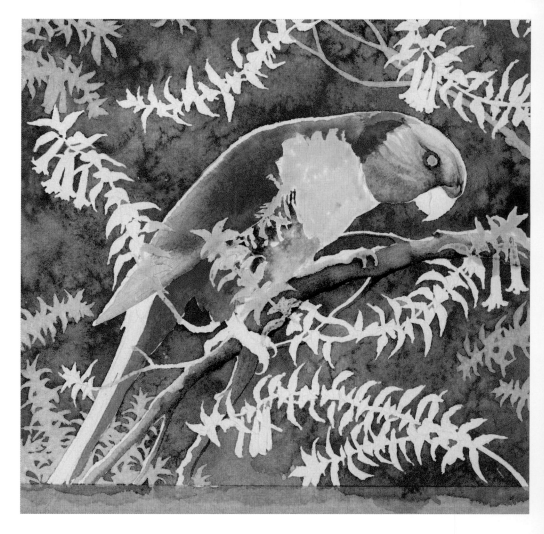

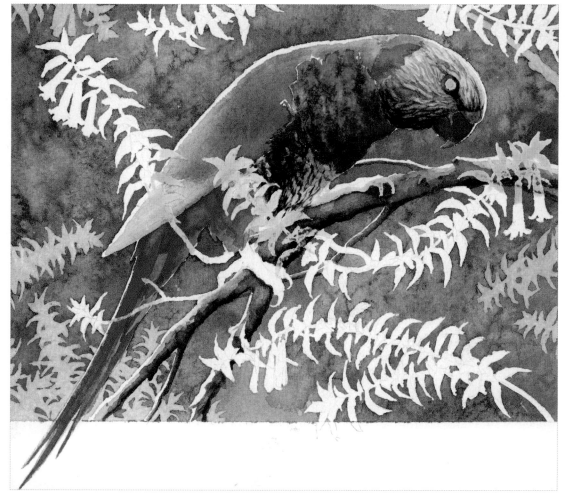

Step 5 I remove the masking fluid from the bird's breast. For the breast, I wet the area and then apply a mix of cadmium red and a bit of cadmium yellow, keeping the bottom of the breast more red than yellow. I also add red to areas of the blue stomach. For the beak, I apply a layer of light orange and add cadmium red for the darker areas. Turning my attention to the tail, I remove the tape from the bottom edge and apply a mix of cadmium yellow and intense green. Next I add blue feather details using ultramarine blue mixed with small amounts of purple and burnt sienna. Again, I keep the values on the top areas of the bird lightest and the shadowed areas beneath darkest.

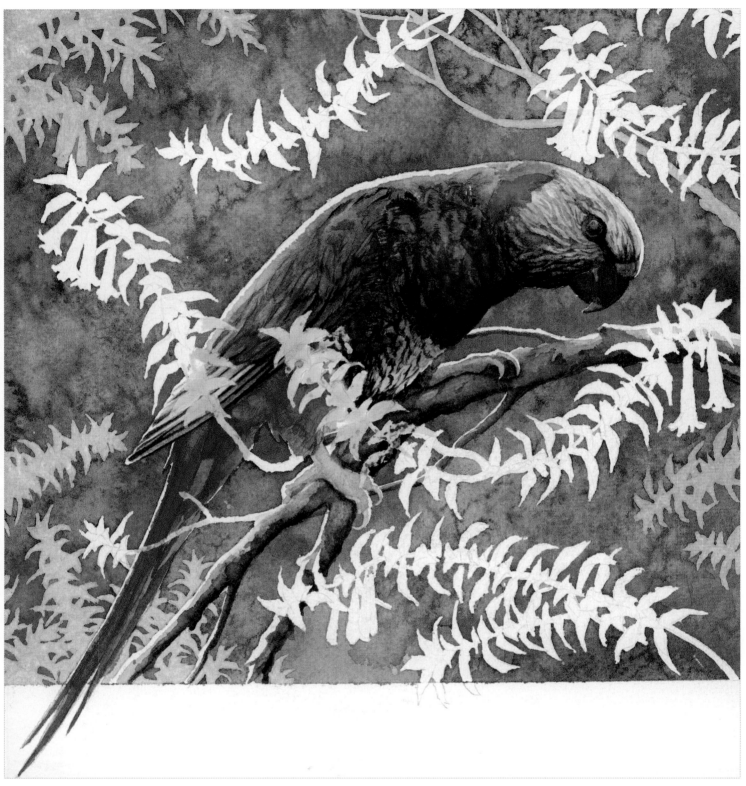

Step 6 I continue detailing the lorikeet's wing and chest feathers, blurring the shadows and sharpening some edges. Using phthalo blue, phthalo green, and a liner brush, I create shadows between the green feathers. For the red feather shadows, I use a mix of alizarin crimson and burnt sienna. For the blue feather shadows, I use heavily pigmented ultramarine blue. Note that I add the most detail to the center of the bird. For the eye, I add cadmium red with heavier pigment along the bottom edge for dimension. To paint the feet, I use burnt sienna and ultramarine blue. Once dry, I use a pencil to lightly sketch details on the tail and leg feathers.

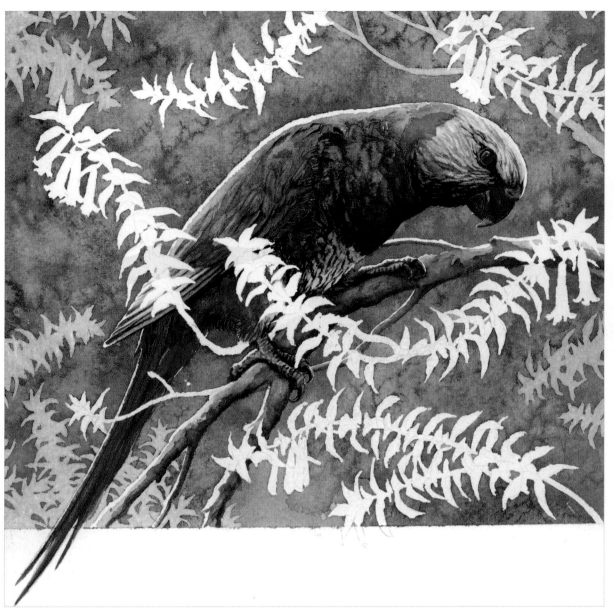

Step 7 Next I remove the masking fluid from the branches. Then, using a liner brush, I add details between feathers around the tail and back leg. I use phthalo blue to detail the green feathers and raw sienna to detail the yellow feathers. For any remaining dark facial details, I use heavily pigmented ultramarine blue. I move my focus to the feet and use this dark blue to detail the scales and claws. For the deepest values, I add burnt sienna to ultramarine blue for an almost-black color. I add the iris using alizarin crimson mixed with burnt sienna. Then I mix this with the almost-black color on my palette to create the pupil.

Step 8 To avoid making the foliage too dark, I create the color in layers and work from light to dark. For the flowers, I fill the tops of the bells with a light wash of alizarin crimson. I leave white edges along the left sides and apply more pigment to the shadowed right edges. I leave the tips of the petals white. For the leaves, I use a small round brush to apply just one color mix: a large puddle of transparent yellow and permanent light green. I am careful to leave white edges so they don't disappear into the background wash. Once I've established the bulk of the color on the leaves, I use a more concentrated mix to suggest shadows.

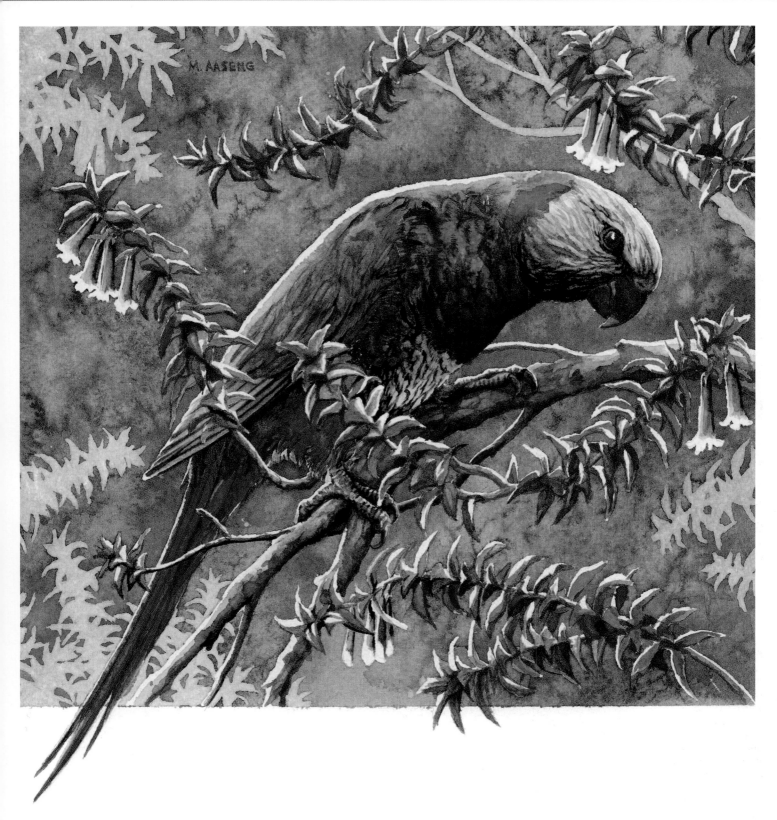

Step 9 In this final step, I define the darkest details on the branch and leaves. Using phthalo blue, I add deeper blues on the undersides of the leaves and in the spaces between them, still careful not to cover up the white highlights. I also use the branch paint mix to add color to the stems. On the undersides of these branches, I add thin shadows of ultramarine blue. I return to the main perch of the lorikeet and add dark shades to the undersides of the branch, using crimsons and blues to create a little more texture in the shadow. Using the smallest liner brush I have, I mix a small puddle of white gouache and dab a highlight in the eye. Then I add a little water to the puddle and gently stroke white into the back of the feathered leg, which helps the green leg pop against the green background.

About the Artists

Maury Aaseng's work has included anatomical illustration and cartoons for medical textbooks, informative illustrations for young adult nonfiction, illustrated guides for outpatient care, custom watercolor work for independent authors, and logo design and creation. In 2010, Maury's artwork was featured in the Upstream People Gallery 7th Annual Color: Bold/ Subtle Juried Online International Art Exhibition. An avid nature enthusiast, Maury moved back to Duluth in 2009, where he supplements his illustration work with wildlife photography and painting, hiking, skiing, and canoeing in the northern forests that border Canada. Maury lives with his wife, who works as a graphic designer at the university. Visit www. mauryillustrates.com.

Lorraine Gray is a pet portrait artist working in pastels, oil, and acrylic in Berkshire, England. Lorraine's love for art and animals started as a young girl, when she spent many hours painting her beloved pet dog and cat. Since launching her website, Lorraine has fulfilled commissioned paintings from all around the world. Her pet portraits hang in the USA, Japan, Canada, Switzerland, Malta, France, Holland, and Dubai, as well as the UK. Lorraine's work has been featured in the Kennel Club Exhibition in Piccadilly, London (2006), live on the BBC from Battersea Dogs and Cats Home, where she painted a portrait of a featured dog (2007), and in the magazine *Your Cat* (2011). Visit www.pastelpetportraits.co.uk.

Jason Morgan is a professional wildlife artist who specializes in big cats and African animals. Jason is heavily involved in conservation through the Cheetah Conservation Fund, the Snow Leopard Conservancy, and the Dian Fossey Gorilla Fund and has been featured in *Artists & Illustrators* magazine. A signature member of Artists for Conservation, Jason strives to paint wildlife as accurately as he can by studying animals in their natural environment. Visit www.onlineartdemos.co.uk to learn more.

Kate Tugwell teaches art courses, workshops, and private lessons at venues and homes near Sussex, UK, and has tutored for London Art College for their Pet Portraits Diploma Course. In 2006, she won the Open Art Exhibition in Cranleigh, Surrey, which resulted in a solo exhibition the following summer. She has participated in other exhibitions along the south coast, including Worthing Pier, and has had numerous Christmas card designs printed and sold through various charities. She paints with acrylics, pastels, and other mediums and works from life or from photographs. Visit www. katetugwellportraits.com.

Toni Watts is a former doctor who gave up medicine to follow her dream of being an artist. Her award-winning work is now held in private collections worldwide, and she splits her time between painting, teaching, and watching the wildlife she loves. Visit www.toniwatts.com to learn more.

Deb Watson spent a good portion of her adult life as an operating room nurse. Working long hours and raising a family didn't leave much spare time, but she continued to paint whenever she could. Deb quit nursing in 1999 to become a full-time watercolorist. Deb maintains a busy teaching schedule and loves helping her students rediscover their own passion for art. An award-winning artist, the most rewarding part of Deb's journey has been the heartfelt responses of those whose hearts have been touched by one of her paintings. Visit www.debwatsonart.com.

Index